*Dedicated to the inventors
of photography 150 years ago,
Joseph Nicephore Niepce
and Louis Jacques Mande Daguerre,
and to all the photographers since.*

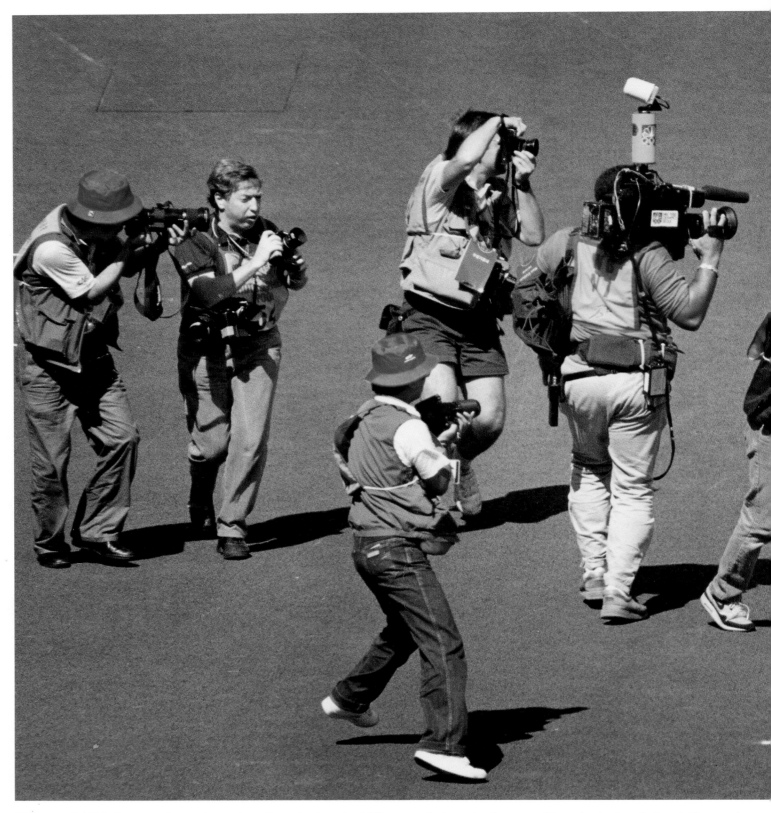

Florence Griffith-Joyner takes a victory lap after winning the 100-meter dash at the Summer Olympics in Seoul, South Korea. /
Fred Comegys, The News Journal, New Castle, Del.

An annual based on the 46th Pictures of the Year competition sponsored by the National Press Photographers Association and the University of Missouri School of Journalism, supported by grants to the university from Canon U.S.A., Inc. and Eastman Kodak Co.

Pictures of the Year
Photojournalism 14

This book is dedicated to photojournalists who serve as the eyes of the world, who show the personal side of news that sound bites or words often fail to communicate.

Who else can show the fatigue of a presidential campaign and at its end the thrill, the defeat? What other way can you see the impact of drug use within a community or the emotional result of domestic violence in our homes, upon our children?

There is no better place to learn of the world than through the eyes of photojournalists. Through their efforts, we see the comings and goings of our community, our world, that most people have neither the time nor access to see.

In this book you'll see the personal side of news in a salute to the best of photojournalism.

William M. Hodge
President, NPPA

© **1989**
National Press Photographers Association
3200 Croasdaile Drive
Suite 306
Durham, NC 27705

Library of Congress Catalog Number: 77-8158.
ISBN: 0-89471-735-9 (Paperback)
ISBN: 0-89471-736-7 (Library binding)

Printed and bound in the United States of America by Jostens Printing and Publishing Division, Topeka, KS 66609

Cover design by Running Press

Canadian representatives: General Publishing Co., Ltd., Don Mills, Ontario M3B 2T6

International representatives: Worldwide Media Services Inc., 115 East 23rd Street, New York, NY 10010

This book may be ordered by mail from the publisher. Please include $16.95 plus $2.50 for postage and handling. But try your bookstore first. Running Press Book Publishers, 125 South 22nd Street, Philadelphia, PA 19103

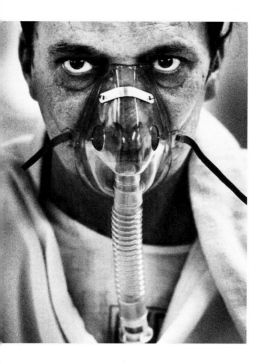

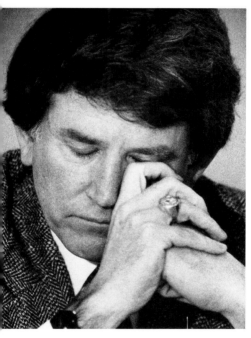

Table of contents

The POY 14 Staff

Editor, designer	Howard I. Finberg
Associate editor, designer	Steve Anderson
Associate editor, photo editor	Joe Coleman
Associate editor, designer	Phil Hennessy
Associate editor, designer	Michael Spector
Associate editor, designer	Pete Watters
Text editor	Patricia Biggs Henley
Editorial assistant	Steve Mounteer
Editorial assistant	Randy Thieben
Lab assistant	David Seal
Lab assistant	Mark Montalvo

The above PJ14 crew are staff members of The Arizona Republic and Phoenix Newspapers Inc. who gave of their time to make this project successful.

Images
&
Ideas

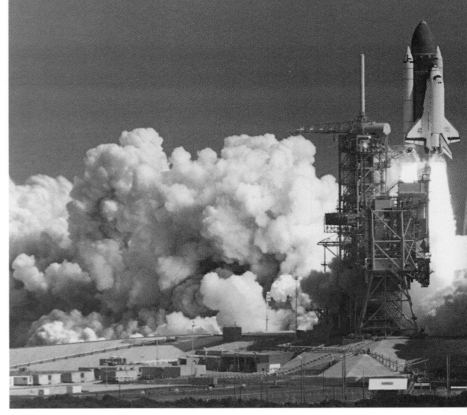

The United States returns to space with the launch of Discovery from Florida on Sept. 29. / **Jim Middleton, Agence France-Presse**

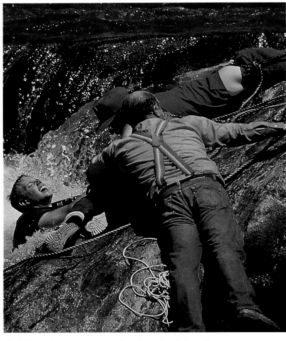

California teen-ager is clutched by three men who rescued him from the Kern River. / **Casey Christie, The Bakersfield Californian**

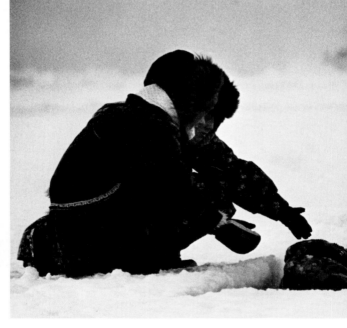

Two Barrow, Alaska, residents say goodbye to the Californi gray whales that were trapped in the Arctic Ocean ice pack fo more than three weeks. The whales were kept alive by holes cu

Never **before** has the future of photojournalism looked so bright and yet so cloudy. Even as new research is showing editors and designers what many photographers secretly knew in their hearts – readers look at pictures before they read a single word – the very essence of photography's credibility is under attack.

Words like "photographic proof" and "th camera doesn't lie" may become as old-fash ioned or antiquated as the Speed Graphi camera or glass plate negatives.

But why should we care? A photograp is a photograph is a photograph. We protect th doctrine of photojournalism because of the ver

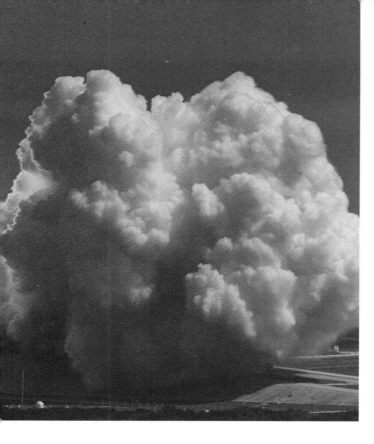

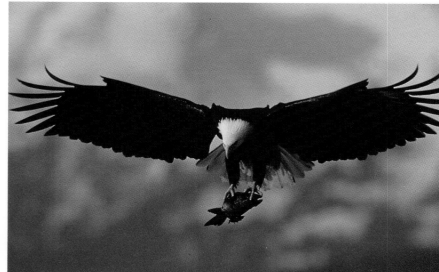

Eagle with a salmon on the Homer Spit in Kachemak Bay, Alaska. /
Bob Hallinem, Anchorage Daily News

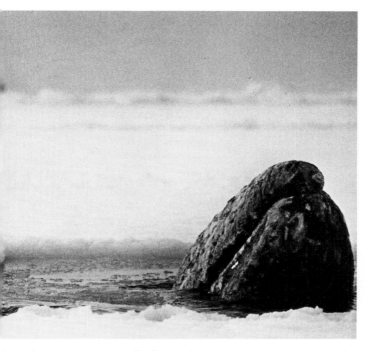

into the ice and eventually freed when a channel was cut into the
ice by a Soviet icebreaker. / **Bill Roth, Anchorage Daily News**

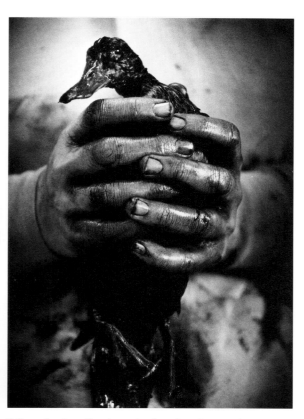

Oil-soaked mallard ready for cleaning at the
International Bird Rescue Center in Berkeley,
Calif., after a spill contaminated a nesting area. /
Scott Henry, Marin, Calif., Independent Journal

power of these images. While it is not original
to remind us that "words divide and pictures
unite," we must remember why we believe this
axiom.

We believe it because of the very power of
photography to capture a split-second of
humanity as the world spins at a seemingly
faster and faster rate. We believe because we see
and have been taught that "seeing is believing."

But what of the future? What if we don't
see the danger signs and if we give in to the siren
song of perfect digital images?

Unfortunately, there are no answers or
guidebooks that can tell us which road to travel,

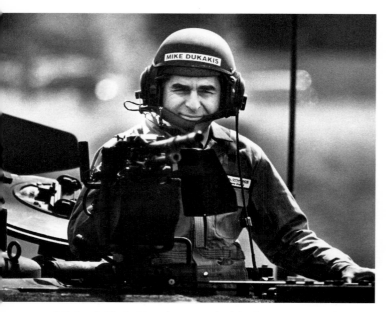

Michael Dukakis takes a tank ride during a presidential campaign visit to General Dynamics factory in Detroit. / **Tracy Baker, United Press International**

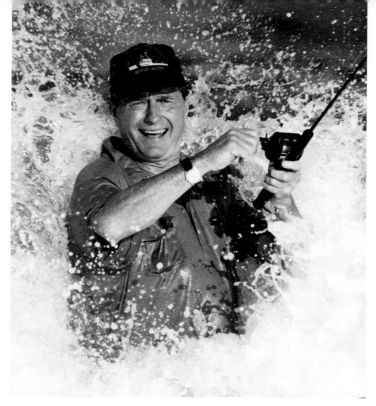

George Bush, shortly after becoming president, takes a day off to go fishing near Palm Beach, Fla.. / **Bob Sullivan, Agence France-Presse**

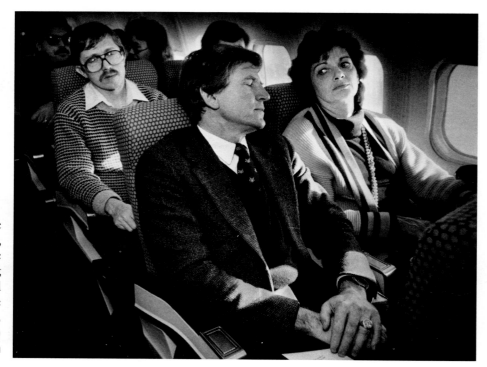

Gary Hart, under the watchful eye of his wife, Lee, takes a quick nap during a plane ride to Denver after announcing his return to the presidential campaign after the Donna Rice scandal. / **Ruben W. Perez, The Providence (R.I.) Journal-Bulletin**

which direction is correct. The best message might be to remember why photography is so valuable and why readers like and want to look at pictures from around the world. Ansel Adams, who captured stillness and beauty with his camera, once commented upon how the works of Dorthea Lange recorded a different type of beauty: "Let us show everything that is false and inhuman, sordid and without hope...we can show the good along with the evil, making good more desirable, and the evil more detestable." Within these pages are the images of cruelty, not only to fellow humans but to the Earth itself. There are the images of evil words – of murder, drug addiction, of death in war and in starvation, of a pestilent oil spill,

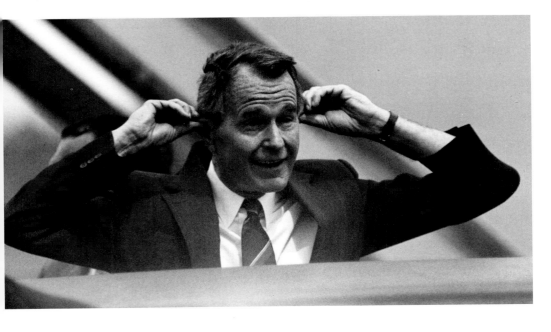

George Bush signals he "can't hear" when asked about possible running mates upon his arrival to New Orleans for the Republican convention. / **Ted Jackson, New Orleans Times Picayune**

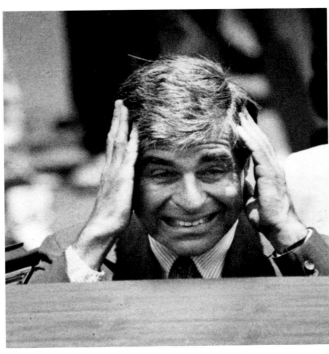

Democratic presidential candidate Michael Dukakis covers his ears as reporters shout questions in Atlanta. / **Michael Meister, The Arizona Republic**

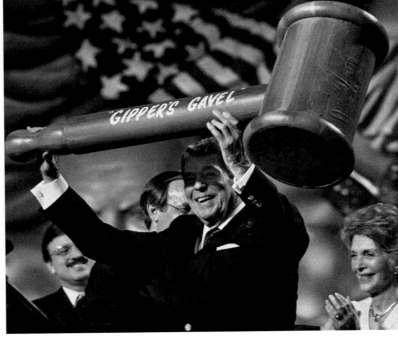

President Ronald Reagan gets a going-away gavel during the Republican convention. / **Bernie Boston, Los Angeles Times**

of pain and sorrow.

But there are also images of the hope and the triumph of the human spirit. These are the photographs that make us smile, the photographs that go beyond the surface and show inner beauty and strength.

The photographs that represent 1988 capture the good and evil of our world, some-

times in surprising and shocking ways. Nineteen Eighty-Eight was one of those special years, although sometimes cursed by editors, when photographers were sent out on quests that show both the splendor and obnoxiousness of humanity – the Olympic games and the seemingly endless presidential campaign.

This is the history that was produced

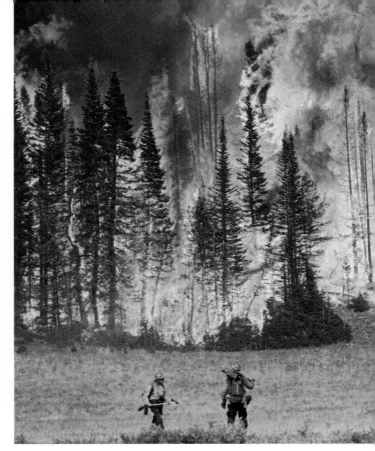

Two firefighters study the south flank of Yellowstone National Park's Storm Creek inferno after it jumped fire lines (August and September). / **Craig Fujii, Seattle Times**

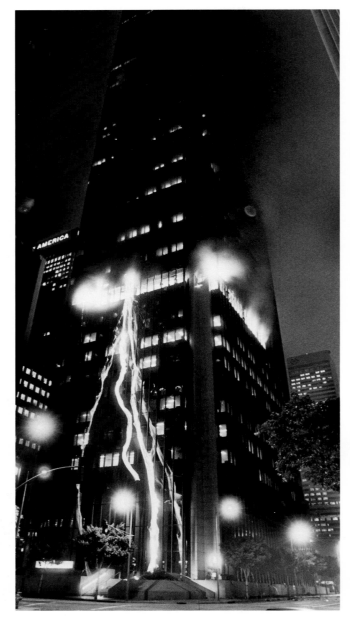

Los Angeles' tallest building burns out of control. One person died in that city's worst fire (May). / **James Ruebsamen**

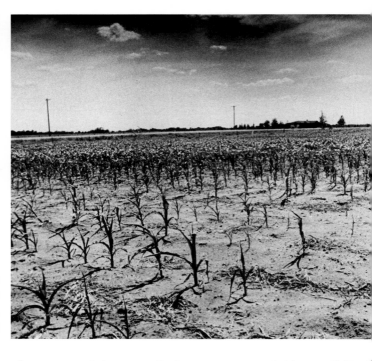

Gilbertville, Iowa, farmer surveys the damage to his drought-stricken crop (June). / **John Caps III, The Associated Press**

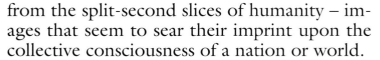

from the split-second slices of humanity – images that seem to sear their imprint upon the collective consciousness of a nation or world.

Some come quickly to mind when teased with words:

√ Eskimos patting the heads of trapped whales in Alaska. The world watched as man reached out to one of the world's most hunted and least understood animals. Without the photographic proof, the story would have failed to capture the attention of the world.

√ The liftoff of the space shuttle Discovery, marking the rekindling of our exploration into the universe.

√ The beauty of the Olympic spirit in South Korea lauding the victory of the human body despite the human toll in the streets.

√ The terror and destruction of a 30-

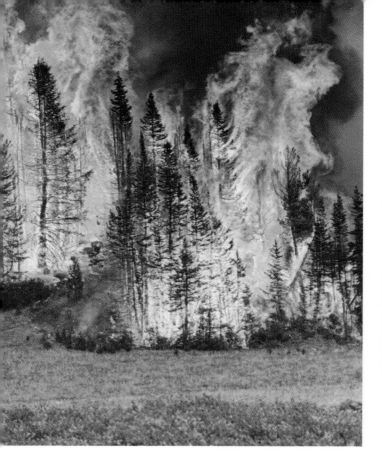

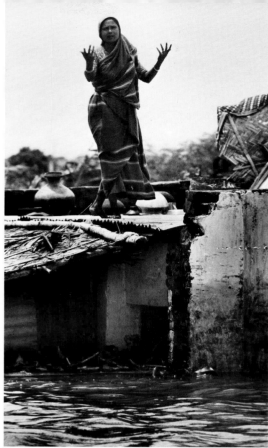

A woman pleads for help from her roof after being stranded by floods in Bangladesh (September). / **Carol Guzy, The Washington Post**

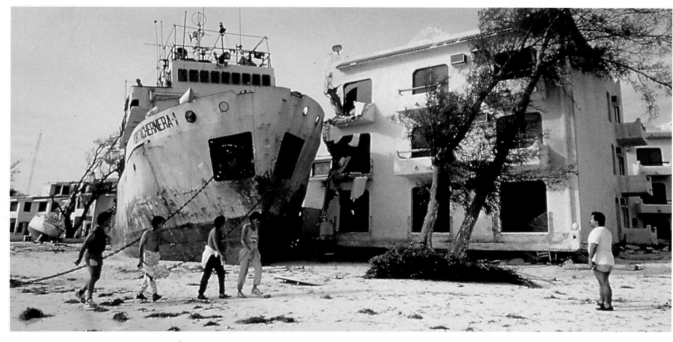

Hurricane Gilbert pushed a Cuban fishing ship against a hotel in Cancun, Mexico, despite its two anchors (September). / **Ricardo Ferro, St. Petersburg Times**

second earthquake in Soviet Armenia and the dazed look of the homeless survivors.

√ Candidates roaring from the podiums at the political conventions. (Occasionally, even the seemingly innocent images can be turned against an individual. Michael Dukakis riding in a tank caught the fancy of photographers and his opponent. George Bush used that image to help get elected to the White House.)

There are photographs that don't win contests, that often don't get seen beyond the community they were taken in. Yet, they too capture the human spirit – the rescue of two teen-agers in California from a raging river or a father's day portrait.

Sometimes, photographers (and their editors) are asked why they take so many pictures of disasters, death and destruction. Often,

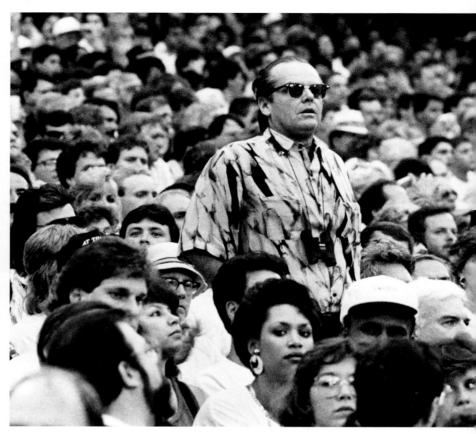

Jack Nicholson, an avid Los Angeles Lakers fan, keeps his eye on the action during the NBA finals against the Detroit Pistons in Pontiac, Mich. / **Doug Bauman, The Oakland Press, Pontiac, Mich.**

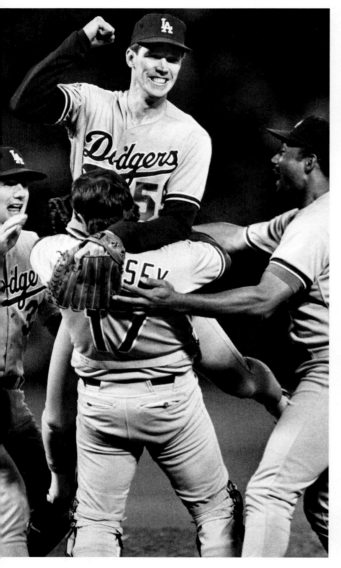

Dodger teammates hoist Orel Hershiser after he pitched a four-hitter to help Los Angeles win the World Series. / **Kim Kulish, Los Angeles Daily News**

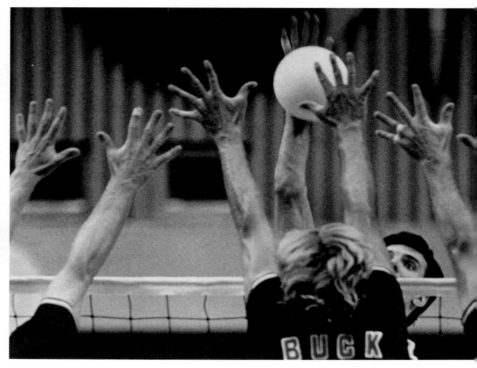

American and Soviet volleyball players battle at the net during the Summer Olympics. / **Rick Rickman**

we say "because it is news." Once in a while, it is because only a photograph can convey the power of the event. Witness the almost unimaginable strength of a hurricane that washed a huge ship into a beachfront hotel. Could words describe such destruction accurately? How does a writer communicate the awesome power of a forest fire? Yet, within a photograph, both the beauty and the horror of the inferno are clearly seen.

And what of the lost souls within our own cities and communities, destroyed by senseless violence, poverty and drugs. At those times, the photographer can only step back and record the damage, a bystander to the world's chaos.

Within the pages of this book are "decisive moments" that tell us something about our souls, our very goodness.

Sul Ross State University pitcher Mike Gonzales works against the shadows during a late afternoon game in Austin, Texas. / **Smiley N. Pool, Austin American-Statesman**

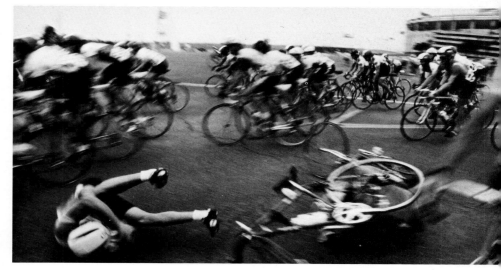

Two competitors collide during the Dan D'Lion Pro-Am Criterium Bicycle race in Anaheim, Calif. / **Ed Carreon, Anaheim Bulletin**

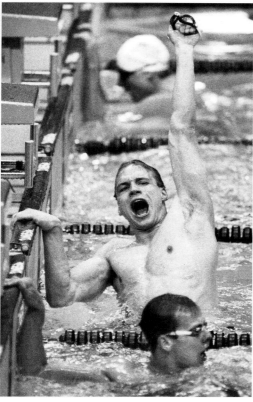

Uwe Dassler of the German Democratic Republic cheers his world record time as he wins the 400 meter freestyle gold medal at the Summer Olympics. / **Mark Duncan, The Associated Press**

This book, the 14th annual presentation from the Pictures of the Year competition, is sponsored by the National Press Photographers Association and the University of Missouri. The editor and staff of *Photojournalism 14* are attempting to reflect both the spirit and the results of the journalism community's most important photographic judging.

Especially important to the staff of this book was the goal of showing a representative amount of work by the contest's most important winners – newspaper photographer of the year (John Kaplan) and magazine photographer of the year (James Nachtwey). As selected by a judging panel of their peers, Kaplan and Nachtwey were considered the best in their respective areas in 1988. We wanted to show

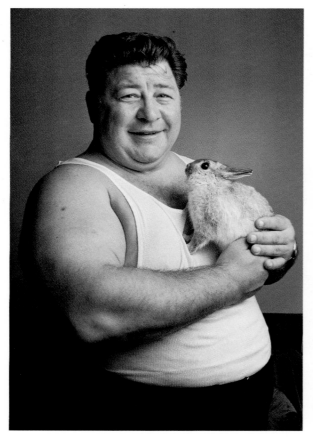

Moe Baker, five-time world arm-wrestling champion, with one of the rabbits he helps raise for his girlfriend. / **Shana Sureck, The Hartford Courant**

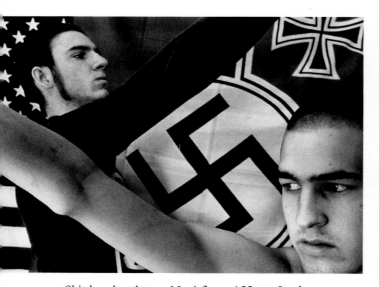

Skinheads salute a Nazi flag. / **Marc Asnin, JB Pictures**

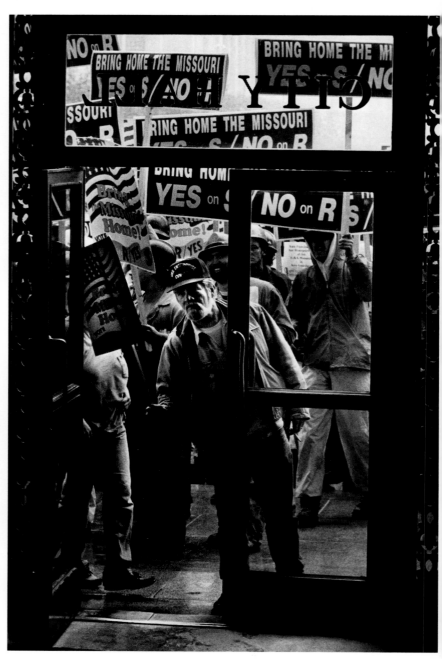

Supporter of the USS Missouri peers through an open door at San Francisco's City Hall during a rally by ship workers. / **Brant Ward, San Francisco Chronicle**

you their work not only in context to each other, but also in context to the runners-up who have similarly strong work.

Other innovations in this book include the grouping of like work, when possible, such as sports or feature photography. There are also two essays that should be noted here:

√ The Canon Essay, given to Eugene Roberts for his striking and distressing look at the epidemic of drugs in a New York neighborhood.

√ The Kodak Crystal Eagle, a new award this year, which was given to the body of work by Charles Moore taken during the civil rights movement in the 1950s and 1960s.

While we could not present both essays in

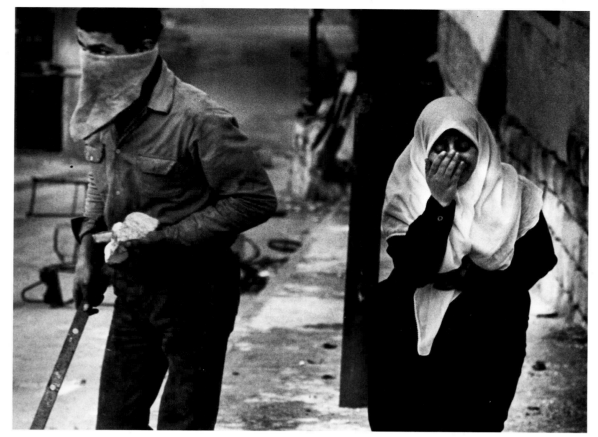

Nablus woman cries upon hearing her son has been killed in a fight with Israeli soldiers. Another youth, armed with a rod and rocks, goes off to the battle. / **Lucian Perkins, The Washington Post**

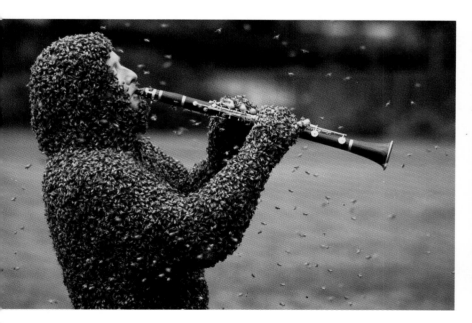

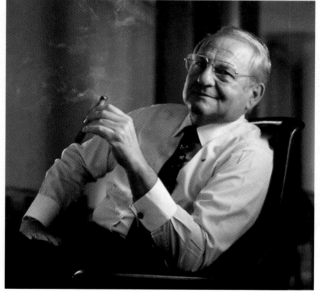

Dr. Norman Gary, an entomologist from the University of California, Davis, plays his clarinet while covered with bees. This stunt, done for the "Day in the Life of California" book, is something Dr. Gary has done many times. / **Michael Williamson, The Sacramento Bee**

Chrysler Chairman Lee Iacocca in his office. / **Gregory Heisler, for Fortune Magazine**

their entirety, we tried to be as faithful as possible to the spirit and intentions of the photographers.

The editor of the *PJ 14* wishes to personally thank his staff: Without your contribution, this book would not have been possible. In addition, the *PJ 14* staff thanks the National Press Photographers Association and its president, Bill Hodge, and the University of Missouri for their help and support.

Finally, we wish to thank all the photographers who contributed pictures, both the winners and non-winners. Without them, the world would be a poorer place in which to live.

—*Hif*

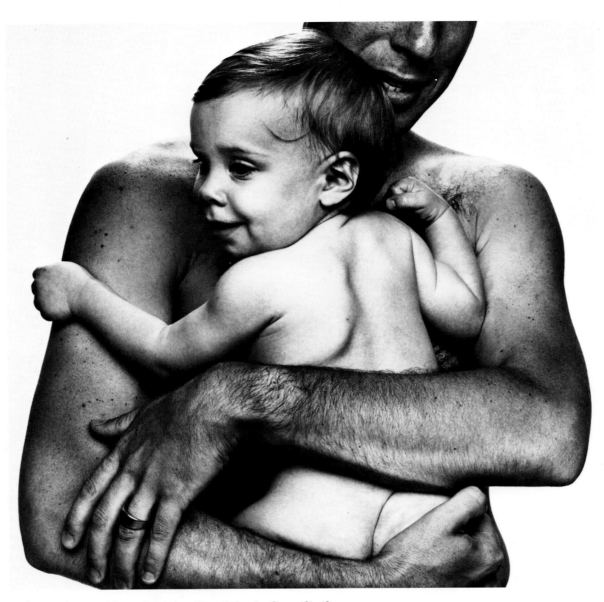

Father and son. / **Joey Ivansco, The Atlanta Constitution**

John Kaplan
The Pittsburgh Press

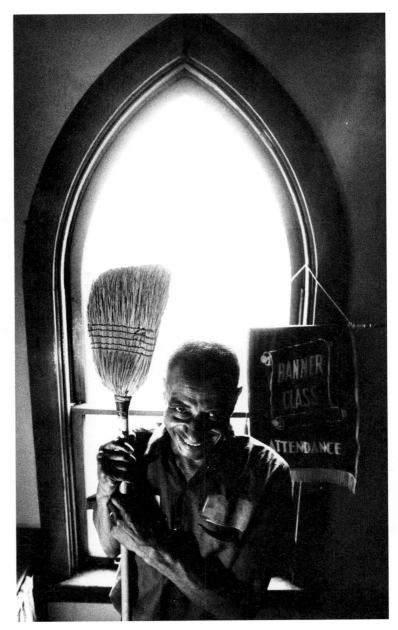

"I ain't no deacon," says Mark Face, janitor and parishioner at
Mount Zion Baptist Church in Pittsburgh; part of a series of
Labor Day portraits.

Rodney's Crime

On a slow news night in October 1987, photojournalist John Kaplan of The Pittsburgh Press accompanied the paper's police reporter to the Public Safety Building, where a suspect in a murder case was turning himself in to the police.

Rodney Woodson, 21, who never before had been arrested, claimed the victim, John Bolden, had been trying to choke him with nunchuks when he shot him in self-defense. Woodson seemed to the photographer to be boyish and vulnerable, rather than what he had previously envisioned as a killer.

During the next several months, Kaplan followed the story of a young man who had found himself in a tough situation and made a tragic error. Kaplan's photographs and first-person account of Woodson's arraignment, trial and eventual imprisonment were published in The Pittsburgh Press Sunday Magazine.

Rodney Woodson turns himself in to police; as a condition of bail, he would show where he hid the gun he used in the killing.

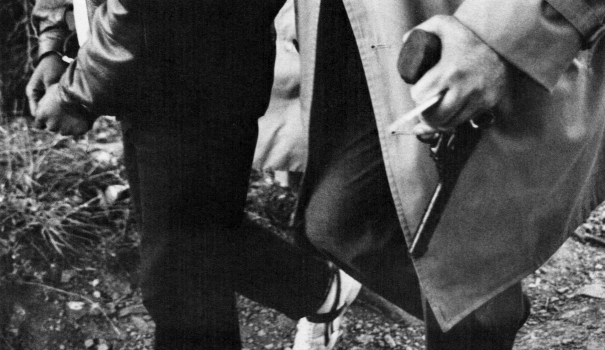

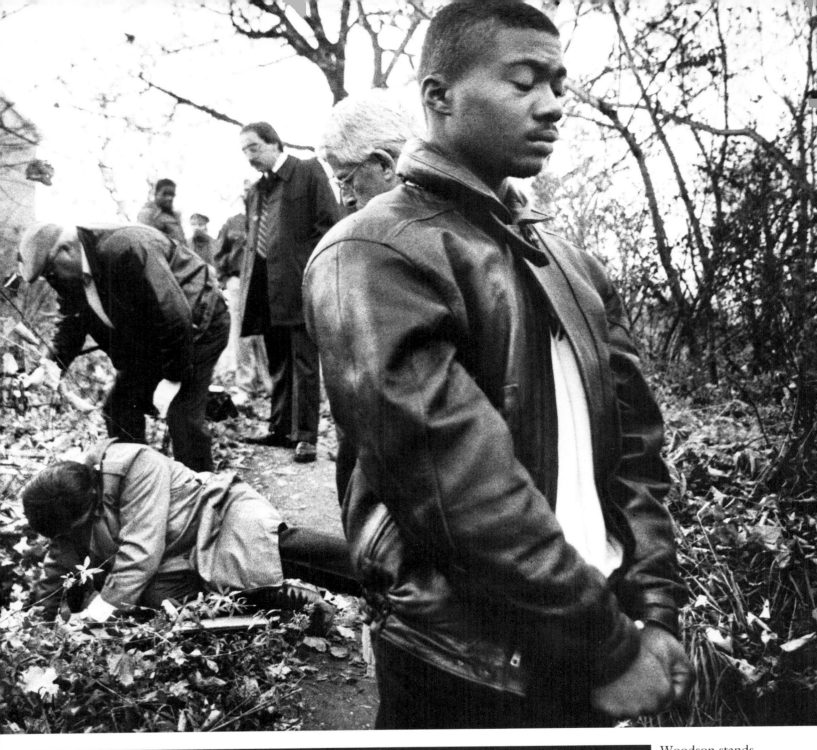

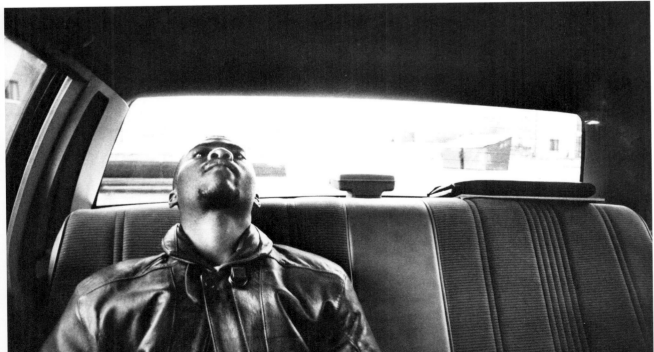

Woodson stands by as police detectives search the area where he had hidden the gun four days earlier. Later, he is locked into a police car as the search for evidence continues.

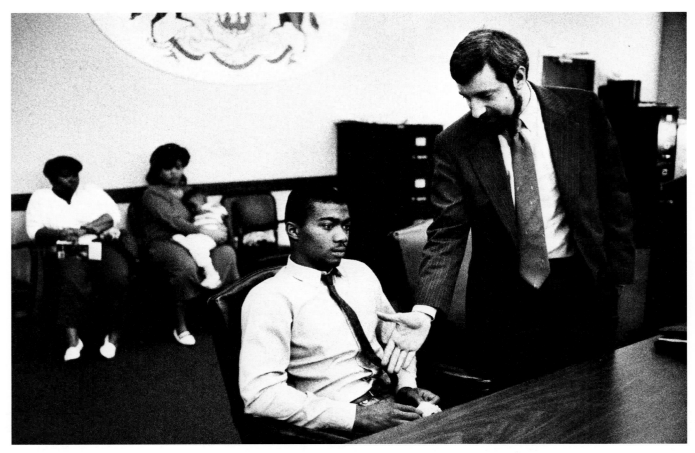

A dazed Rodney Woodson sits in court during his trial, not realizing his defense attorney is greeting him.

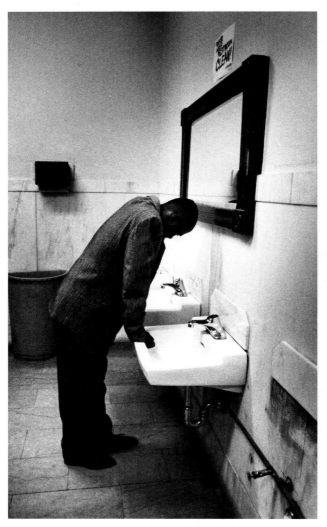

On the first day of trial, Woodson tries to steel himself for his fate.

Newspaper POY / John Kaplan, First Place

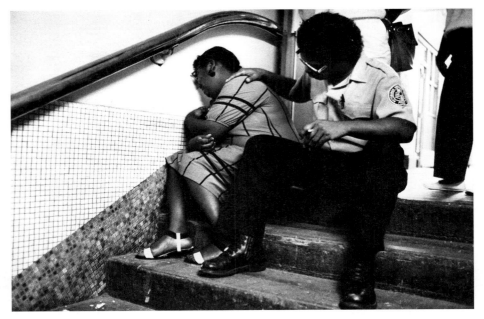

Woodson's mother, Cassandra, is found in a basement stairwell of the courthouse an hour after the verdict was read. "I couldn't bear to watch them take my baby away," she said.

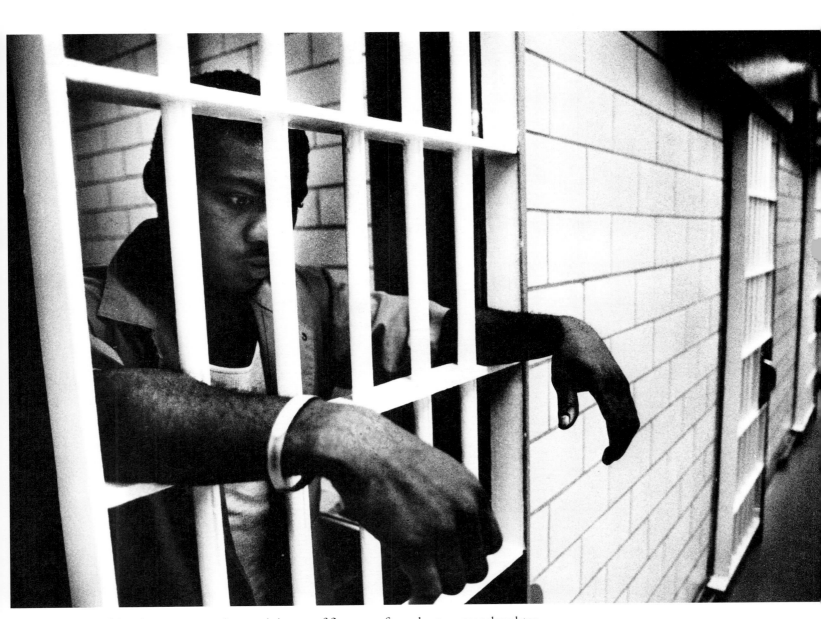

Woodson begins his prison term, serving a minimum of five years for voluntary manslaughter.

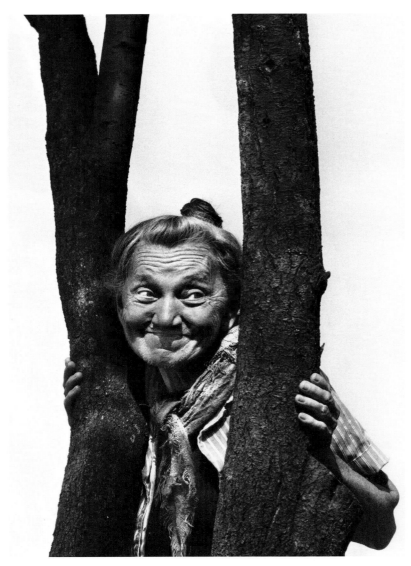

Hilda East, who won't reveal her age but admits to probably being older than the tree she's peering from, enjoys nature, Pittsburgh-style.

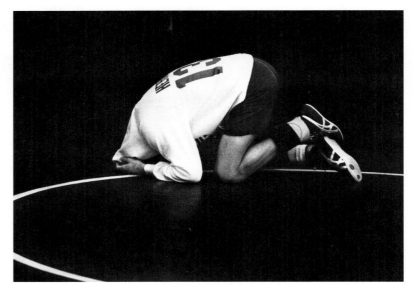

High school wrestler Jim Herriot meditates before a crucial match. He won the 132-pound contest to become Western Pennsylvania champion.

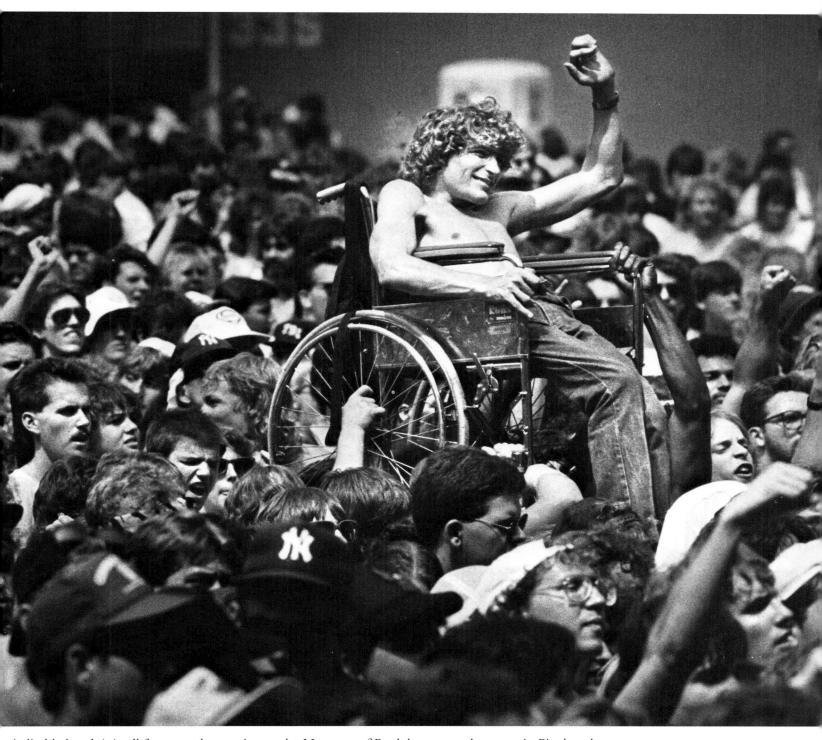

A disabled rock 'n' roll fan gets a better view at the Monsters of Rock heavy metal concert in Pittsburgh.

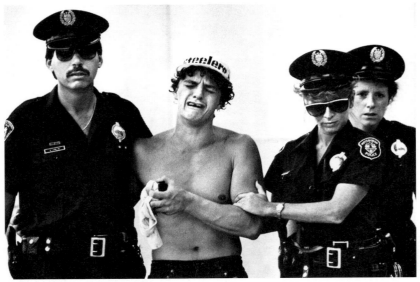

Above, Pittsburgh police officers lead Matthew Armstrong away from the Allegheny River where his brother, Larry, drowned. The two brothers had been drinking and attempted to swim.

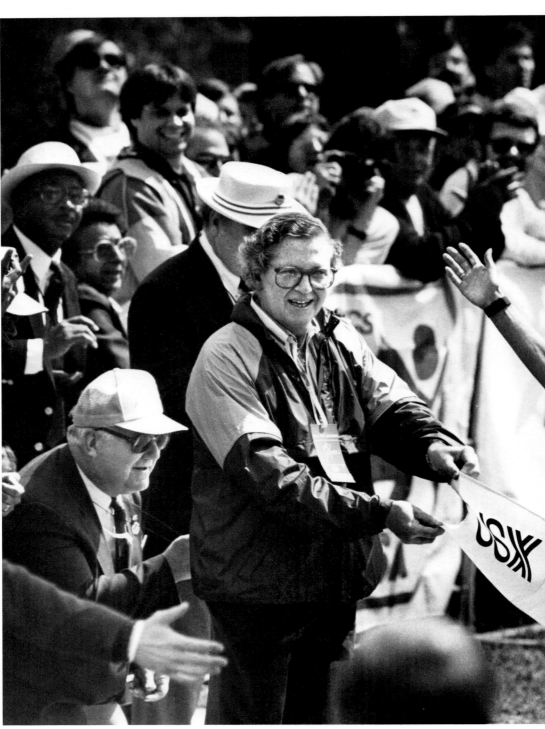

Newspaper POY/John Kaplan, First Place

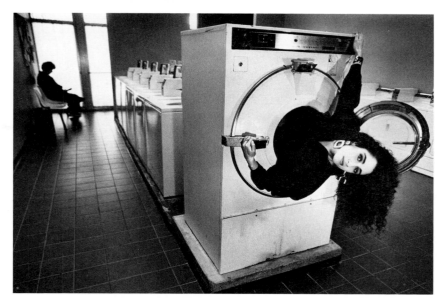

Above, Washable silks.

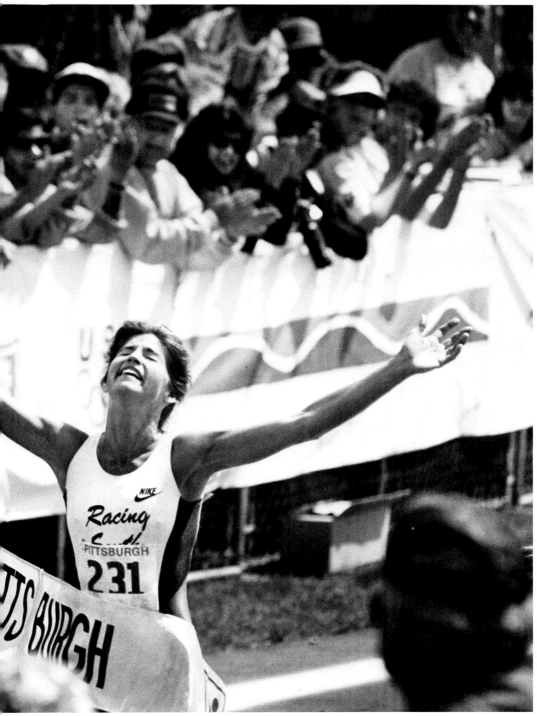

An ecstatic Margaret Groos qualifies for the U.S. Olympic team by placing first in the Pittsburgh Marathon.

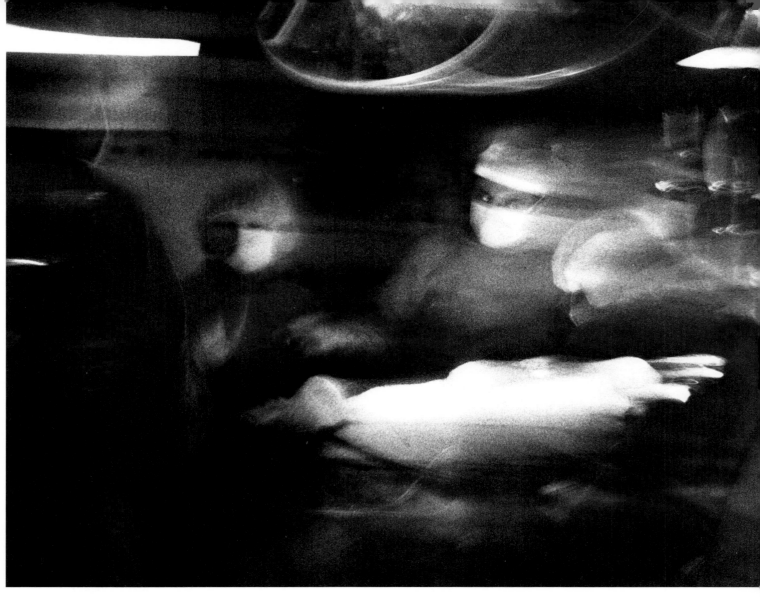

Surgeons at Presbyterian University Hospital in Pittsburgh operate on Ashby Bodden, a 47-year-old Miami police officer who suffered a massive heart attack. Too weak to survive an immediate transplant, his life was saved by the implant of a Novacor artificial heart pump.

A Life in the Balance

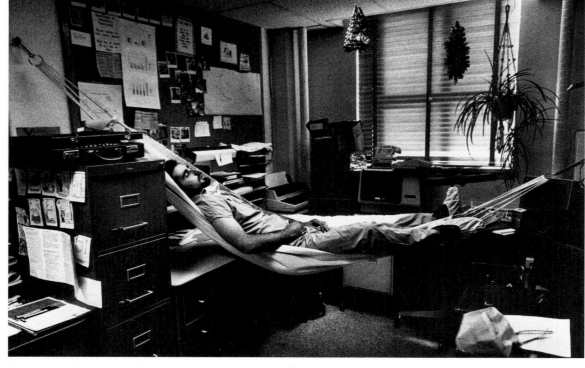

Technician James Antaki gets some sleep in his office after monitoring the Novacor's performance.

Newspaper POY / John Kaplan, First Place

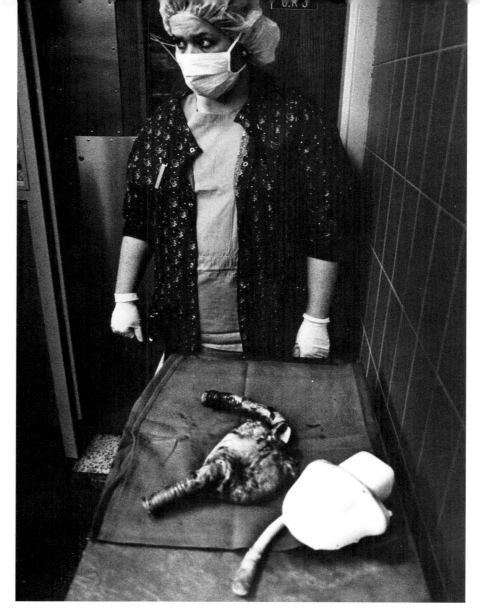

After a second operation in which Bodden received a human heart, his diseased heart and the Novacor lie discarded.

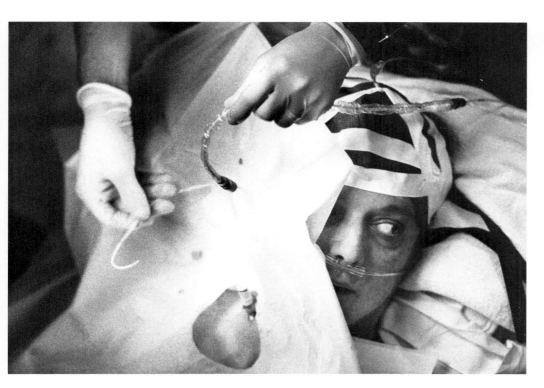

Bodden is the 22nd patient worldwide to receive the Novacor pump.

Scales of Justice

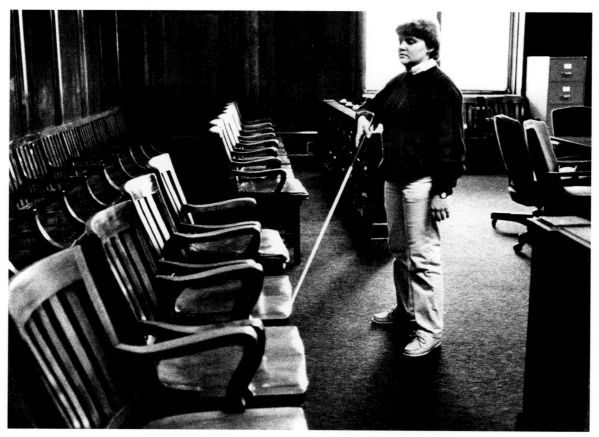

Pennsylvania attorney Natalie Ruschell, who lost her sight during her last year of law school, learns the layout of a courtroom before a trial.

Symbols of her chosen profession bedeck Ruschell's cane.

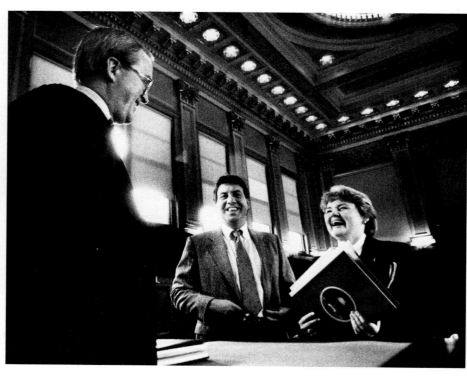

Judge Thomas D. Gladden and state Rep. Victor Lescovitz honor Ruschell for passing the bar exam and entering the legal community.

James Nachtwey

Magnum

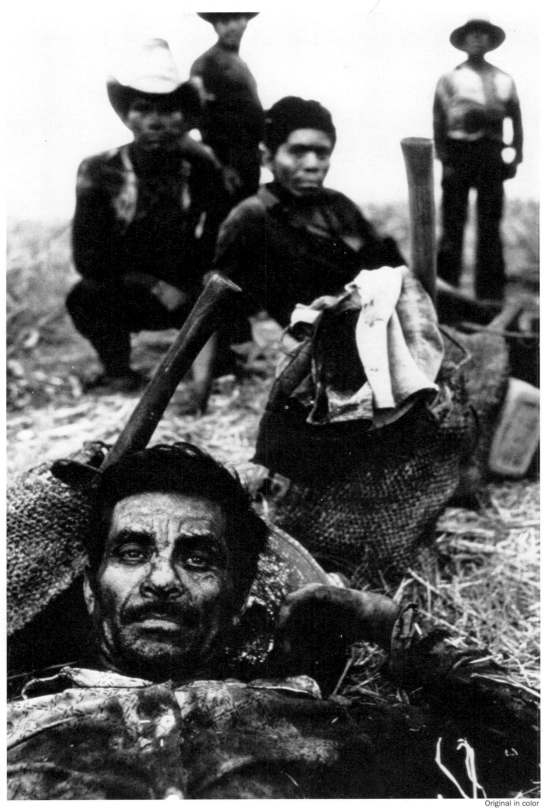

Original in color

Sugarcane cutters, faces black from the soot of the burned Guatemalan fields, rest after their day's work.

Seeking Refuge

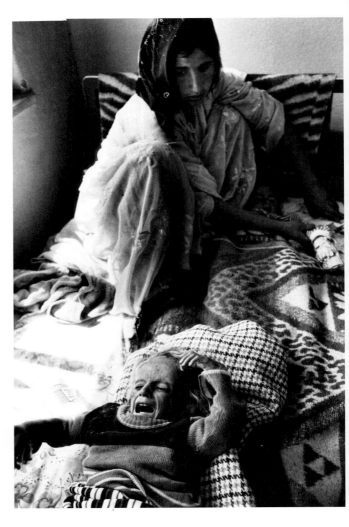

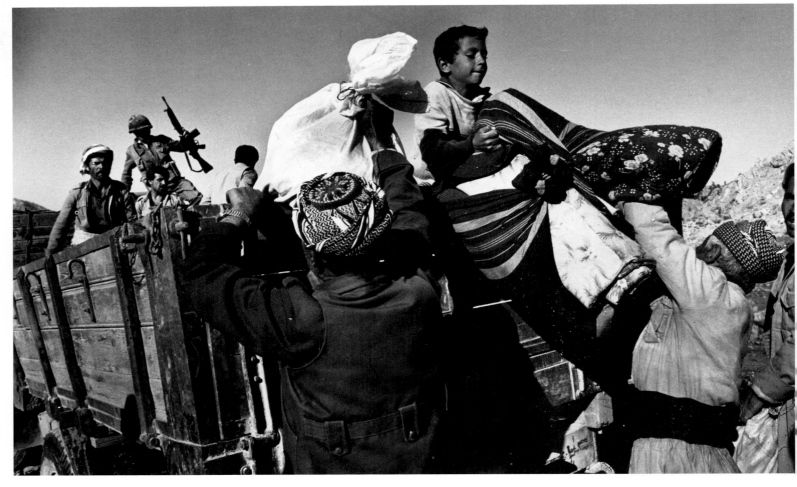

Magazine POY / James Nachtwey, First Place

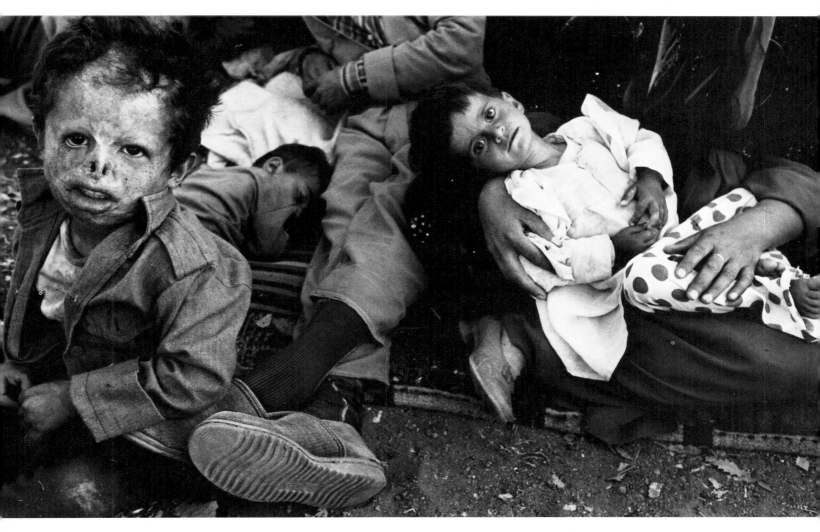

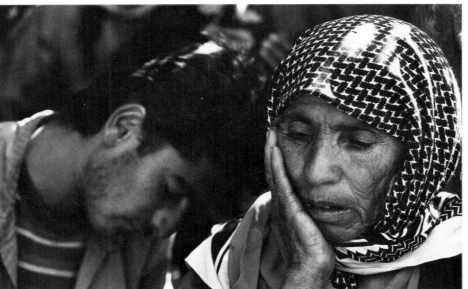

The Iraqi Kurds have existed as a separate people, maintaining their own mountain culture and speaking their own language, for 3,000 years. Several years ago the Kurds rose in rebellion, trying for the sixth time in 40 years to become independent of Iraqi rule.

When Iraq was able to turn its attention away from Iran, the military sent 60,000 men against the Kurdish guerrillas, pressing them up against the Turkish frontier.

Kurdish spokesmen claim the Iraqis used mustard gas, cyanide and other chemical warfare against the civilians in an attempt to break their spirit.

During a two-day period in September, an estimated 130,000 Kurds fled across the border into Turkey, where they were given refuge.

Visit to a War Zone

Casualties of clashes between Palestinians and Israeli soldiers in the Gaza Strip often end up in Al-Ahli Arab hospital.

The wounds, say the embattled doctors, are caused by live ammunition, tear gas, rubber bullets and beatings.

As many as 10,000 residents of the occupied territories have been wounded, and more than 150 have died, some of them children.

Many of the injured have been afraid to seek medical help for fear of being arrested while at the hospital.

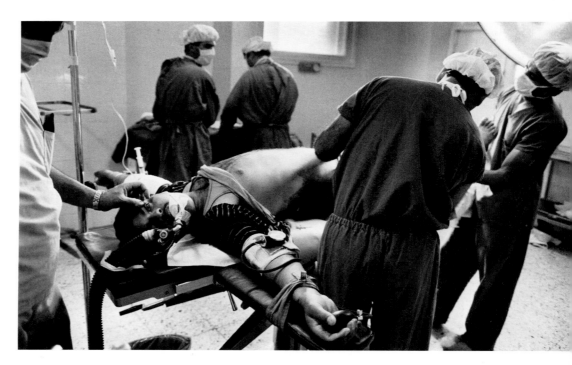

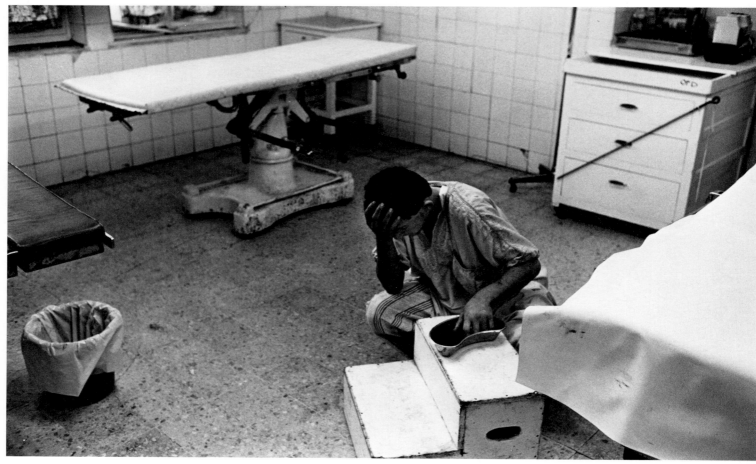

Magazine POY / James Nachtwey, First Place

Magazine POY / James Nachtwey, First Place

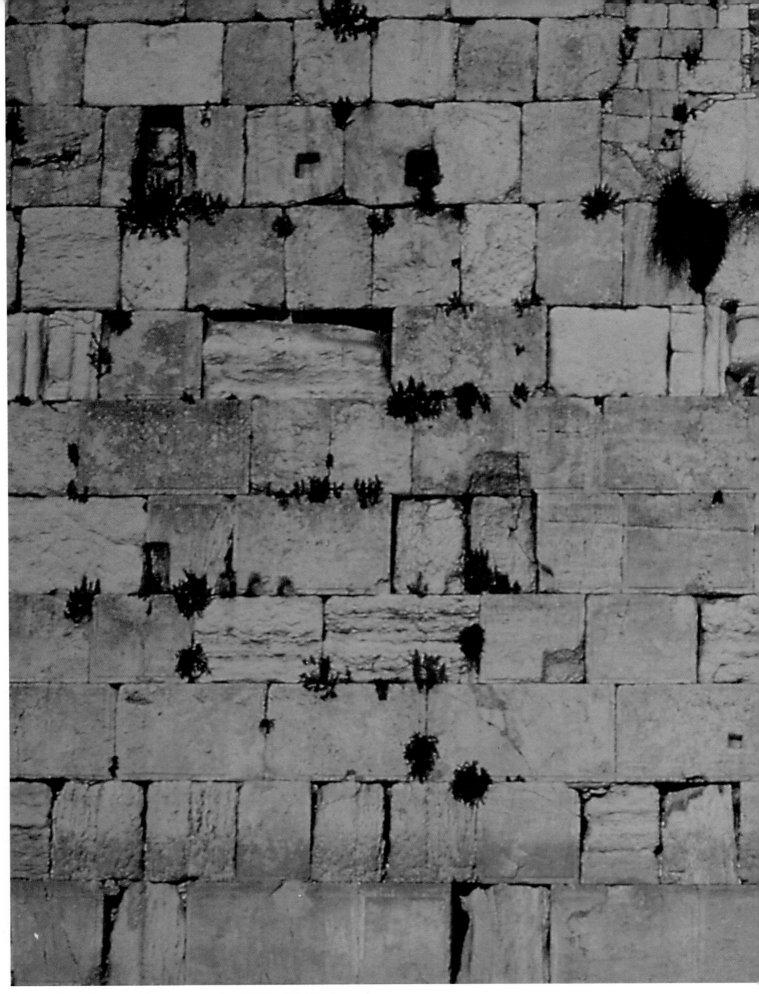

A lone Orthodox worshiper prays at the Wailing Wall in Jerusalem.

Magazine POY / James Nachtwey, First Place

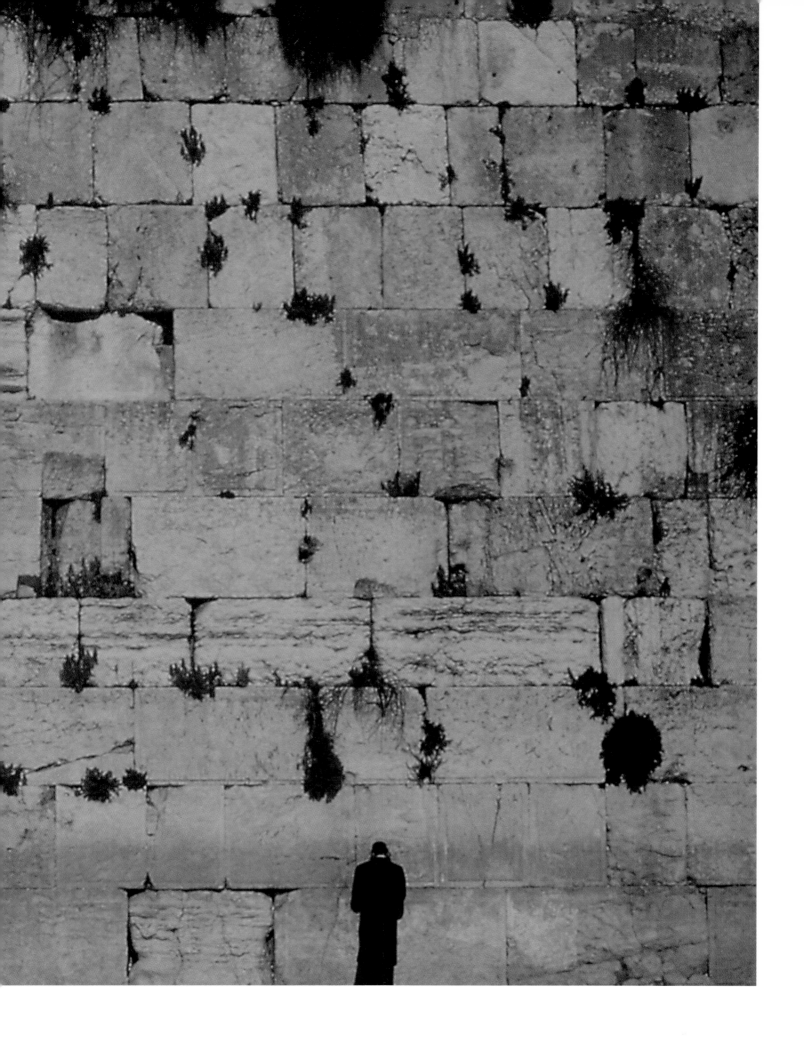

Uprisings in the Israeli-occupied West Bank escalated during the year, and Palestinians hurled rocks and erected flaming roadblocks against their longtime pursuers.

Opposite page, an Israeli soldier lies wounded after being shot at point-blank range in Bethlehem.

Says Nachtwey: "The most violent incidents occurred when no cameras were around. That's an important point to make — this uprising has a life of its own, independent of the press."

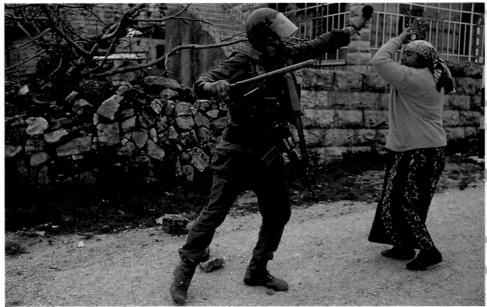

Magazine POY / James Nachtwey, First Place

Continuing Saga

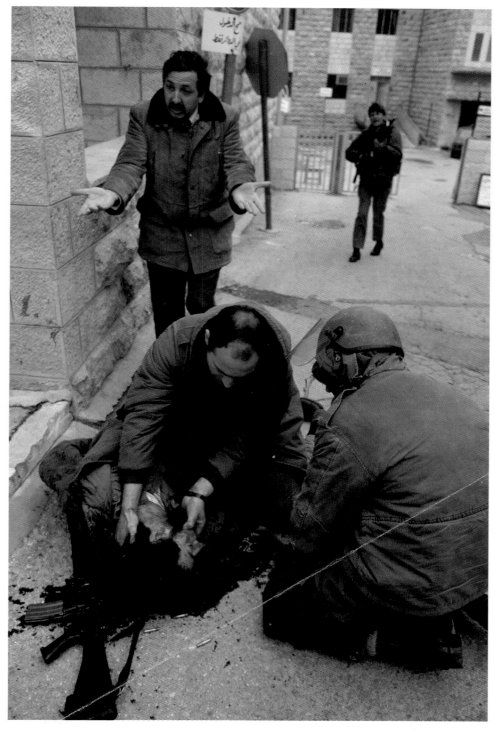

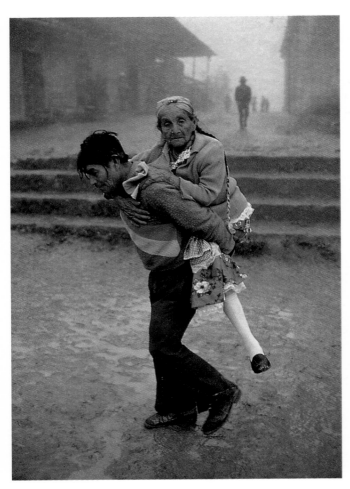

As Guatemala continues its experiment with democracy, the Central American country faces the challenge of bridging its gulf between rich and poor. *Above,* a man brings his ailing mother to a Catholic festival in Chajul. *Below,* a campesino labors in the cane fields.

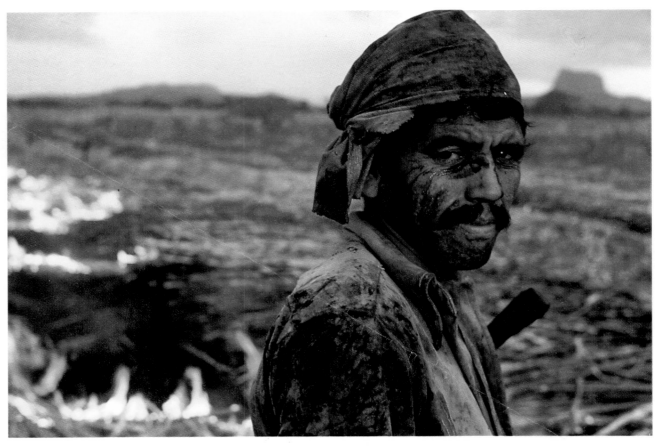

Magazine POY / James Nachtwey, First Place

Delicate Democracy

Guatemala, Mexico's southern neighbor, has been shaken by the longest running insurgency in Central America.

In a country whose leading industry is agriculture, an estimated 3 percent of Guatemala's 8 million people own half the land.

Land reform has become a large factor of national turmoil. President Vinicio Cerezo is committed to social reform, but also has vowed to respect private agricultural property.

Currently, the balance of power in Guatemala is juggled between military leaders, industrialists and wealthy landowners.

An Indian child leans on posters sold by her mother in Guatemala City, the capital. *Left,* President Vinicio Cerezo views Army Day with military chiefs. He is the country's first civilian chief of state since 1972.

Scenes
of
Seoul

Colonel Sanders is a
fast-food fixture in Seoul.
Below, the whirling patterns
of the city's night life.

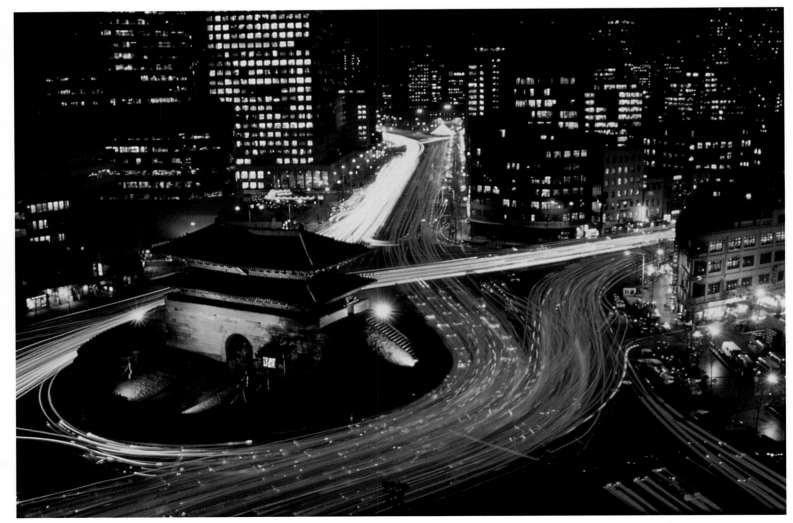

Magazine POY / James Nachtwey, First Place

Michael Bryant

The Philadelphia Inquirer

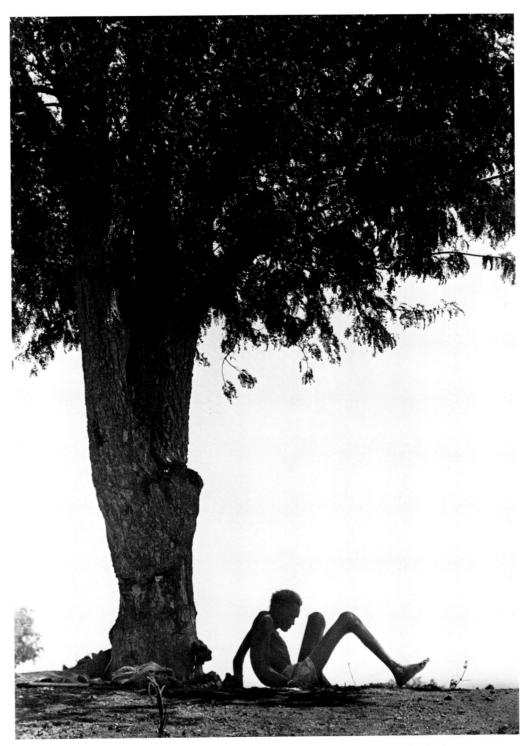

A starving refugee finds shade beneath a tree in the Jabel Kajur camp in Sudan.
(From a story, see page 44.)

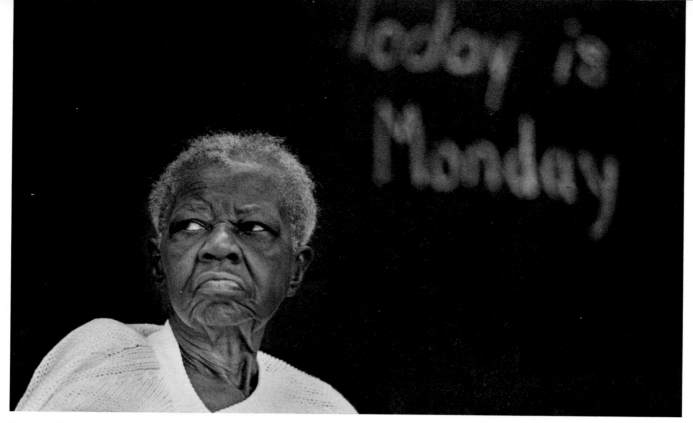

Rehova Bennett, a client of the Catholic Social Services Adult Daycare in Indianapolis, awaits the start of the day at the center. Each day, workers at the center write the day of the week on a blackboard so clients will know what it is.

On a bitterly cold day, Lou Sciloa finds he has his choice of park benches as he surveys the field for the next race at Philadelphia Park.

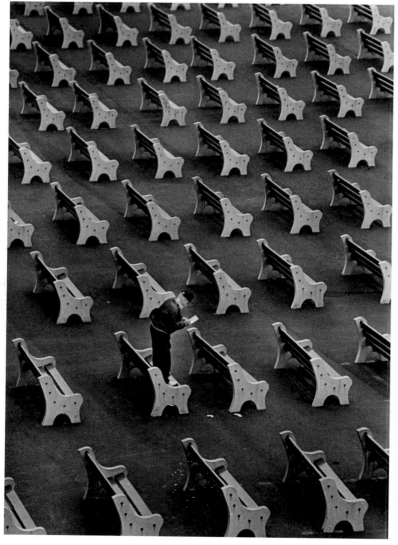

The real Adrian Cronauer belts out the words that made him famous as a disc jockey in Saigon during the Vietnam War.

The Rev. Jesse Jackson stands above a sea of supporters at the University of Pennsylvania after giving a speech to students the day before the November election.

Sudan's Refugees

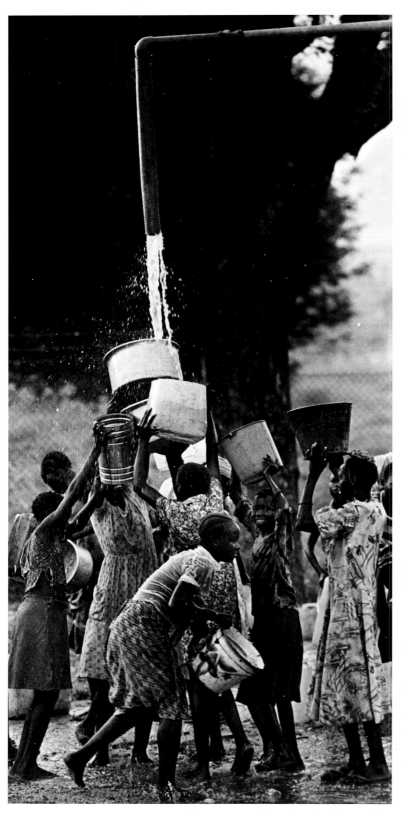

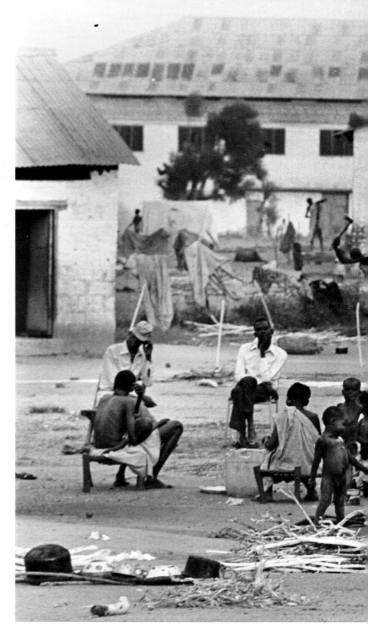

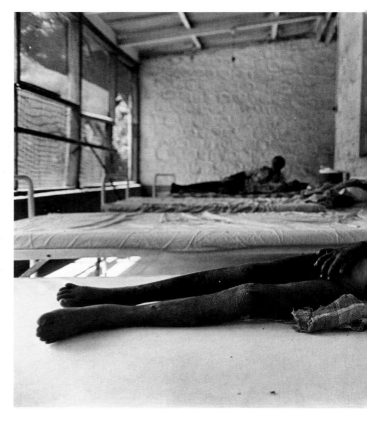

Refugee women in Juba, Sudan, gather underneath a water pipe that is turned on for just an hour each day. *Right,* a malnourished little boy lies on one of the many empty beds at the Juba Teaching Hospital.

Newspaper POY / Michael Bryant, Second Place

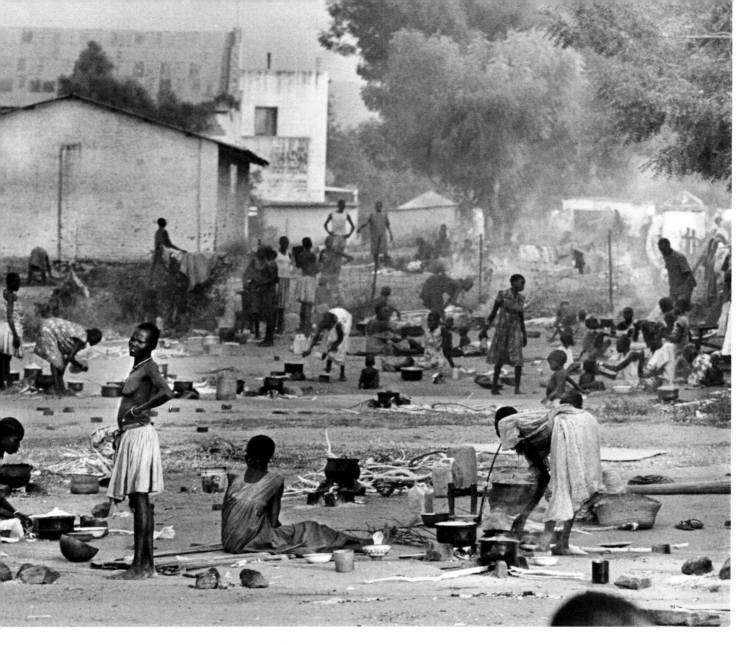

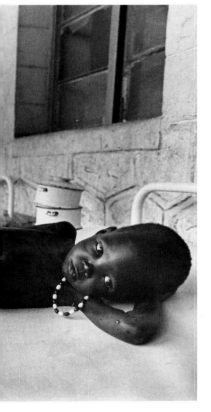

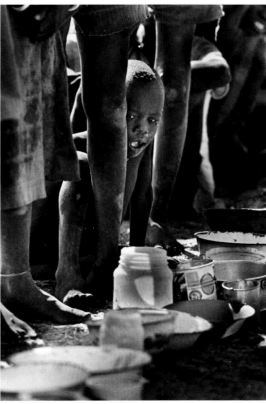

Above, with all the refugee camps in Juba full of members of the Bari tribe, other refugees from the south take over an abandoned school. *Left,* A child peers through his father's legs as he watches the approach of food bearers. Each refugee receives one bowl of maize porridge each day.

Lois Bernstein

The Virginian-Pilot and The Ledger Star

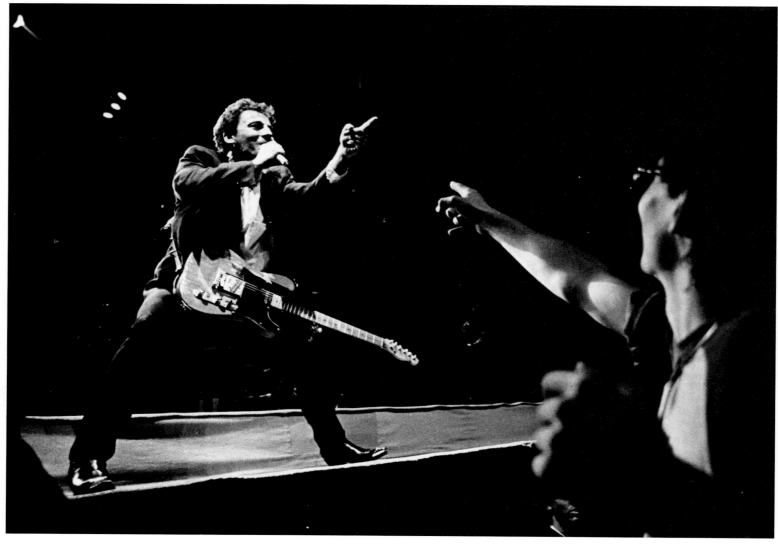

Bruce Springsteen plays the crowd during the second stop of his "Tunnel of Love" tour in Chapel Hill, N.C.

Mr. Fatwrench, also known as Wilson Toula, is a fix-it man, stand-up comedian and part-time professor. He earned his nickname with his wide girth, wide smile and expertise in his auto-repair shop behind his home.

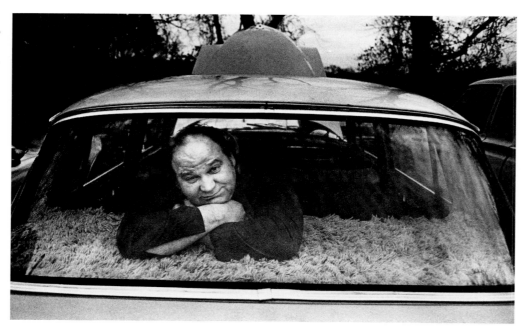

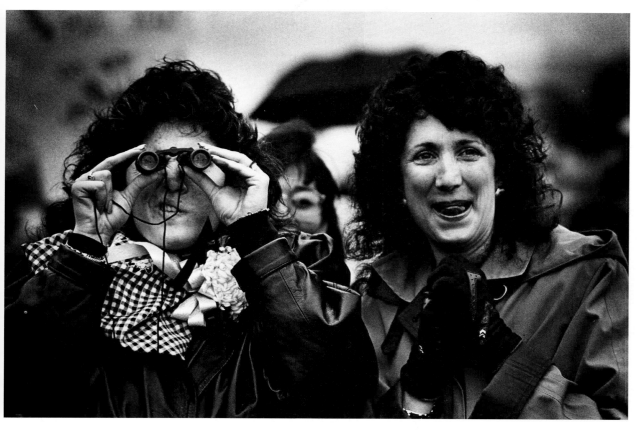

Left, Michele Dill, with binoculars, and Donnie Holder scan the deck of the USS Iowa for their husbands as the battleship pulls in to the Norfolk Naval Station. *Below,* Tony Rementer and his wife, Deborah, embrace under the Iowa's big guns. On a later tour, the ship would suffer an explosion in the No. 2 gun turret, killing 47 men.

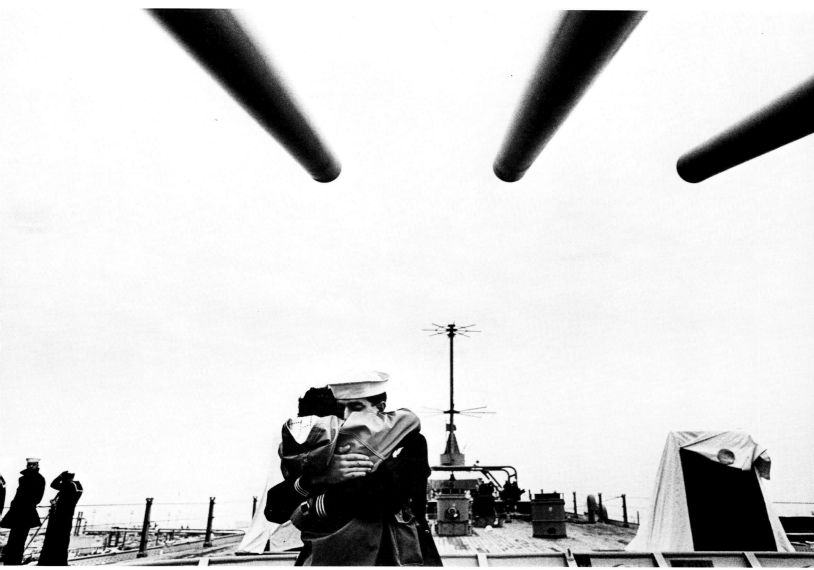

A new life in the hills of Virginia

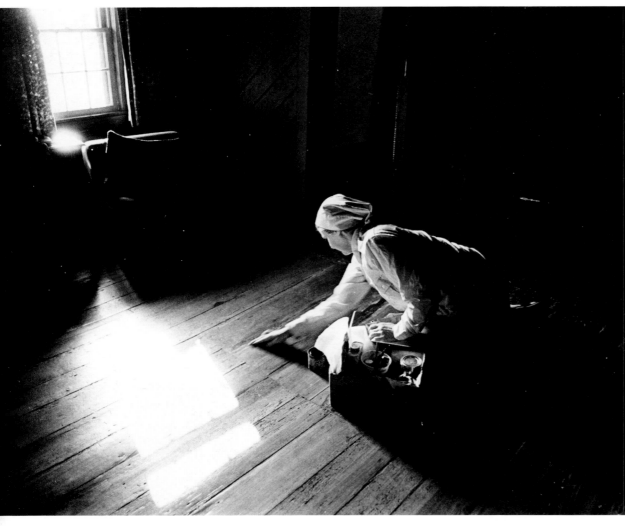

In the hills of Virginia, 20 miles outside Charlottesville, six Trappistine nuns have come from their mother house in Wrentham, Mass., to set up a new monastery. While they build the monastery, the six live in two log cabins on 500 acres of rolling pastureland. Here they will spend the rest of their cloistered lives. *Above,* Sister David, the group's handywoman, patches, sands and stains the floors of one of the 19th century cabins. *Below,* Sister Marilyn, who was raised in the Jewish faith and entered the Order of Cistercians in 1975, takes in the midafternoon wash.

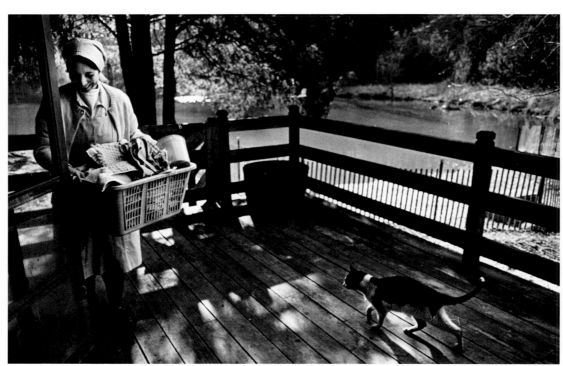

Newspaper POY / Lois Bernstein, Third Place

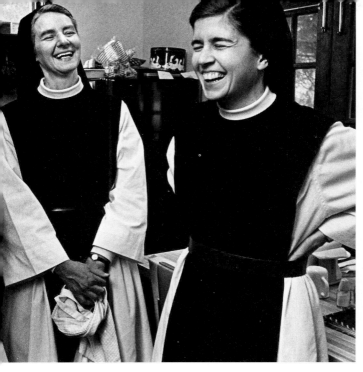

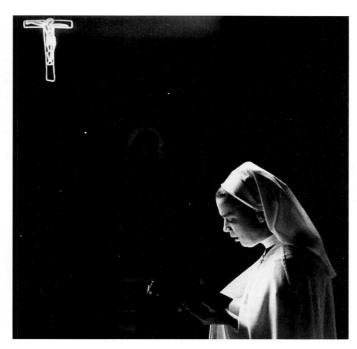

Above left, Sisters Marilyn, David and Margaret share a laugh after lunch. *Above right,* Sister Mary Beth shares a 3 a.m. scriptural reading. *Below,* Mother Veronica, Sister Mary Beth and Sister Barbara pray during morning Mass in the makeshift chapel of their living room.

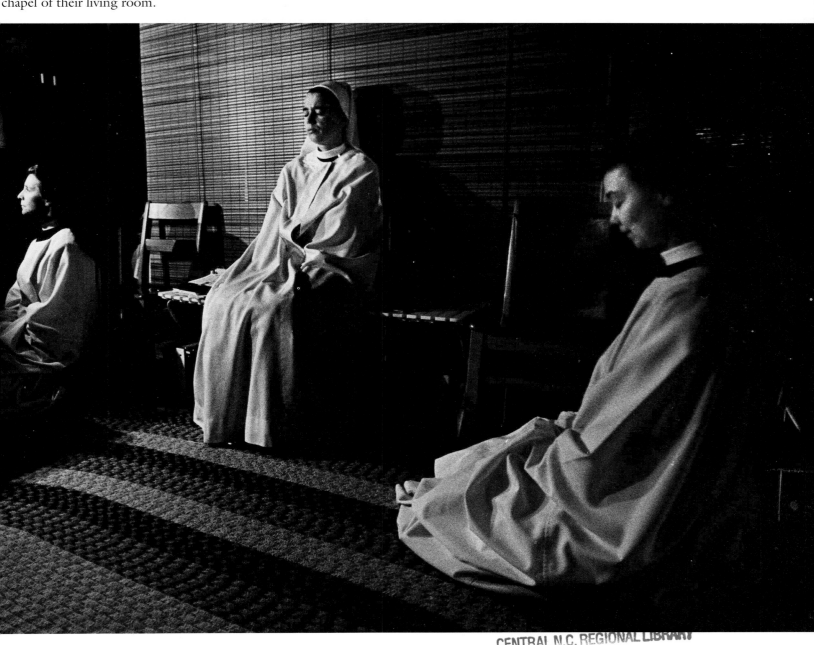

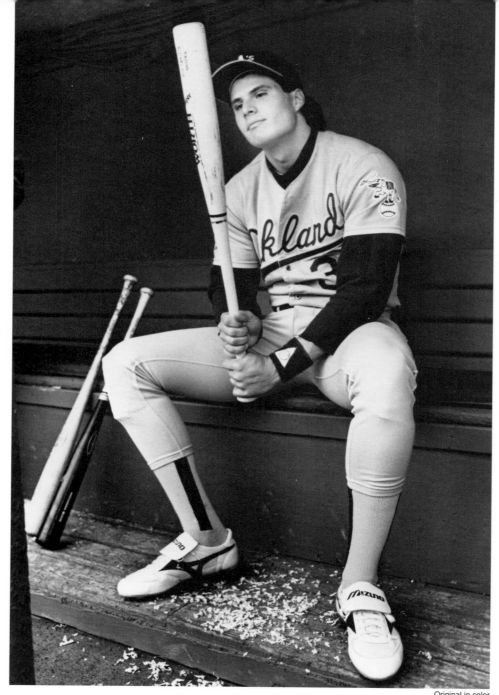

Original in color

Oakland Athletics star Jose Canseco checks his bat after whittling it a bit.

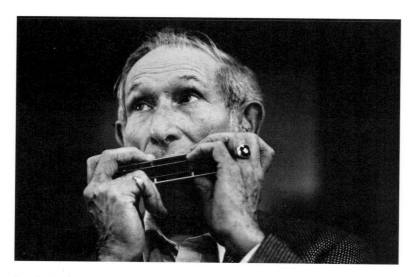

Louis Nelson practices at a rehearsal of the Cardinal State
Harmonica Club, which meets every Saturday at a local church.

Newspaper POY / Lois Bernstein, Third Place

Kenneth Jarecke

Contact Press Images

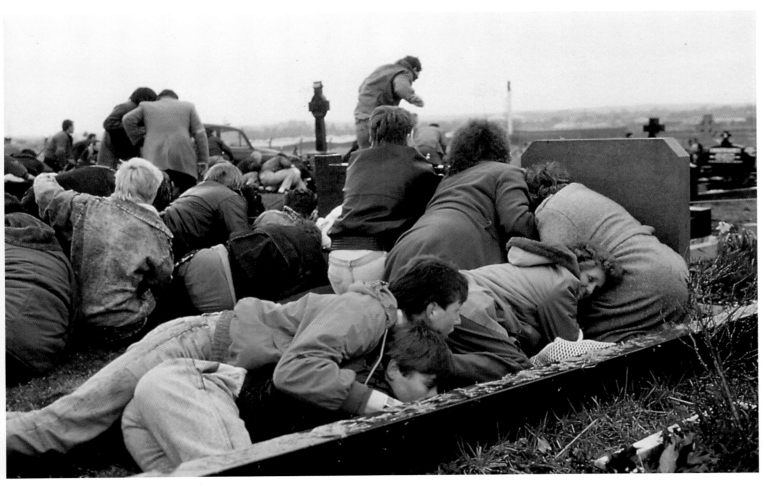

During the burial of three members of the outlawed Irish Republican Army in Belfast, Northern Ireland, snipers launch a grenade and gun attack on mourners. "It was a madhouse," one witness said of the events at Milltown Cemetery in March, "with people ducking behind tombstones to avoid the gunfire and explosions, and others running through the cemetery trying to catch the gunmen even as they were shooting."

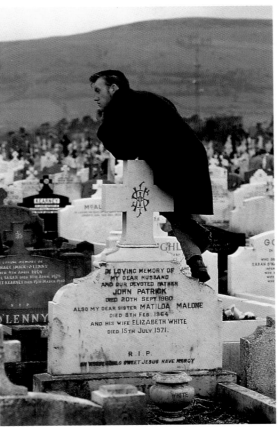

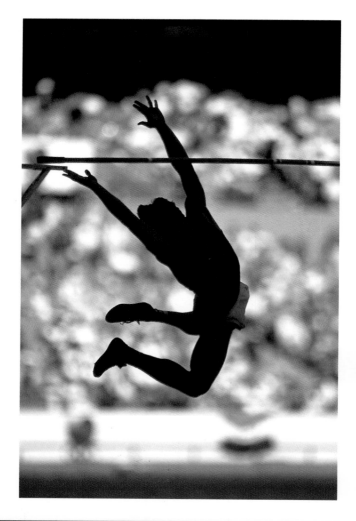

Magazine POY / Kenneth Jarecke, Second Place

The Summer Games

The XXIV Olympiad Summer Games in Seoul boasted a record 13,000 athletes from 161 nations. South Korea spent years — and $3.1 billion — preparing for the two-week event.

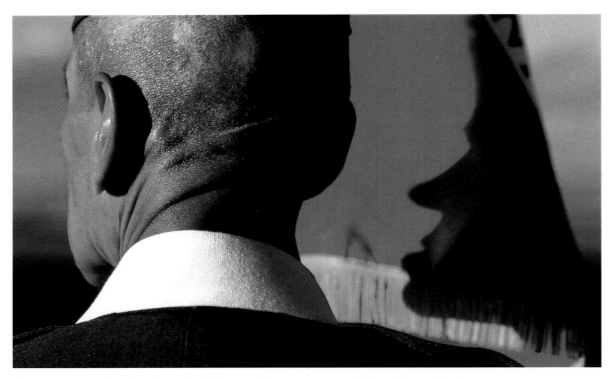

A veteran stops by the airport in Billings, Mont., to see candidate George Bush.

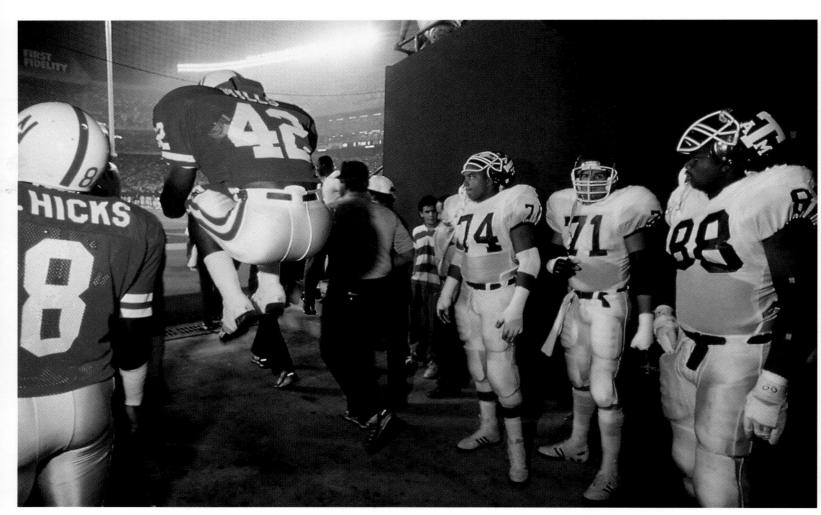

Pumped up? This Nebraska Cornhusker is before his team takes the field against Texas A&M in the Kickoff Classic.

Magazine POY / Kenneth Jarecke, Second Place

Protection takes precedence over privacy for presidential candidate Jesse Jackson on the campaign trail in Iowa.

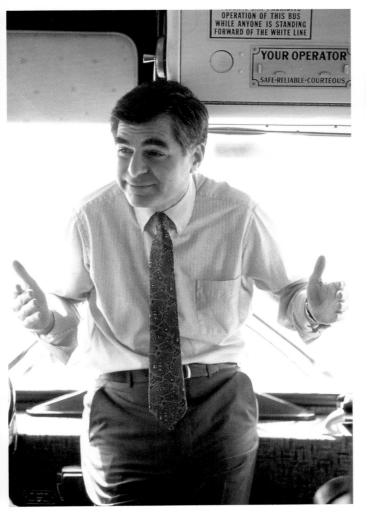

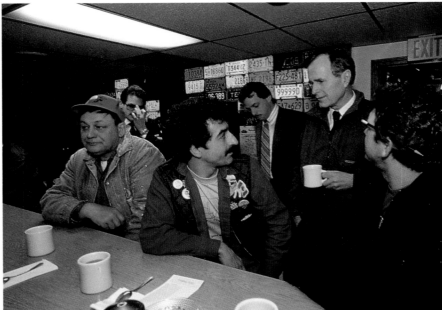

Coffee mug in hand, George Bush makes small talk with diners at Couzzin Richie's truck stop in Greeland, N.H. *Left,* Michael Dukakis searches for answers for reporters aboard his campaign bus.

Anthony Suau
Black Star

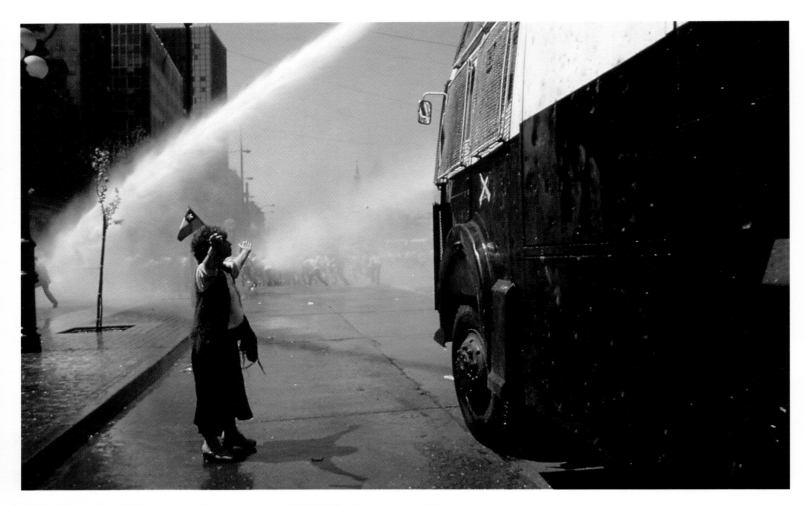

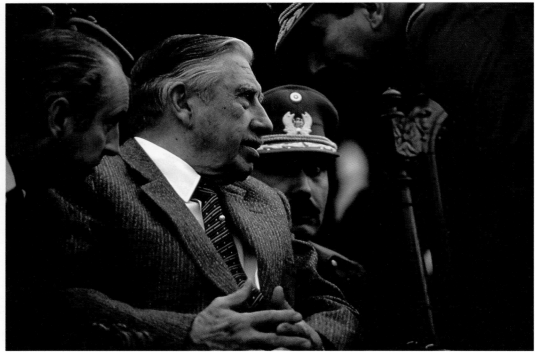

Chileans held anti-government rallies in the streets of Santiago, hoping for democracy after a plebiscite rejected dictator Augusto Pinochet's request for an eight-year extension to his term. Government police countered with water cannons and a barrage of tear gas.

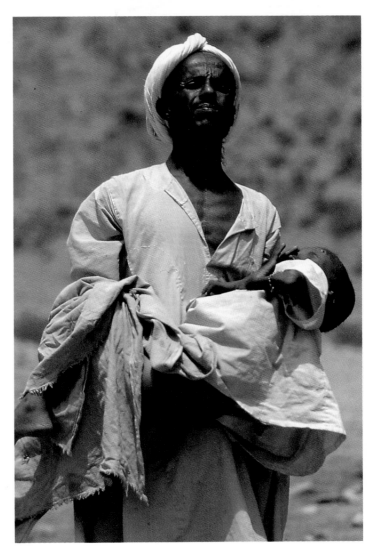

Twenty-five years of warfare continued as Eritereans launched major offensives against Ethiopian troops, killing thousands and forcing thousands more to become refugees. *Below*, an Ethiopian soldier walks through a cemetery of tanks.

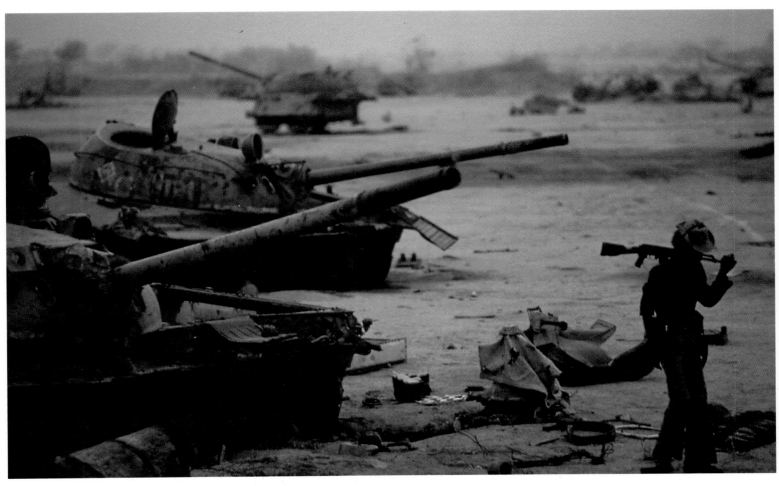

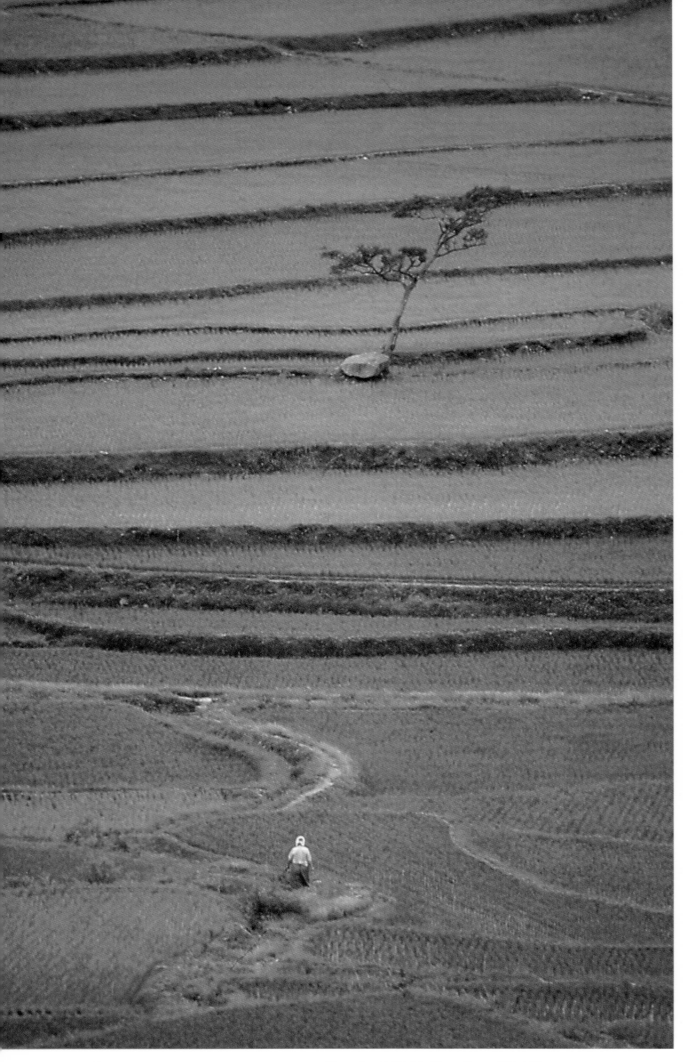

Magazine POY / Anthony Suau, Third Place

Heart
of Seoul

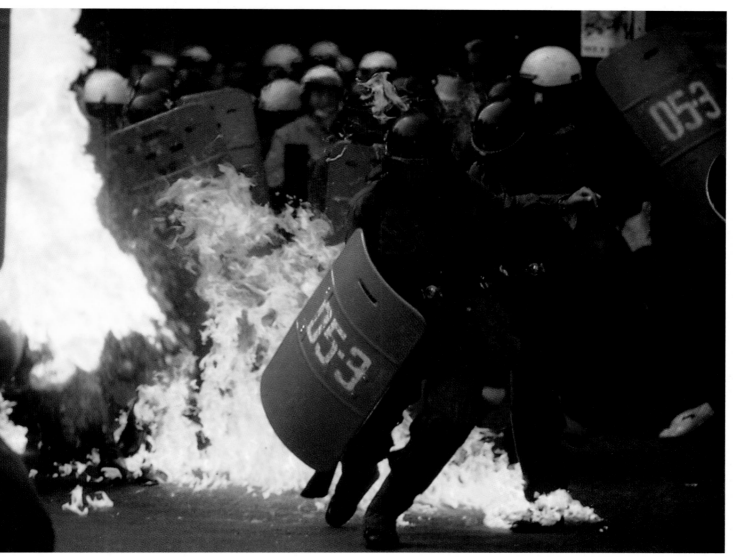

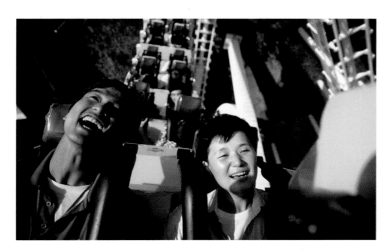

As hosts of the 1988 Summer Olympics, South Korea offered the world a view of its culture, its emerging prosperity and its problems. The pastoral scene of a rice-growing village and the glee of amusement park riders contrast sharply with the frequent demonstrations by students on the streets of Seoul.

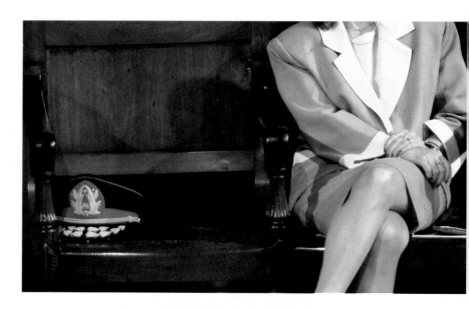

A young Palestinian fighter clasps the arsenal he uses to fight Israeli soldiers in the West Bank. *Right,* the hat of Gen. Augusto Pinochet as the president of Chile attends a Mass in Santiago.

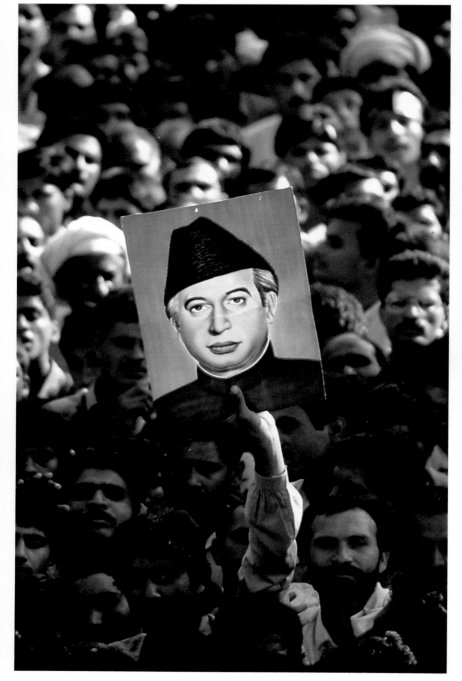

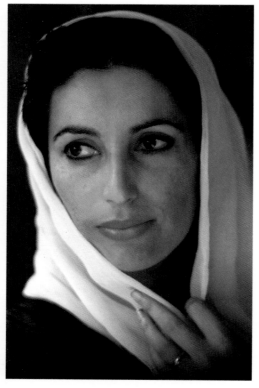

Pakistan's opposition party leader, Benazir Bhutto, attends a rally in Punjab Province during her campaign for prime minister. *Left,* supporters carry an image of her late father, former Prime Minister Zulfikar Ali Bhutto, who was overthrown in a political coup in 1977 and executed in 1979. In November, Benazir Bhutto became the first woman to lead an Islamic state when her party carried the most seats in the country's first free elections in 11 years.

Eugene Richards
Magnum

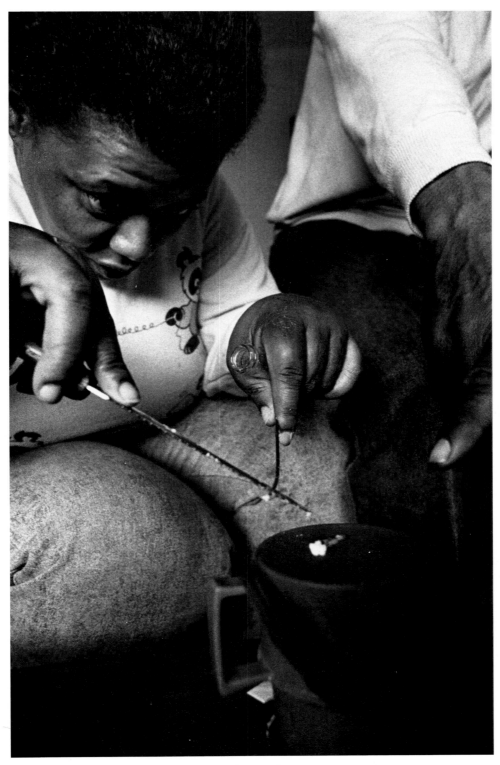

The cycle of crack addiction begins inside a project apartment.

Dealers, bearing chains and brass knuckles, gather near a flagpole.

On the lookout for police in a second-floor stairwell.

Canon Photo Essay / Eugene Richards

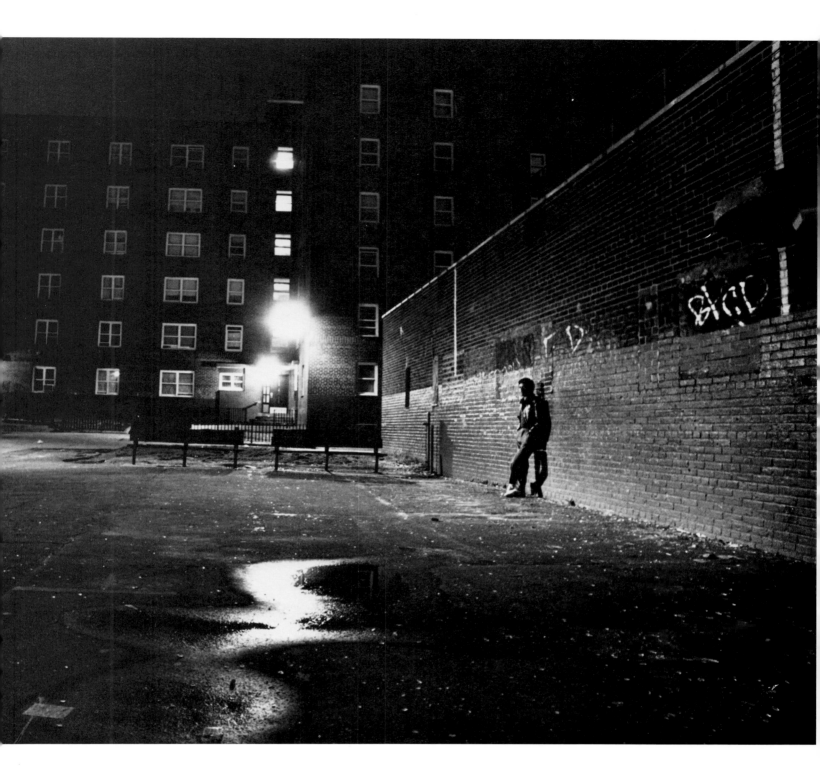

The Downfall of a Neighborhood

Eugene Richards, a member of Magnum Photos, is winner of the Canon Photo Essayist Award for his photo series, "Crack: The Downfall of a Neighborhood," which appeared in *Life* magazine.

The photographs were taken at the Red Hook housing project in South Brooklyn, N.Y., where violent crimes have more than doubled in the past three years. Police attribute the rise in crime to the use of crack, a concentrated form of cocaine.

The war on drugs, in Red Hook, has been lost. Two police cars assigned to the project don't enter the grounds unless they are called in, and residents have given up trying to establish neighborhood-watch programs. At the local medical clinic, 75 percent of the cases are crack related.

Richards' photographs vividly portray the users, dealers and victims in an area where all the lives have been affected by America's most devastating drug.

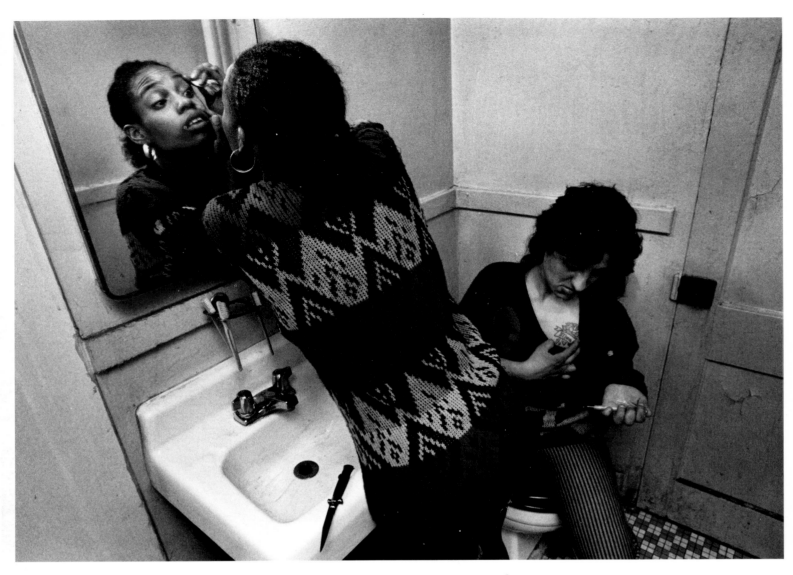

While Tasha checks for an eye infection, Jenny, a former nurse, battles nausea after smoking crack and taking Valium.

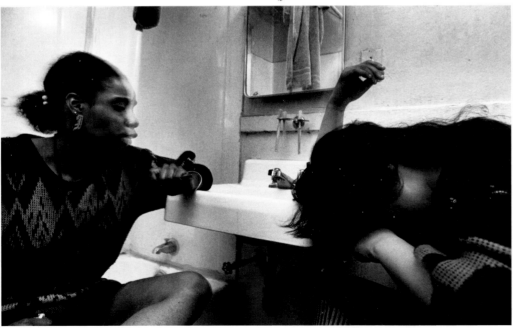

Canon Photo Essay / Eugene Richards

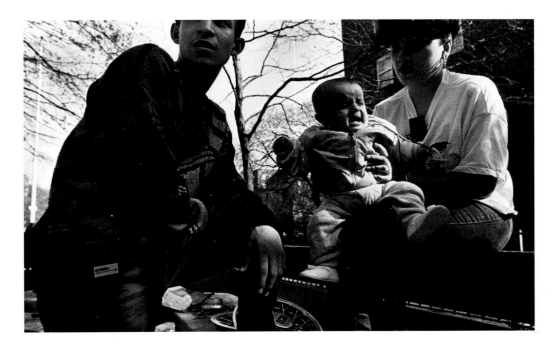

Left, 17-year-old Billy, with a pager on his belt, works the front of the project with his wife and 6-month-old child. *Below,* Roger, 42, lost his family and his savings because of his crack habit. His apartment, where he deals, is sometimes used as a clandestine emergency room. "I've taken bullets out of eight people," he says.

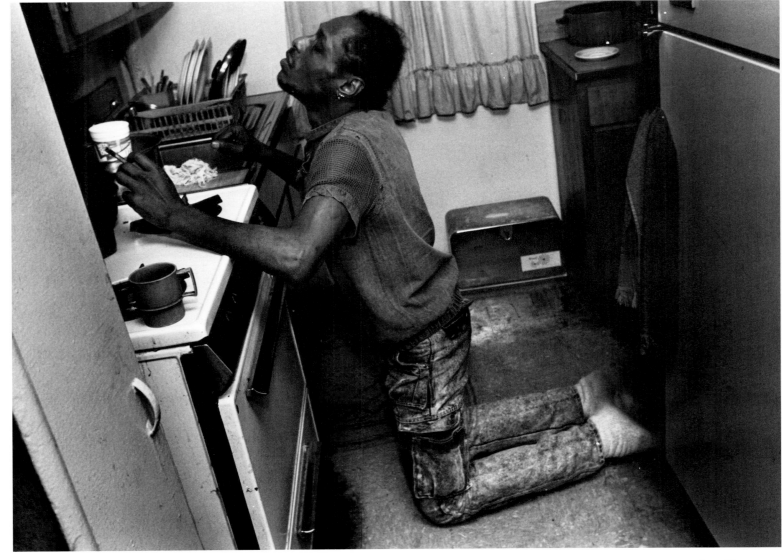

Shooting up on a rooftop. *Below,* youths share a crack pipe.

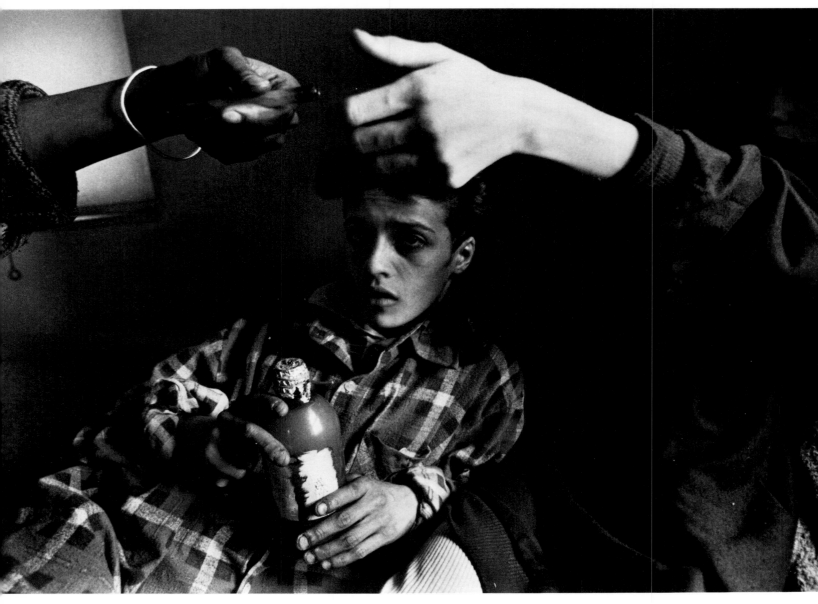

Canon Photo Essay / Eugene Richards

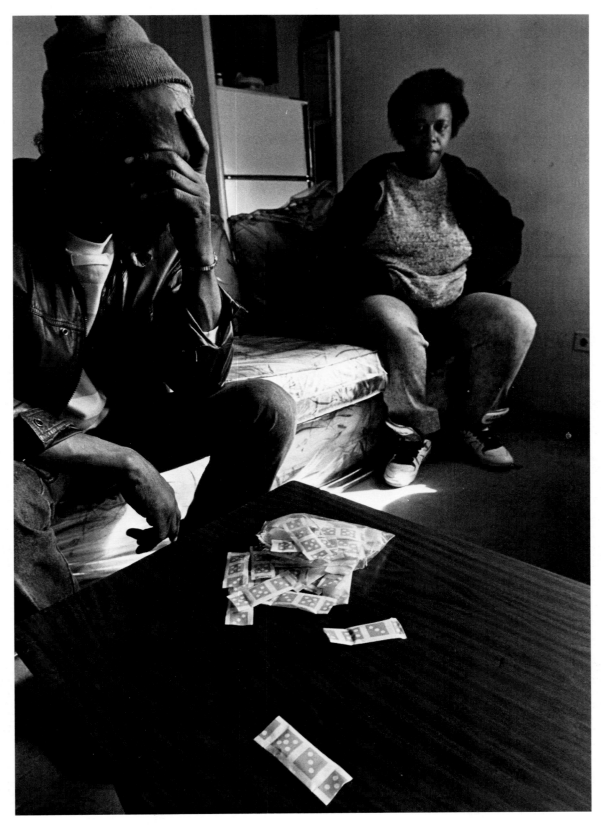

A couple share despair inside their project apartment.

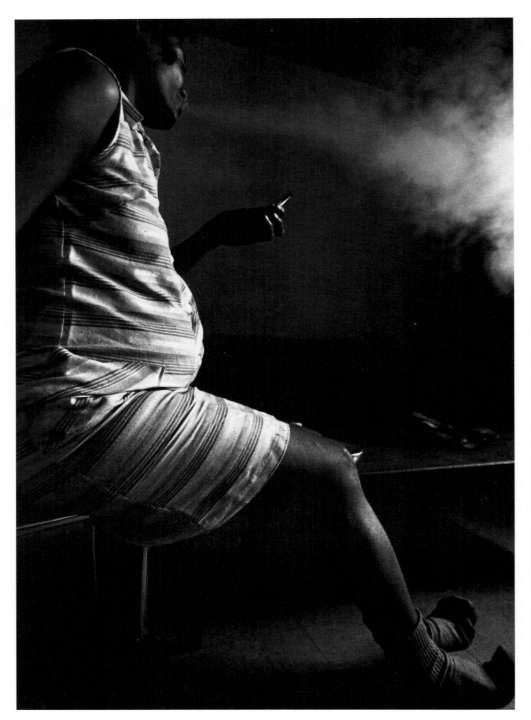

Donna, pregnant with twins, exhales a cloud of crack smoke.

Canon Photo Essay / Eugene Richards

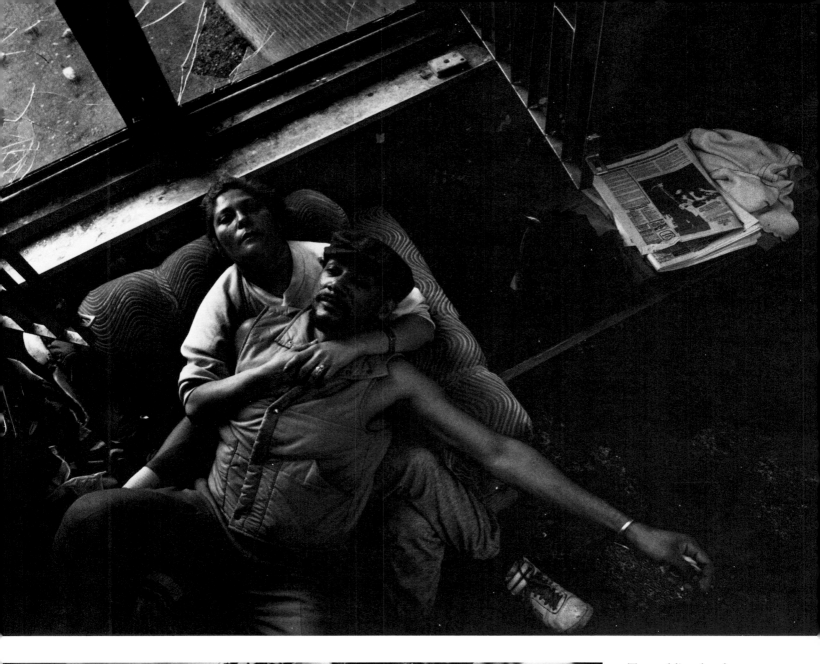

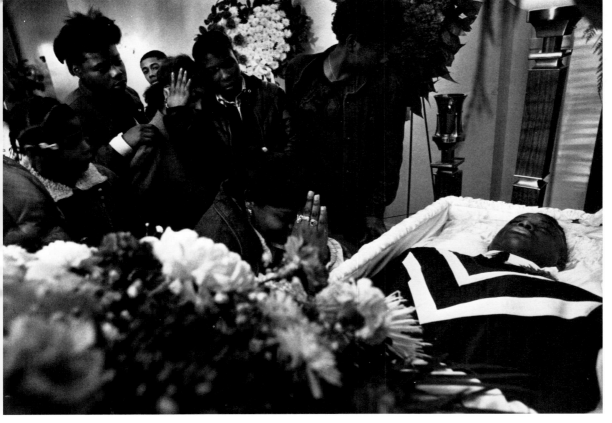

Two addicts let the afternoon slip away. *Left,* family and relatives mourn at the funeral of Lovett, 15, shot to death after refusing to give up his leather coat on the subway.

Pam, a dealer, and her 13-year-old son peer from their apartment. *Below,* Ann, 48, sleeps on the bedroom floor with her son and granddaughter to stay out of the line of gunfire. "It's like Dodge City," she says of the nightly shootings.

Canon Photo Essay / Eugene Richards

Original in color

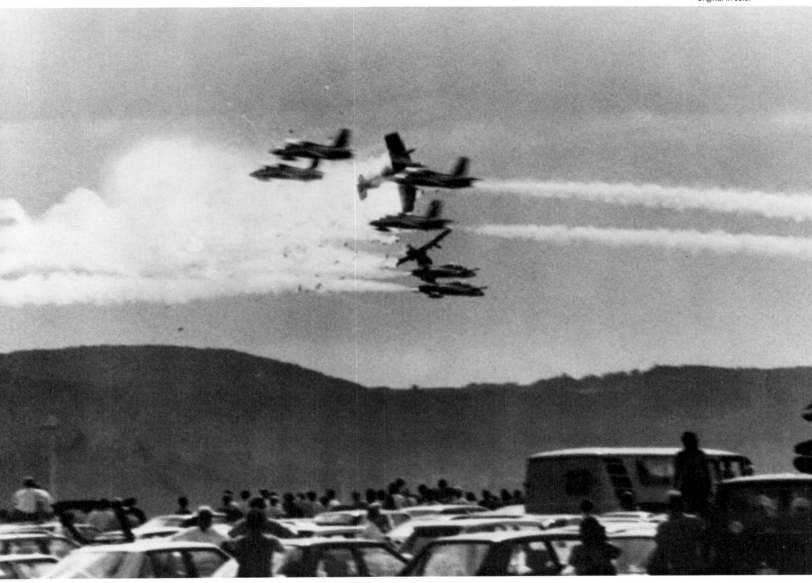

Three Italian air force jets collide during an air show over the U.S. Air Base at Ramstein, West Germany. Seventy people died from injuries when one of the planes crashed into the crowd. At least 350 were injured. / **Charles Daughty, The Associated Press, 1st Place in Newspaper Spot News.**

Paul Herrera holds a cocked pistol to his head in Pittsburgh as Officer Paul Laukaitis holds his hand. After 90 minutes, he handed the gun to the officer. / **Robin Rombach, The Pittsburgh Press, 2nd Place in Newspaper Spot News.**

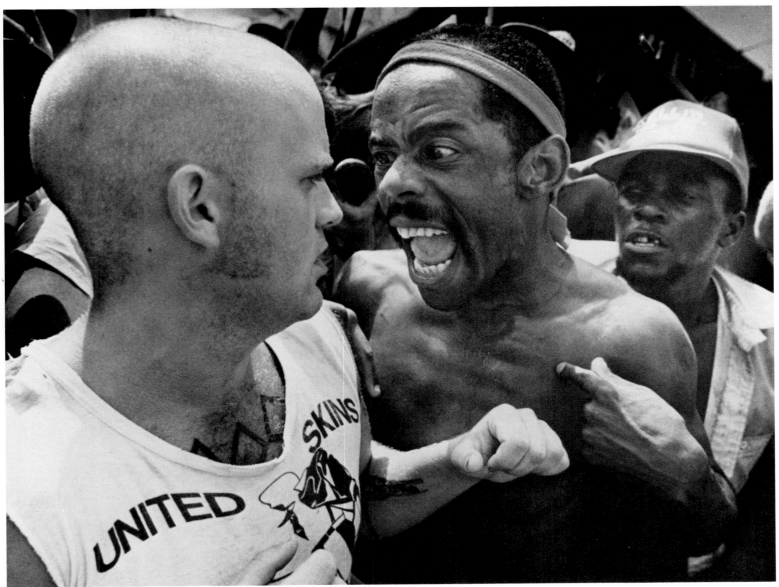

Original in color

An angry Donald Singleterry of Atlanta confronts a "skinhead" in the street outside the Democratic National Convention. / **Michael Rondou, San Jose Mercury News, 3rd Place in Newspaper Spot News.**

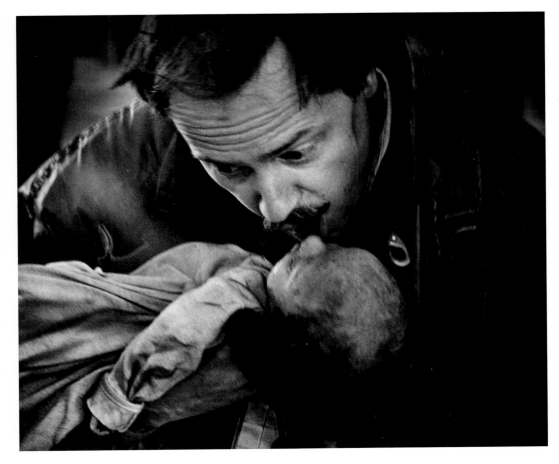

Milwaukee firefighter Dean Thomas revives a 3-week-old infant he rescued from a burning building. / **Patrick Murphy-Racey, The Milwaukee Sentinel, Award of Excellence in Newspaper Spot News.**

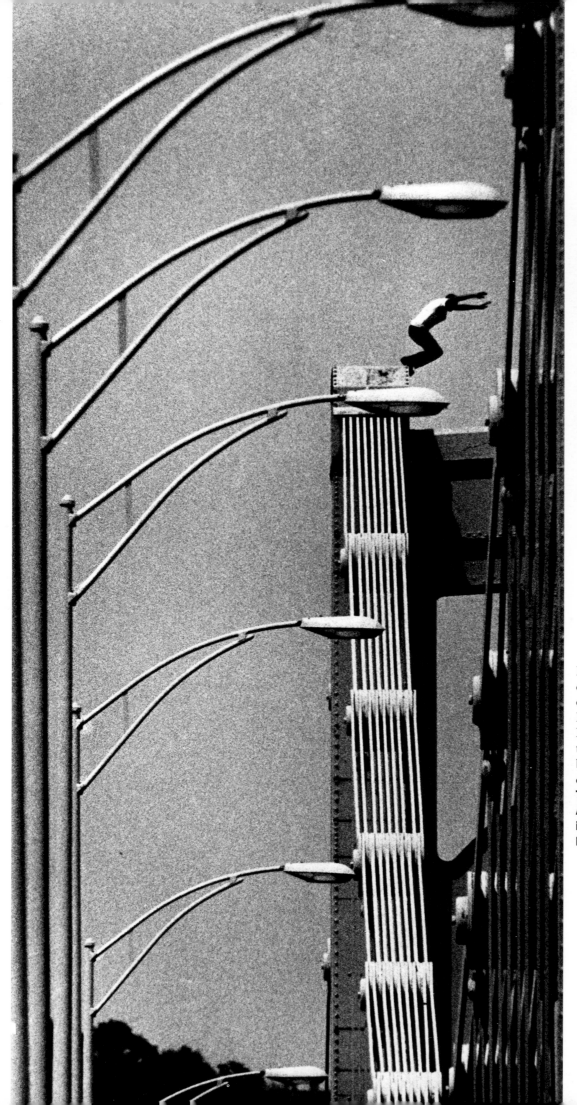

Phillip J. Lorenz jumps down to the crossbeam on the Sixth Street Bridge in Pittsburgh. He eventually was talked down from the bridge by police officers. / **Susie Post, The Pittsburgh Press, Award of Excellence in Newspaper Spot News.**

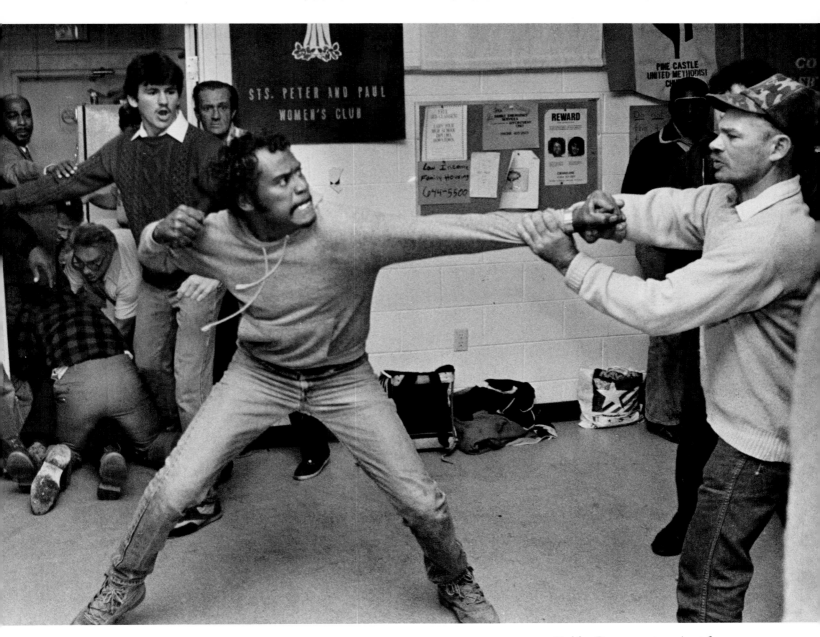

Bobby Burton, a transient from Georgia, tries to strike a man during a fight that broke out in an Orlando, Fla., homeless shelter. / **Joe Burbank, The Orlando Sentinel, Award of Excellence in Newspaper Spot News.**

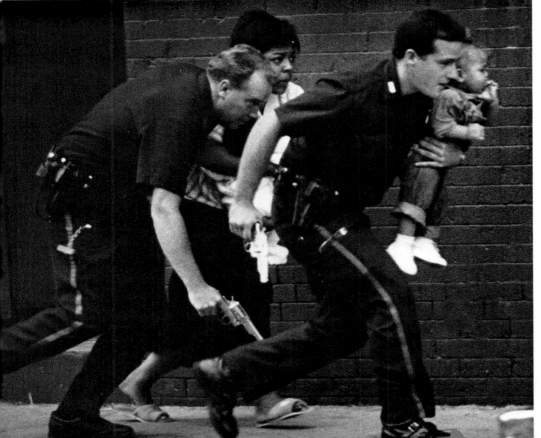

Boston Police officers rush two children and a woman away from an apartment where they had been held hostage by a gunman. / **Jim Mahoney, Boston Herald, Award of Excellence in Newspaper Spot News.**

Long Beach Police Officer Cheryl Perkins enjoys the "sting" as other vice officers arrest a man on charges of soliciting prostitution. / **Bruce Chambers, Long Beach (Calif.) Press-Telegram, 1st Place in Newspaper General News.**

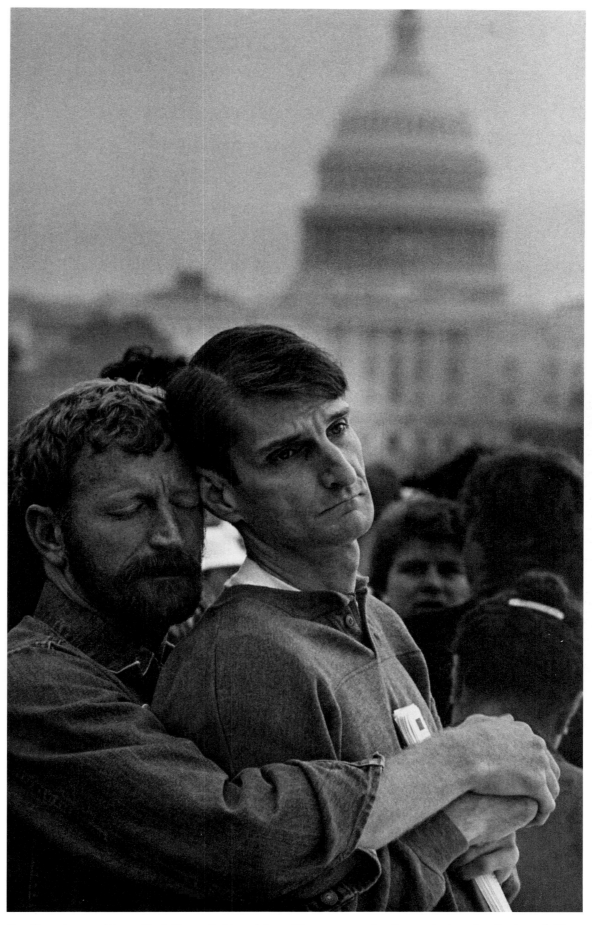

San Francisco residents Paul Carey (left) and Jerry Turner pause in silence during the display of The Names Project quilt for AIDS victims in Washington, D.C. / **Elaine M. Thompson, The Athens (Ohio) News, 2nd Place in Newspaper General News.**

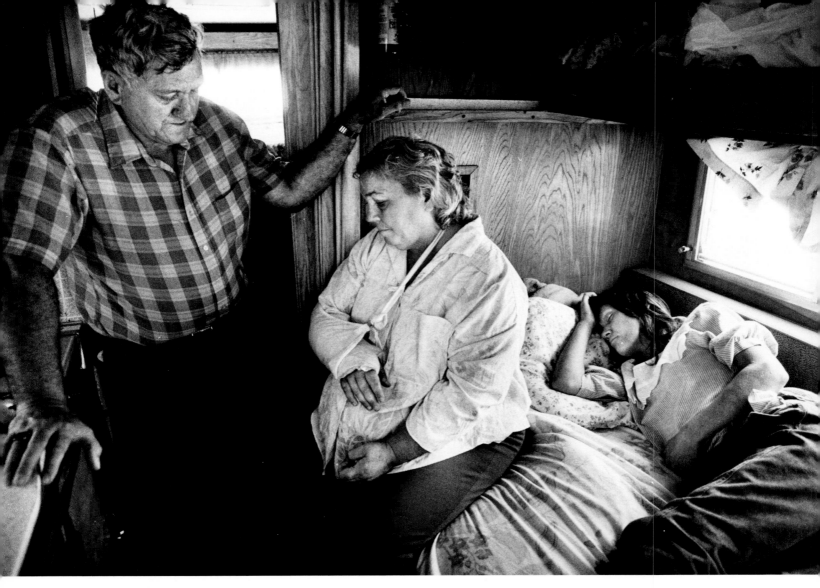

Near death and yellow from jaundice, Pollie Smolenski sleeps in a trailer as she and her parents await her liver-transplant operation. The family had traveled to Pittsburgh for her operation but had no place adequate to stay.in the over-100-degree weather. / **Vince Musi, The Pittsburgh Press, 3rd Place in Newspaper General News.**

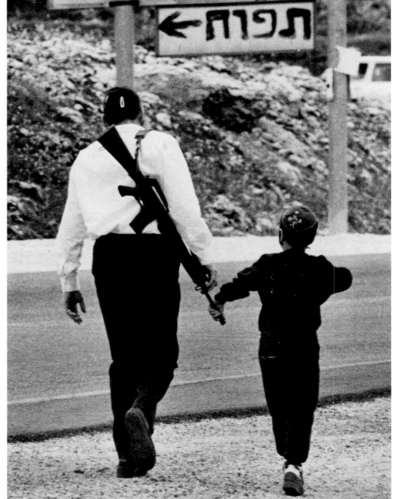

An Israeli settler and his son walk away from a roadblock set up to keep Palestinians away from the area where a young Israeli girl was shot during a scuffle in the Israeli-occupied territories. / **Jon Kral, The Miami Herald, Award of Excellence in Newspaper General News.**

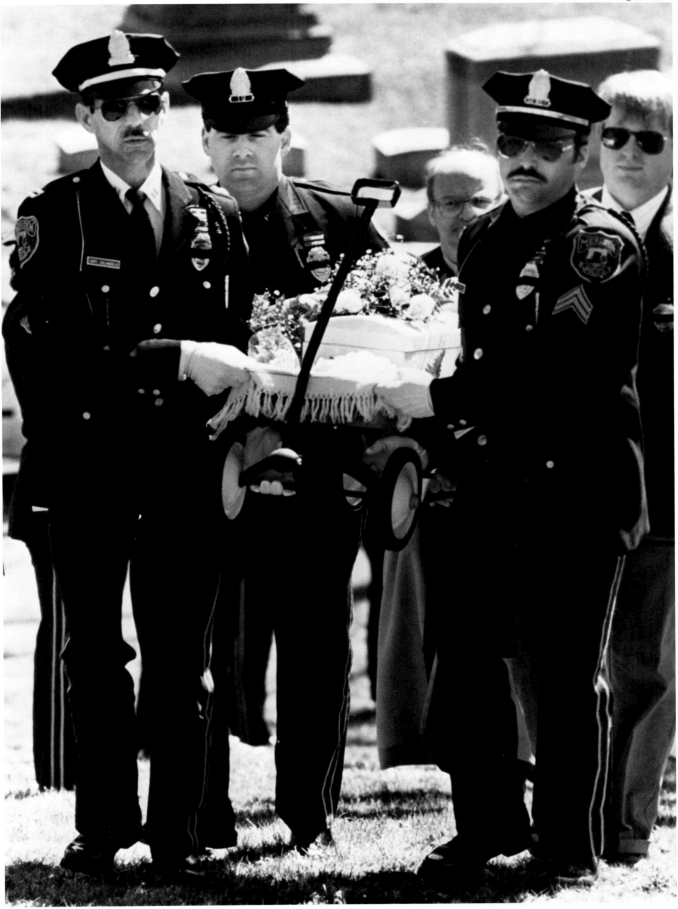

Members of the Meriden, Conn., police force hold a funeral for an abandoned newborn who was found dead from exposure in a parking lot. / **Cloe Poisson, The Hartford Courant, Award of Excellence in Newspaper General News.**

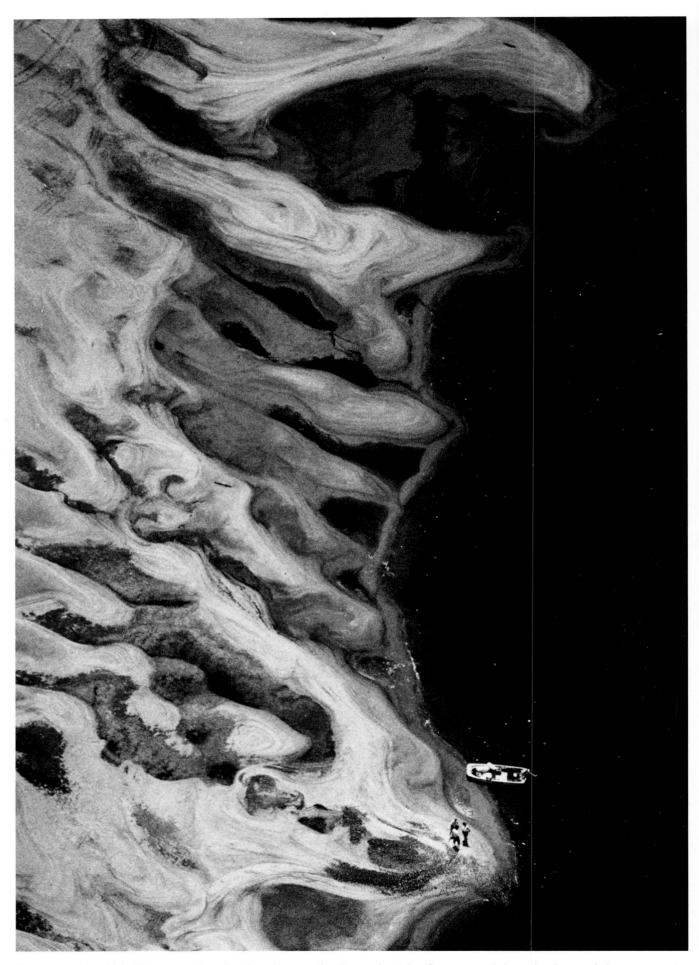

Boaters on the Ohio River examine the shoreline on the Kentucky side after a record drought dropped the water to its lowest level since 1930. / **Todd Buchanan, The Louisville (Ky.) Courier-Journal, Award of Excellence in Newspaper General News.**

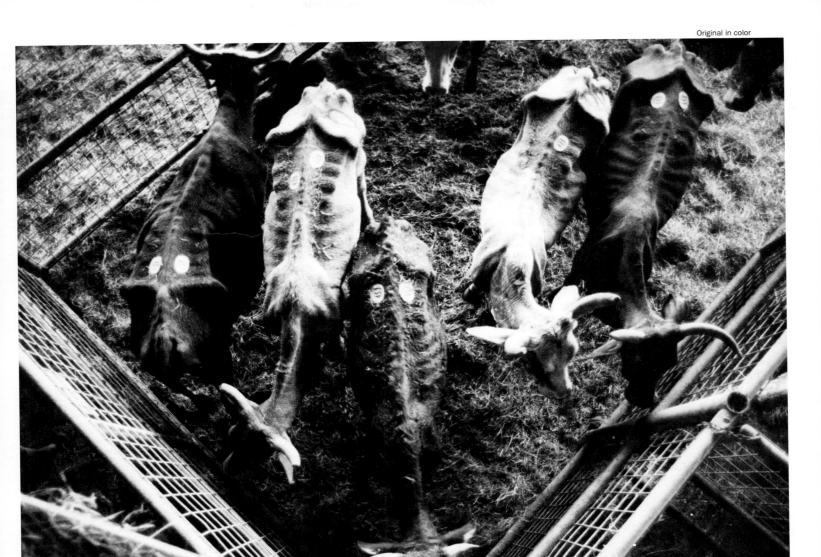

Starving cattle await auction in Freer, Texas, as a drought forces ranchers to sell their stock. / **Nuri Vallbona, The Dallas Morning News, Award of Excellence in Newspaper General News.**

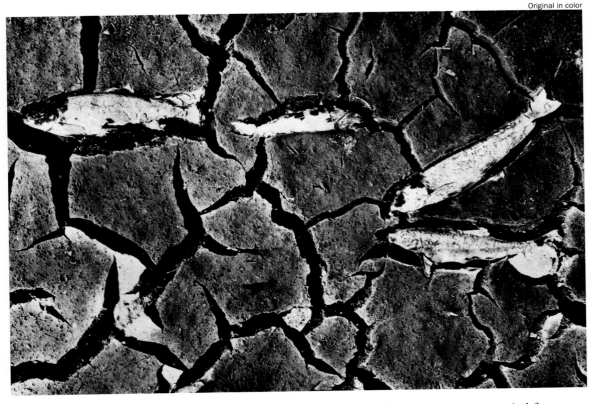

Trout lie dead in the drained Bridgeport Reservoir in California. The reservoir was emptied for agricultural needs in Nevada. / **Richard D. Schmidt, The Sacramento Bee, Award of Excellence in Newspaper General News.**

"I hit you with the pot to make you stop hitting her. I hate you!" a boy screams at his father as the man is arrested by Minneapolis police officers in a domestic-violence case. / **Donna Ferrato, Black Star for Life magazine, 1st Place in Magazine News or Documentary.**

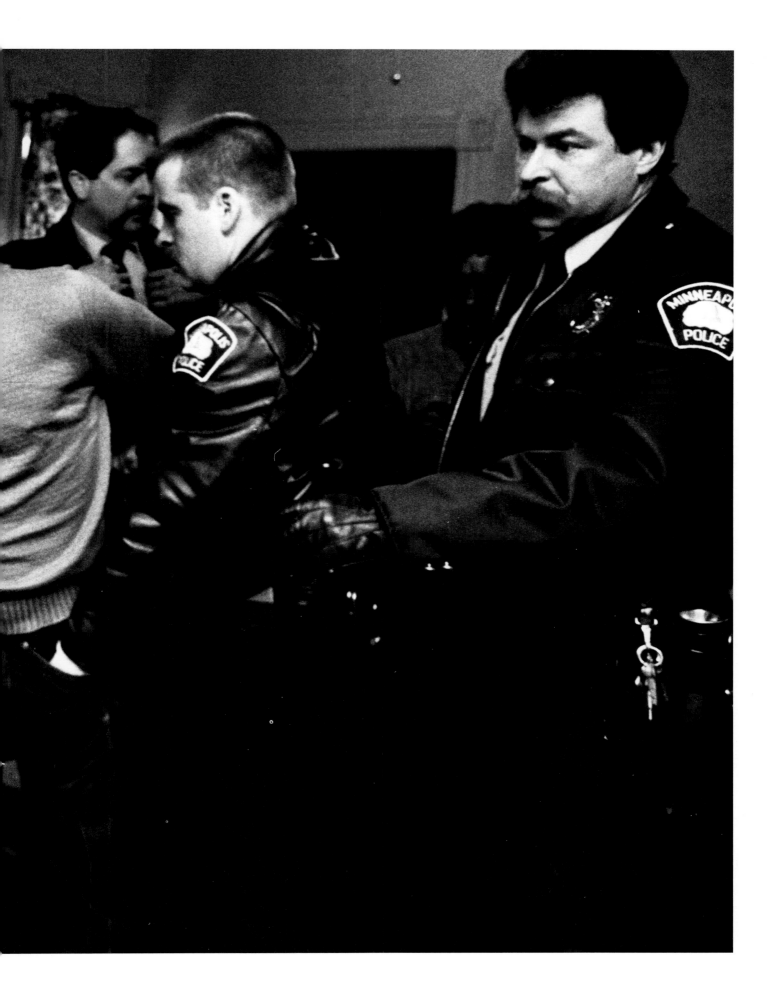

Hungry and sick, a mother and child struggle for life in southern Sudan. / **James Nachtwey, for Life magazine, Award of Excellence in Magazine News or Documentary.**

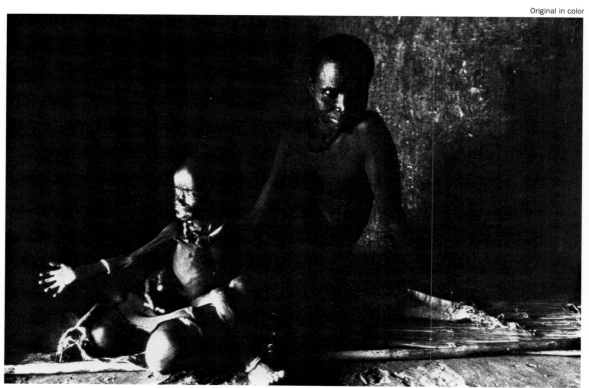

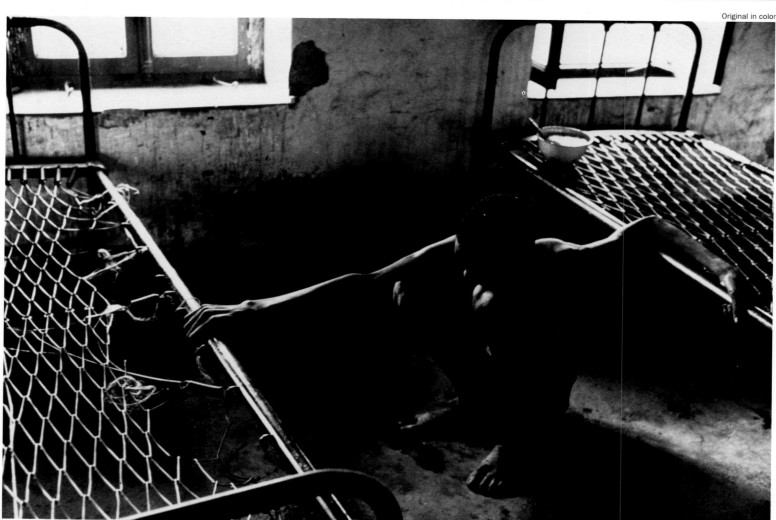

A sick and starving tribesman clings to life in a rebel-controlled hospital in southern Sudan. / **James Nachtwey, for Life magazine, 2nd Place in Magazine News or Documentary.**

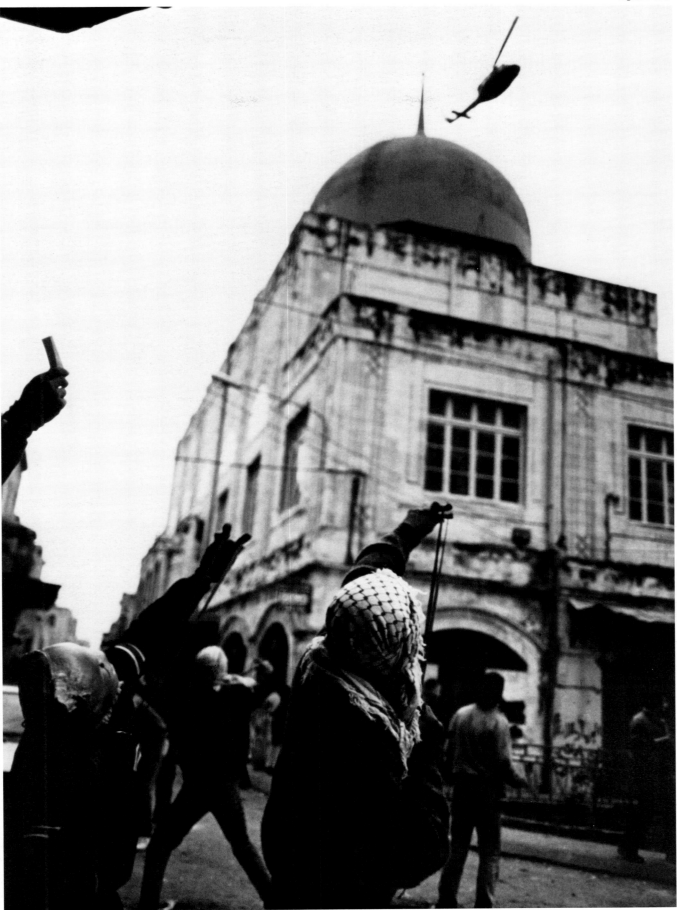

Arab youths aim their slingshots at an Israeli helicopter hovering over a mosque in Nablus, in the Israeli-occupied territories. / **Allan Tannenbaum, Sygma, 3rd Place in Magazine News or Documentary.**

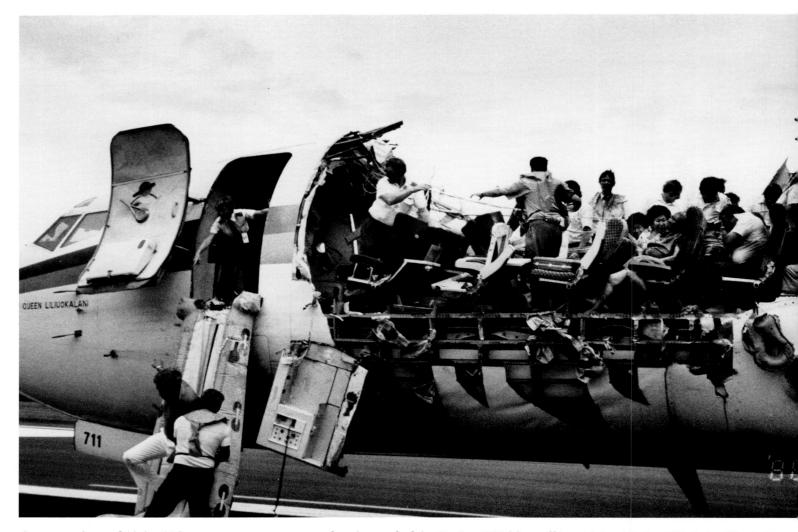

Crew members of Aloha Airlines evacuate passengers after the roof of the Boeing 737 blew off in midair. / **Robert Nichols, Black Star, Award of Excellence in Magazine News or Documentary.**

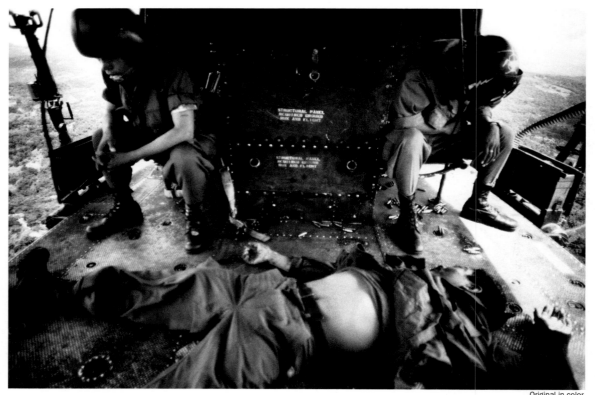

Original in color

Air force door-gunners transport the body of a comrade killed in an ambush in El Salvador. /
Dick Swanson, Award of Excellence in Magazine News or Documentary.

Below, Gen. Augusto Pinochet gives thumbs up to a supporter trying to touch the window of his passing car after a rally in Chile. / **Christopher Morris, Black Star for Newsweek, Award of Excellence in Magazine News or Documentary.**

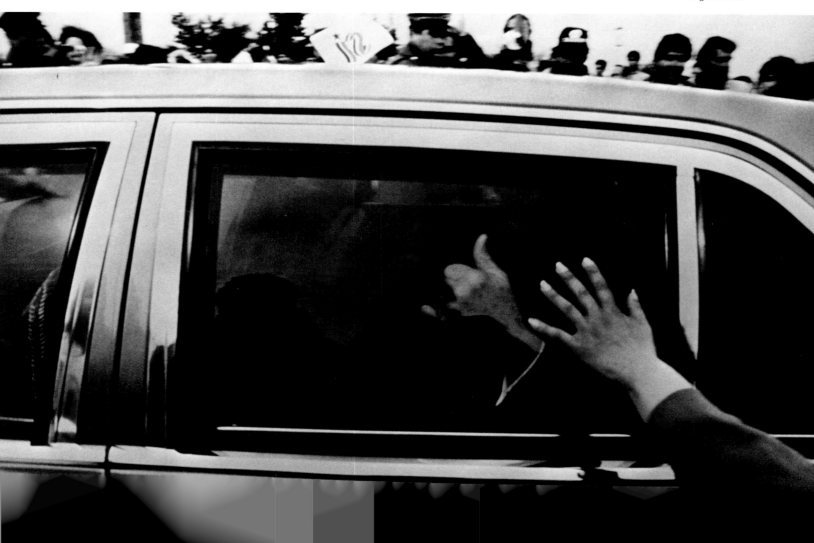

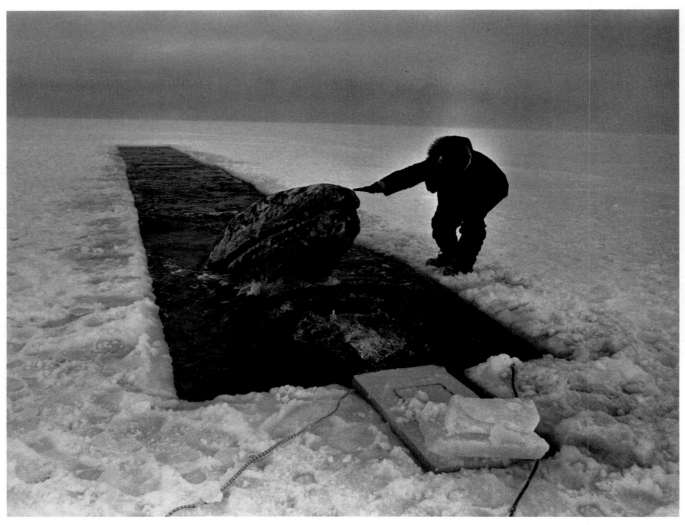

Malik, an Inupiat Eskimo who helped engineer a path out to open water for California gray whales trapped near Alaska, stays to wish a final goodbye before a Soviet ice breaker approaches. / **Bill Hess, Uiniq Magazine, Award of Excellence in Magazine News or Documentary.**

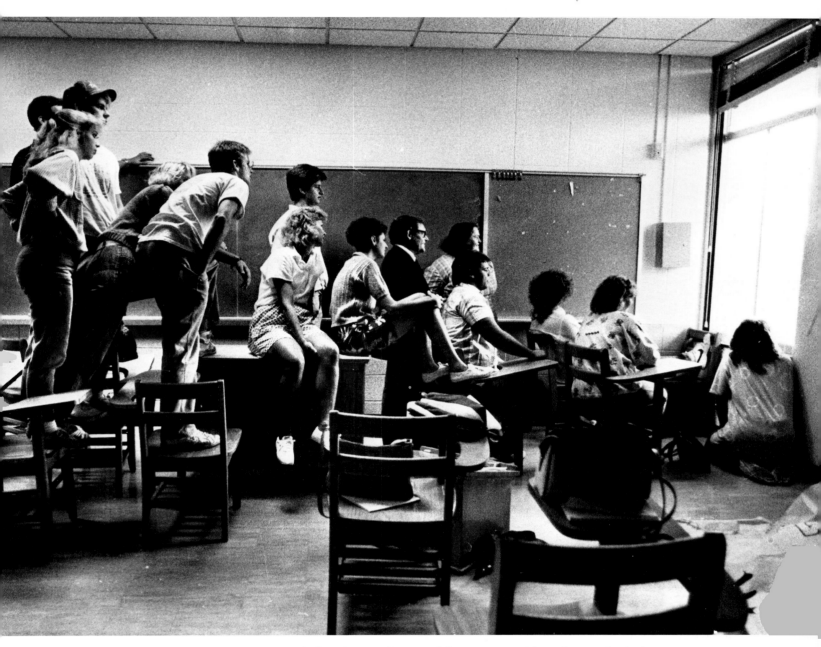

Students at Middle Tennessee State University stretch for a better glimpse of then-Vice President George Bush during a campaign visit to Murfreesboro. / **Larry McCormack, Nashville Banner, 1st Place in Newspaper Campaign '88.**

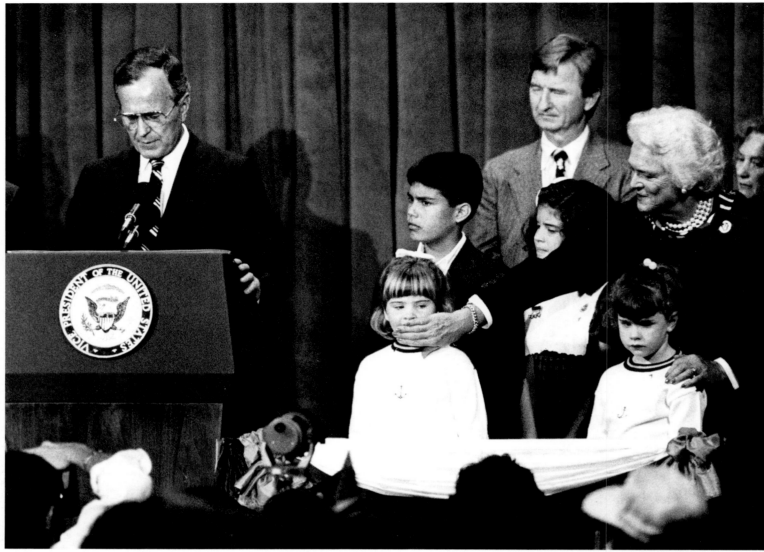

Original in color

As President-elect Bush gives his acceptance speech, granddaughter Barbara yawns with campaign weariness. /
Richard J. Carson, Houston Chronicle, 3rd Place in Newspaper Campaign '88.

The president-
elect relaxes in
the surf in
Gulfstream, Fla.,
after the
election. /
**Allen Eyestone,
The Palm Beach
Post, Award of
Excellence in
Newspaper
Campaign '88.**

Original in color

Candidate Gary Hart recounts events that plagued his campaign. / **David Peterson, The Des Moines (Iowa) Register, Award of Excellence in Newspaper Campaign '88.**

Michael Dukakis stumps for votes at a child-care facility in Cranston, N.J. / **Bonnie Weller, The Philadelphia Inquirer, Award of Excellence in Newspaper Campaign '88.**

Naomi Singleton, 77, assumes a characteristic hands-on-hip stance while listening to 9-year-old Wei Wei Huang during lessons at Singleton's apartment in a retirement home. / **Guy Reynolds, Baton Rouge, La., Morning Advocate/State-Times, 1st Place in Newspaper Portrait/Personality.**

Peggy Briller, 78, owner of a grill in Detroit's Cass Corridor, explains how she stopped a would-be robber the day before. The gunman put his starting pistol on the counter and beat a hasty retreat when he saw Briller's .38. / **David C. Coates, The Detroit News, 2nd Place in Newspaper Portrait/Personality.**

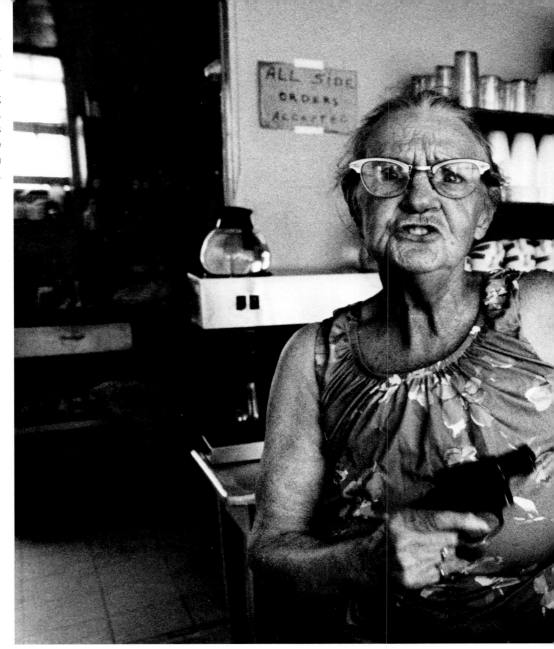

Sugar, a male prostitute and diagnosed AIDS victim, stares from the rear window of an abandoned Cadillac in which he lives and entertains his clients. / **Brian Poulter, Stamford (Conn.) Advocate, 3rd Place in Newspaper Portrait/ Personality.**

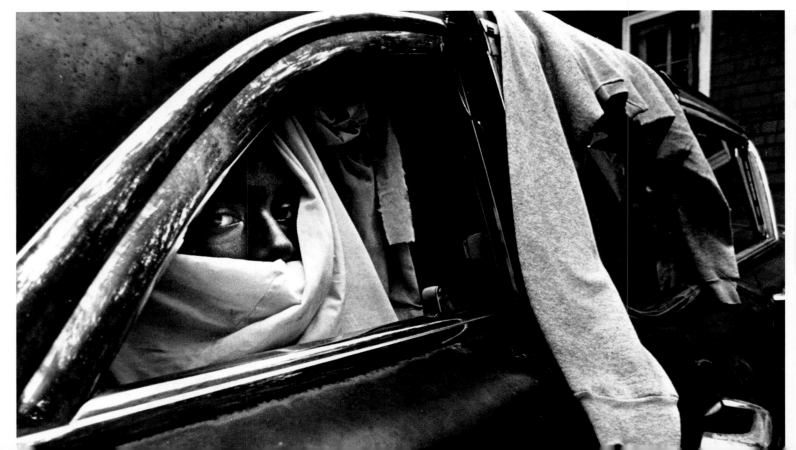

A young Haitian boy, alone with his thoughts, cowers in a corner on election day in Port au Prince after an early morning fire broke out downtown. / **Brant Ward, San Francisco Chronicle, Award of Excellence in Newspaper Portrait/ Personality.**

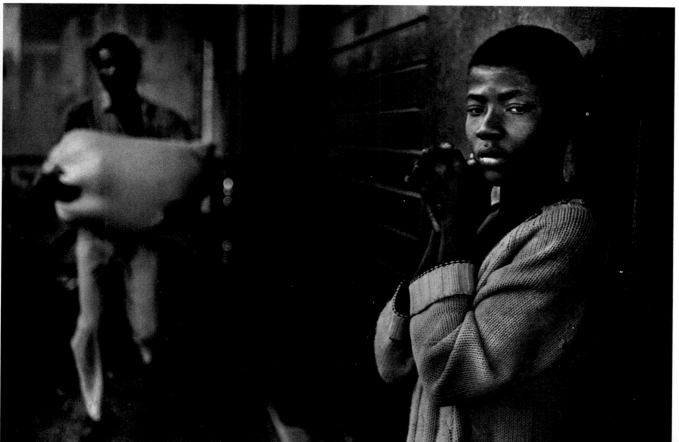

"A Leg Up" was used to illustrate a feature on summer hosiery. / **Betty Udesen, The Seattle Times, 1st Place in Newspaper Fashion Illustration.**

"Fashion With Pears" appeared as part of a spread on fall fashions. /
Rosanne Olson, freelance for Seattle Weekly, 2nd Place in Newspaper Fashion Illustration.

"Black Magic" appeared with a story on fall pants.
/ **J. Kyle Keener, Philadelphia Inquirer, Award of Excellence in Newspaper Fashion Illustration.**

"Pocket Square, New Under the Moon" suggests that women can borrow a bit of flair from a man's wardrobe.
/ **Bill Wade, The Pittsburgh Press, 3rd Place in Newspaper Fashion Illustration.**

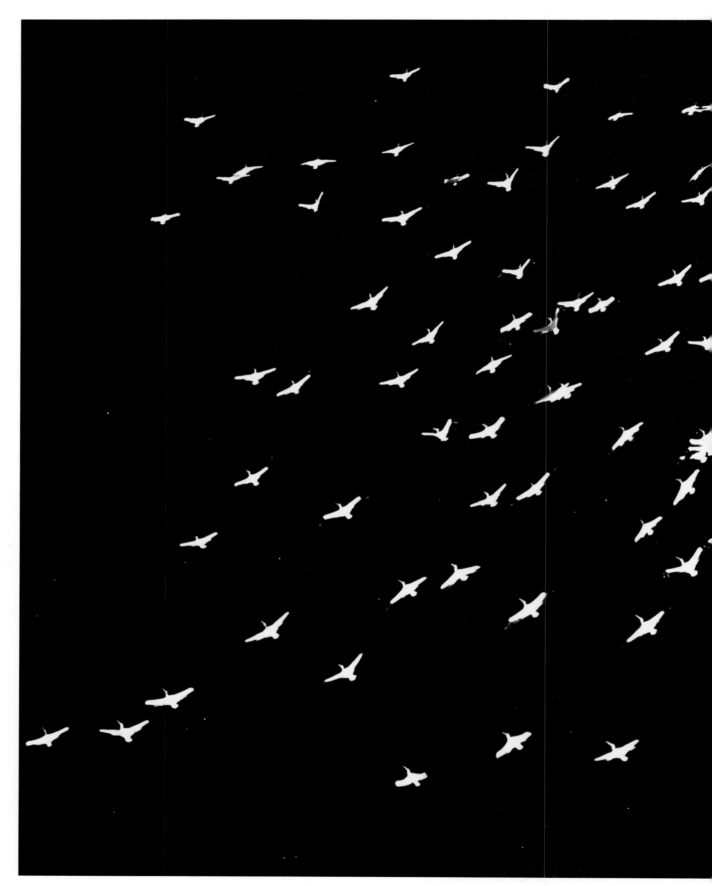

A flock of white pelicans takes flight over Camanche Lake, Calif. / **Richard Schmidt, The Sacramento Bee, 1st Place in Newspaper Pictorial.**

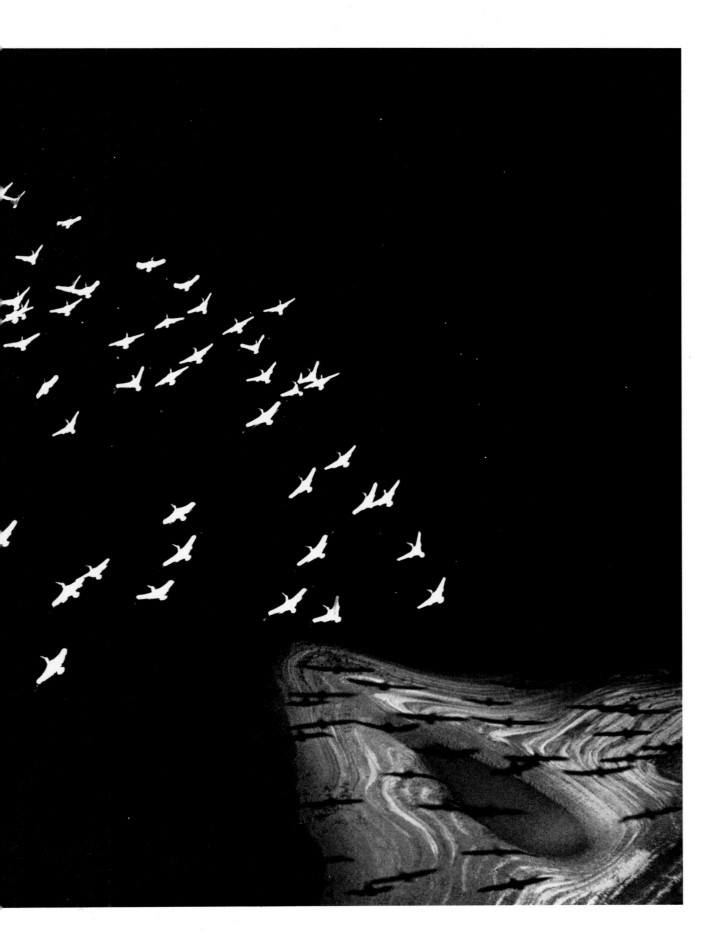

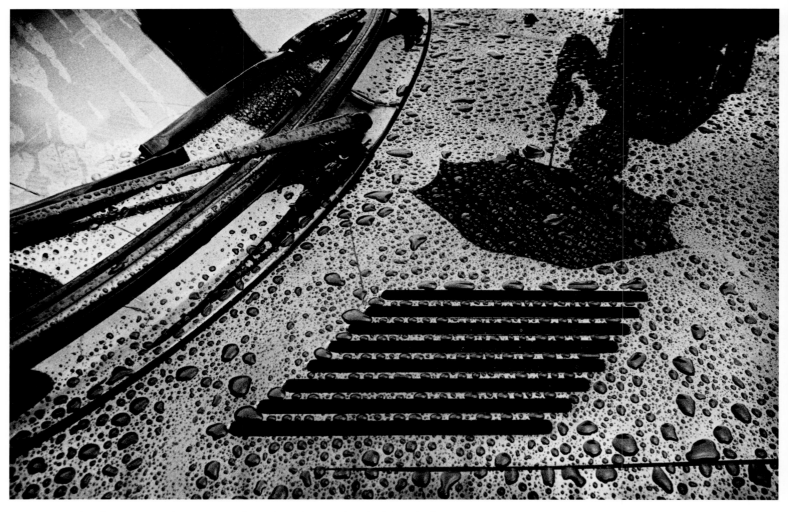

An umbrella-toting pedestrian is reflected in the rain-beaded hood of a car. / **Carl D. Walsh, Biddeford (Maine) Journal Tribune, 2nd Place in Newspaper Pictorial.**

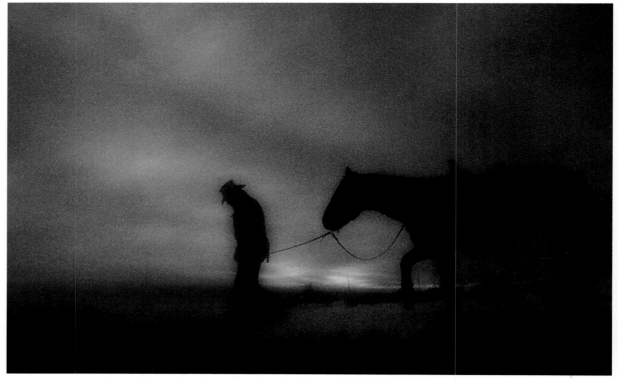

As a winter storm approaches at dusk, New Mexico rancher Leo Larranaga heads home. / **Pat Davison, The Albuquerque Tribune, 3rd Place in Newspaper Pictorial.**

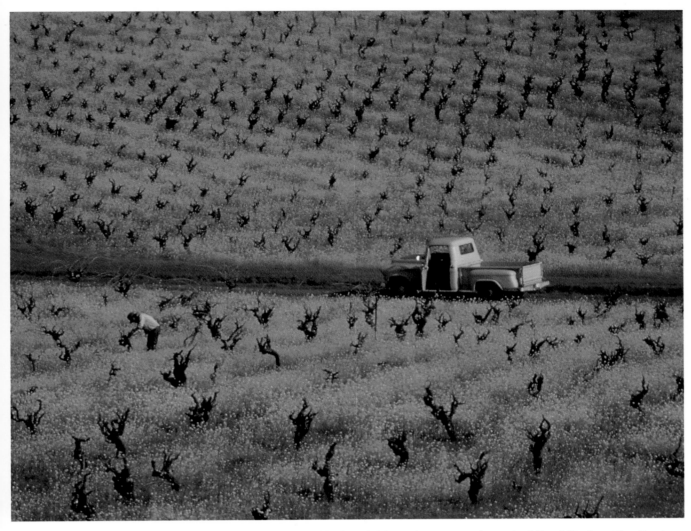

Paul Rossi prunes grape vines in his father's vineyard, filled with blooming mustard weed. / **Kent Porter, The Santa Rosa (Calif.) Press Democrat, Award of Excellence in Newspaper Pictorial.**

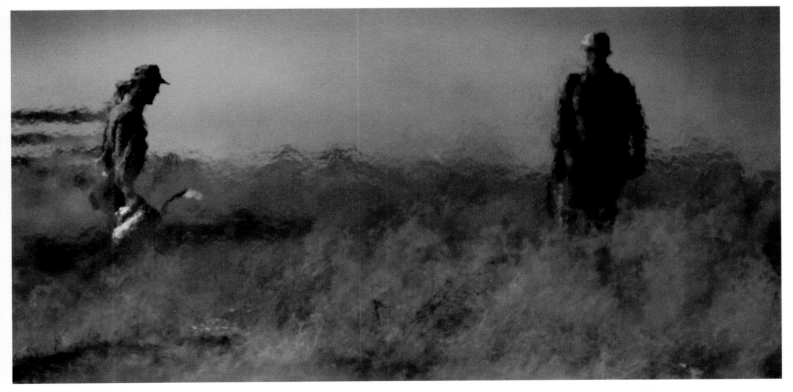

Two prairie restorationists appear through the heat of an intentional prairie burn. / **Richard C. Sennott, Star Tribune Newspaper of the Twin Cities, Minn., Award of Excellence in Newspaper Pictorial.**

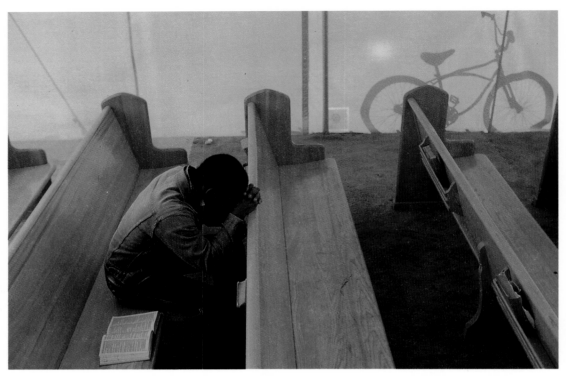

Eugene White finds shelter and prayer at the New Life Institute in Newhall, Calif. The institute provides support for 200 male residents while they learn a marketable skill. / **Nick Kelsh, A Day in the Life of California, Award of Excellence in Magazine Pictorial.**

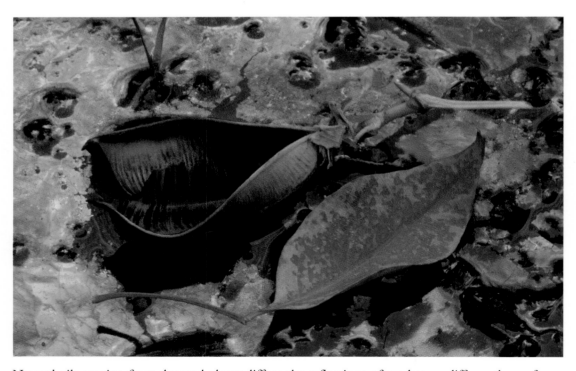

Natural oils seeping from decayed plants diffuse the reflections of sandstone cliffs on the surface of a stream in Utah's Zion National Park. / **Bob and Clara Calhoun, National Wildlife Magazine, Award of Excellence in Magazine Pictorial.**

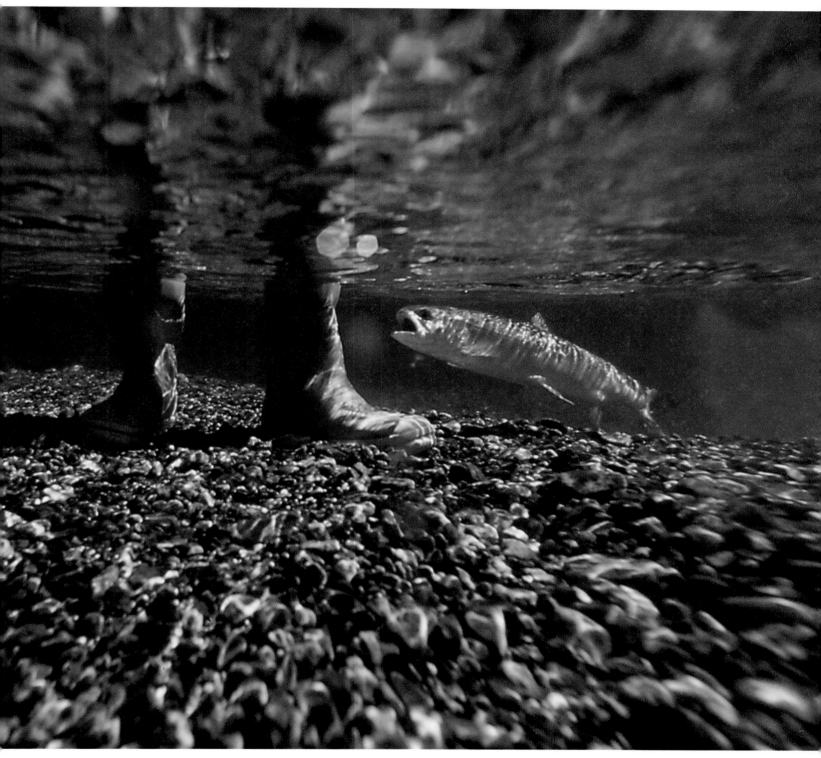

"Trout fishing in Patagonia." / **Jose Azel, Contact Press Images, 1st Place in Magazine Pictorial.**

The Los Angeles sky slowly clears after an April storm. The photo was taken from the roof of the Marina Beach Hotel in Marina Del Rey, Calif. / **Art Streiber, LA West Magazine, 2nd Place in Magazine Pictorial.**

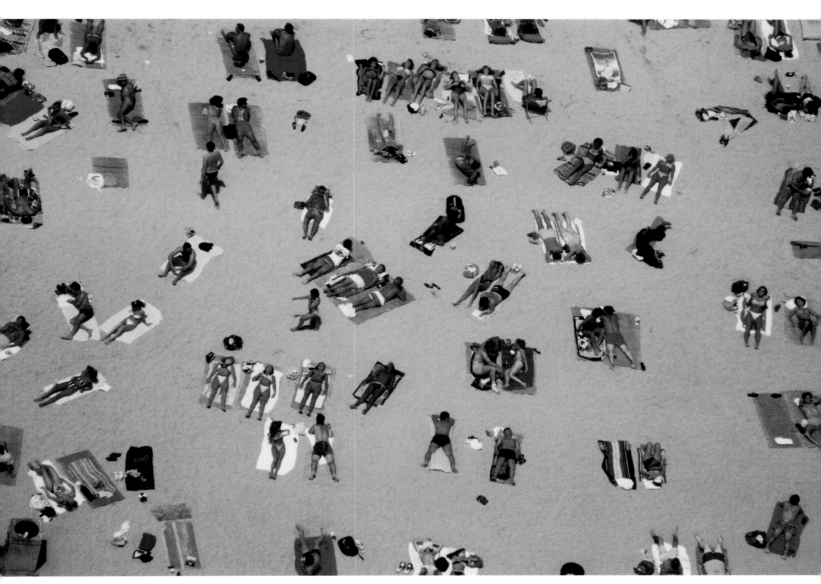

Honolulu beachgoers stake out a place in the sand in preparation for a day in the sun. / **Jim Jennings, National Geographic World, 3rd Place in Magazine Pictorial.**

Just before daylight, a lobsterman rows a dinghy out to his lobster boat moored off Spruce Island, Maine. / **Darryl Heikes, U.S. News and World Report, Award of Excellence in Magazine Pictorial.**

"High-tech mushrooms." / **Thomas B. Szalay, The (San Diego) Tribune, 1st Place in Food Illustration.**

"Bananas: handle with care." / **Dennis Hamilton Jr., Florida Times-Union, Award of Excellence in Food Illustration.**

"Wishy washy asparagus." / **Hoyt Carrier II, The Grand Rapids Press, 2nd Place in Food Illustration.**

"Chocolate shells delight." / **Stan Badz, The Florida Times-Union, 3rd Place in Food Illustration.**

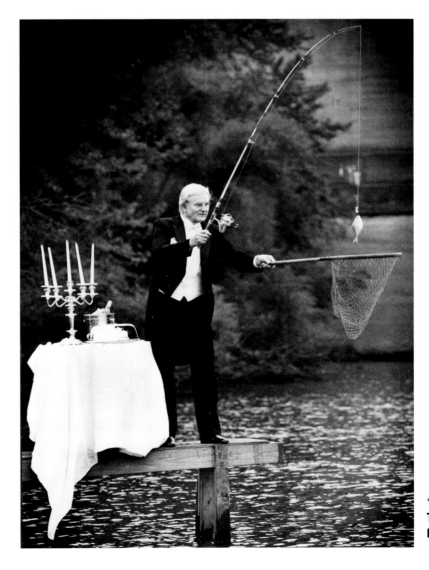

"Pricey catch." / **Anne Lennox, The Pittsburgh Press, Award of Excellence in Food Illustration.**

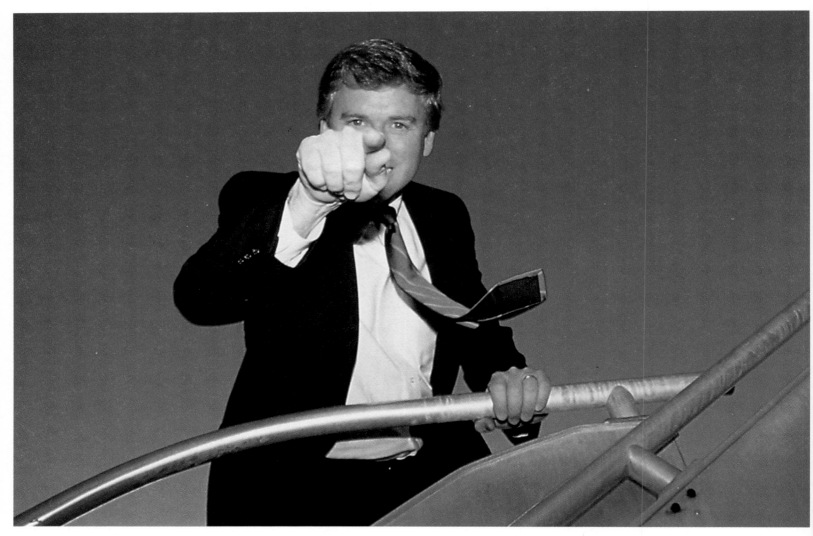

Dan Quayle seems to be saying, "I want you," as he boards a plane. / **P.F. Bentley, Time, 1st Place in Magazine Campaign '88.**

...orge Bush at a New Jersey campaign rally in October. / **Cynthia Johnson, Time, 2nd Place in Magazine Campaign '88.**

Sleeping Michael Dukakis. / **Kenneth Jarecke, Contact Press Images, 3rd Place in Magazine Campaign '88.**

Gary Hart's five-minute television speech plays to an empty house in the lobby of the Kirkwood Hotel in Des Moines, Iowa. /
Jim Curley, Agence France Presse (freelance), Award of Excellence in Magazine Campaign '88.

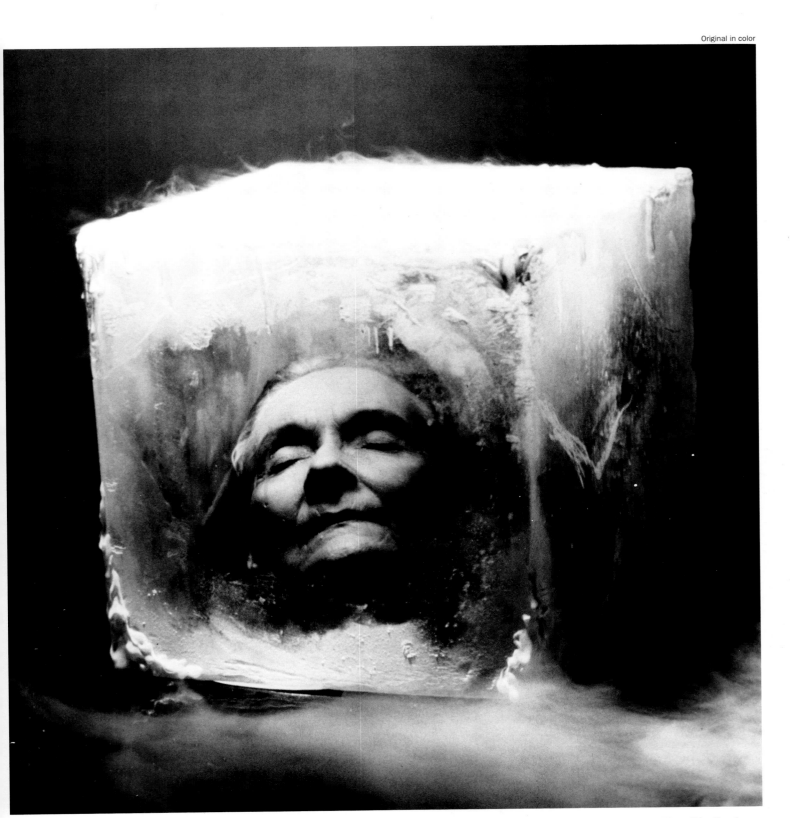

The cryonics controversy: We have seen the future, and it is cold. / **Susan Gardner, Fort Lauderdale (Fla.) News/Sun-Sentinel, 1st Place in Newspaper Editorial Illustration.**

Filters for tap water:
a muddy issue. /
**Peter Monsees,
The Record,
Hackensack, N.J.,
2nd Place
in Newspaper
Editorial
Illustration.**

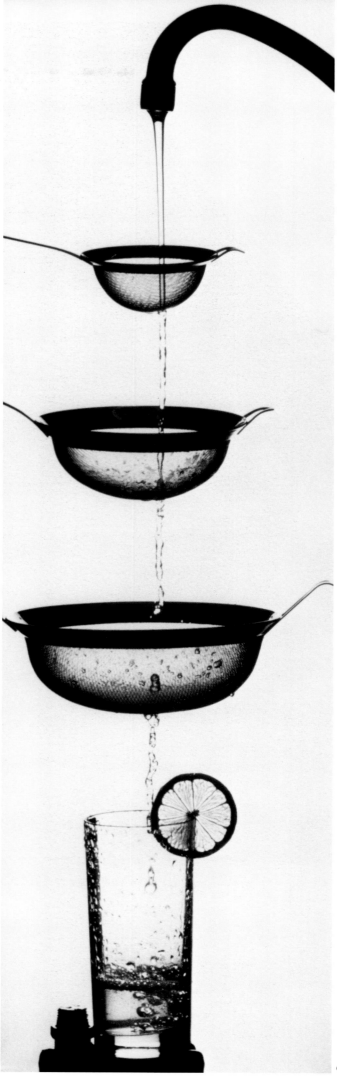

Original in color

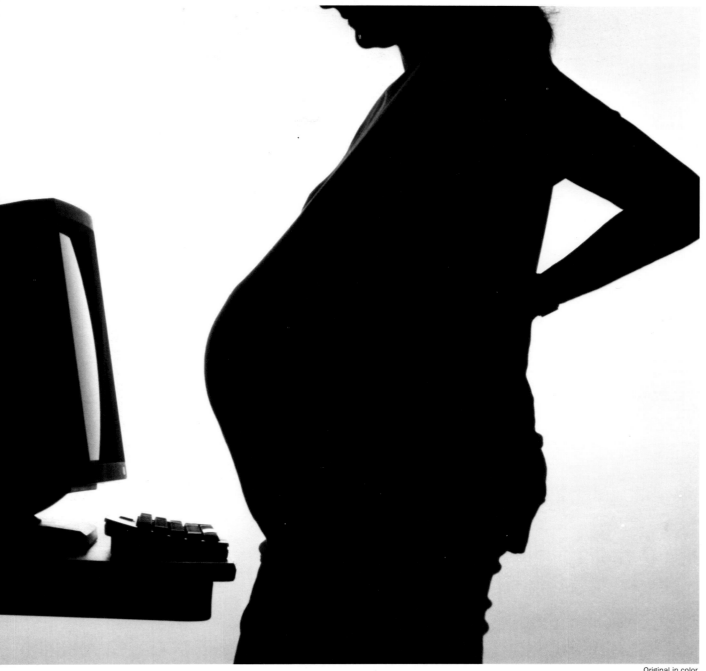

Original in color

Are VDTs hazardous to pregnant women in the workplace? / **David Crane, Los Angeles Daily News, Award of Excellence in Newspaper Editorial Illustration.**

Original in color

Natural gas vs. electricity: which is best for heating and cooling a home? / **Steve Douglass, Amarillo (Texas) Globe/News, 3rd Place in Newspaper Editorial Illustration.**

Page 115

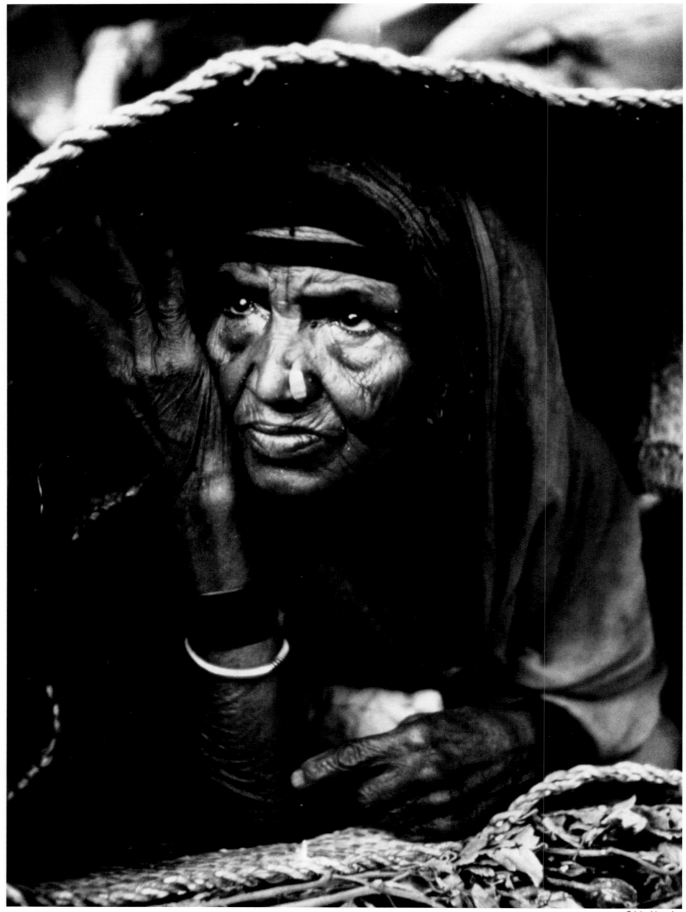

A refugee's home. / **Anthony Suau, Black Star, 1st Place in Magazine Portrait.**

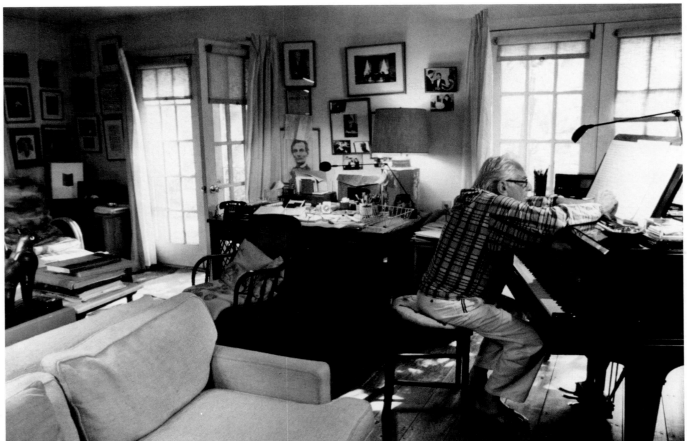

Original in color

Leonard Bernstein composes at his piano at his country house. / **Joseph McNally, freelance, Award of Excellence in Magazine Portrait.**

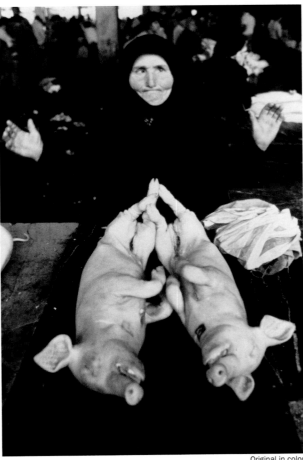

A woman markets her piglets in Tbilisi, Georgia, in the Soviet Union. While cities in the north have long lines and shortages, southern markets are filled with meats and produce. / **Joe Traver, The New York Times (freelance), 2nd Place in Magazine Portrait.**

Original in color

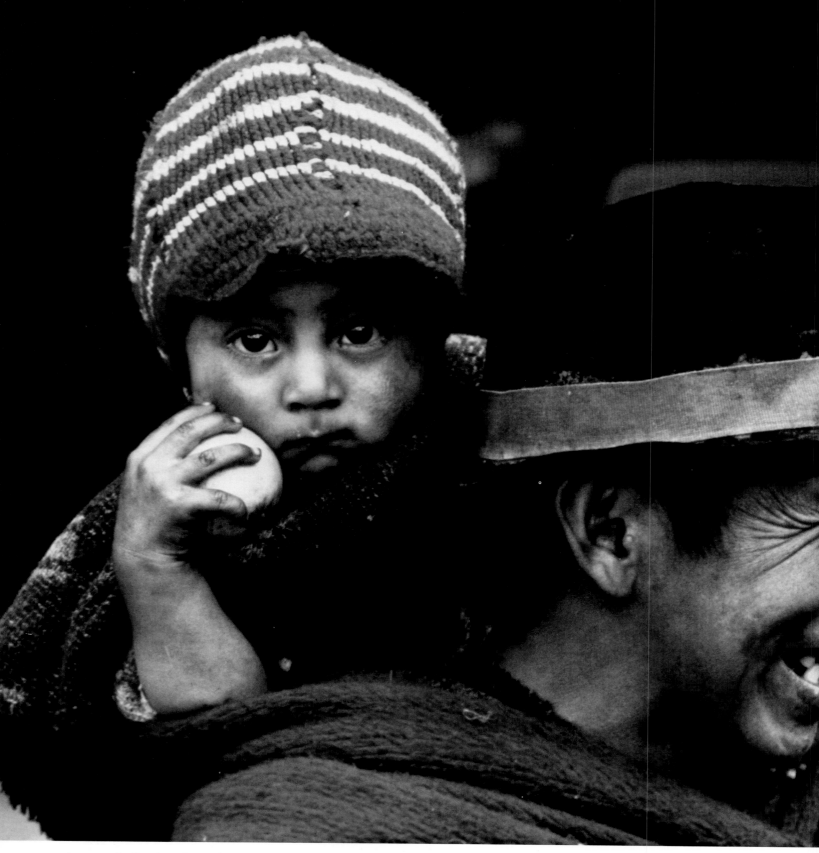

A young Indian boy from the highlands of Ecuador visits the weekly Ambato market with his father. Staged every Monday, this is one of Ecuador's largest open-air Indian markets, drawing thousands of people from the country's tribes. / **Ric Ergenbright, Children of the World, 3rd Place in Magazine Portrait.**

A homeless man sits in the afternoon sun in the streets of Greenwich Village. **/ Andrew Holbrooke, Black Star, Award of Excellence in Magazine Portrait.**

Ken Exner says goodbye to friend Casey Coor after a night at the movies while his mother, Lenita, waits. / **Robert Durell, Los Angeles Times (freelance), 1st Place in Newspaper Feature Picture.**

Matthew Stubbs and his cousin Alyssa plead with passing motorists to adopt a kitten. / **Timothy C. Barmann, The Providence Journal-Bulletin, 3rd Place in Newspaper Feature Picture.**

"The Gesture" / **Pete Cross, The Miami Herald, 2nd Place in Newspaper Feature Picture.**

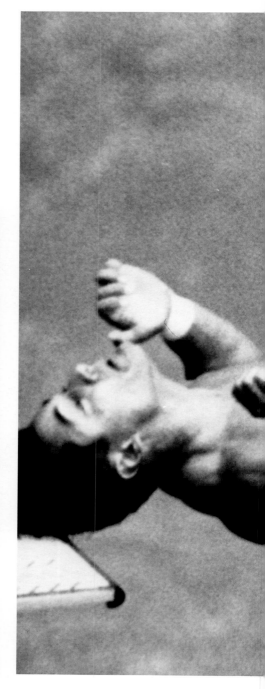

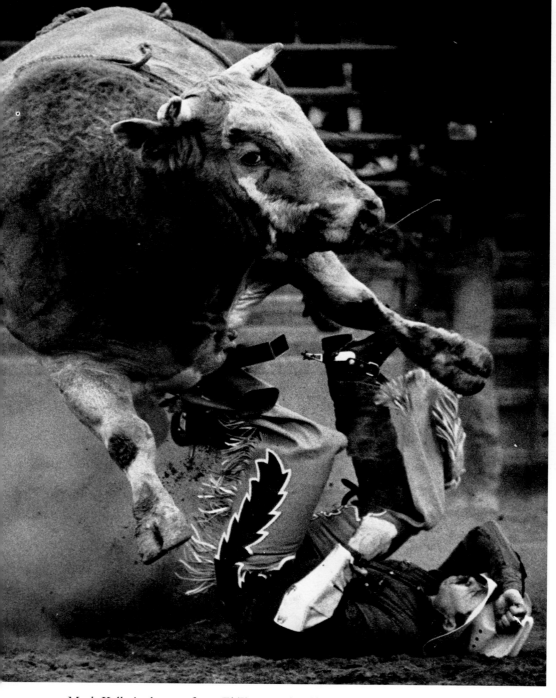

Mark Kelly is thrown from El Toro at the Alaska State Fair Rodeo. Kelly was not injured in the fall. / **Bill Roth, Anchorage Daily News, Award of Excellence in Newspaper Sports Action.**

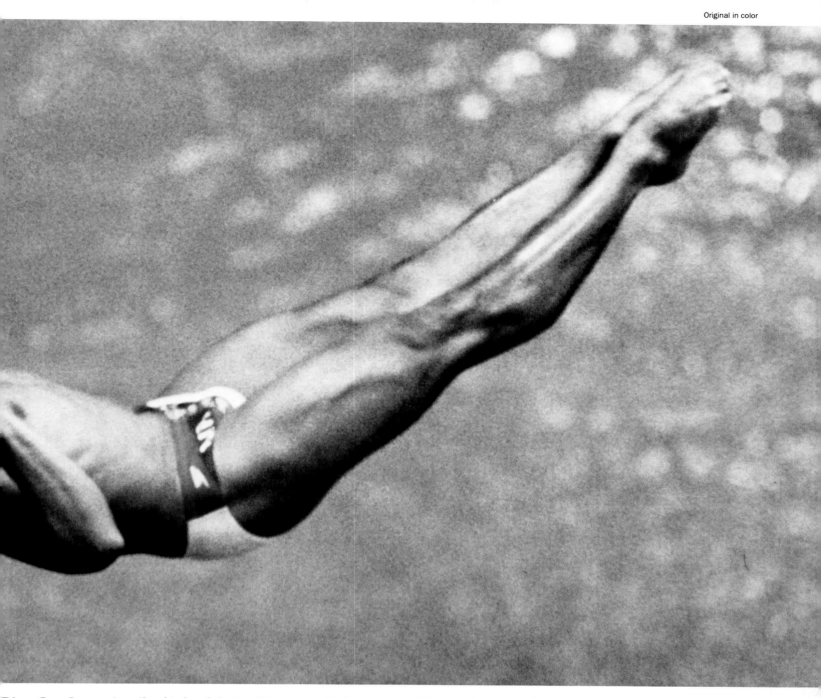

Diver Greg Louganis strikes his head during Olympic preliminary competition on the three-meter springboard. / **Brian Smith, The Miami Herald for Agence France Presse, 1st Place in Newspaper Sports Action.**

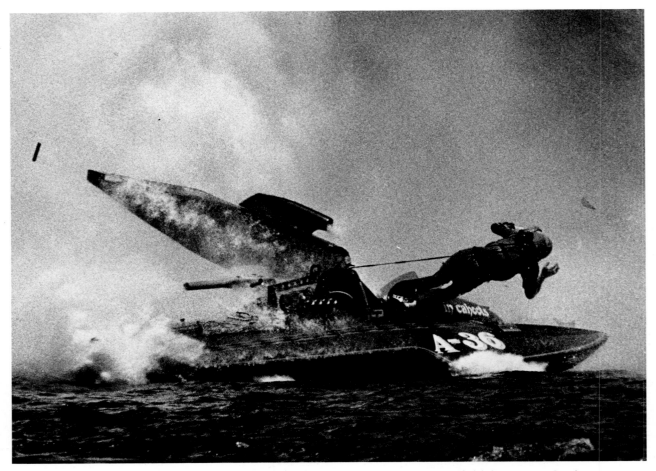

Pilot John Voss is ejected from his 2.5-liter boat during the 50th annual Valleyfield Regatta in Quebec. /
Bernard Brault, La Presse, 3rd Place in Newspaper Sports Action.

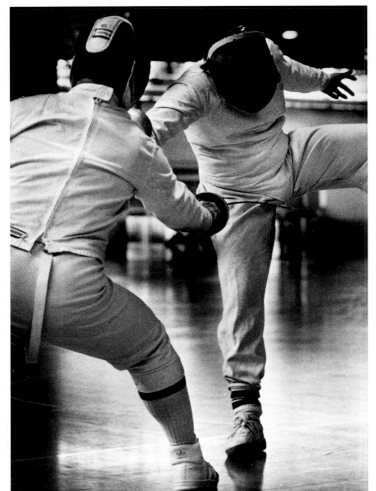

Dale Schrauth takes a jab from his instructor, Felix Tan, while practicing epee fencing at Kent State University. /
Carol Cefaratti, unpublished, Award of Excellence in Newspaper Sports Action.

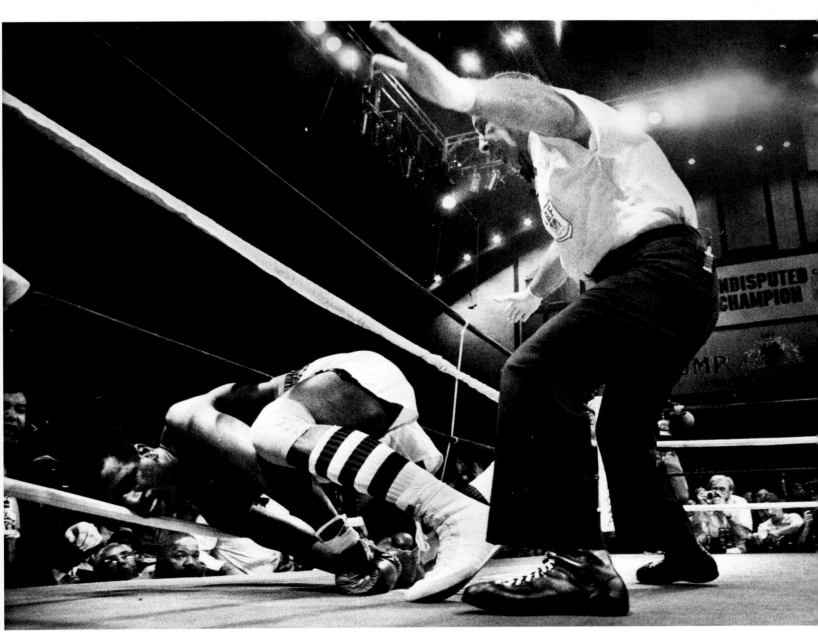

Michael Spinks goes down from a blow by Mike Tyson during the first round of their heavyweight title fight in Atlantic City. /
Vernon Ogrodnek, The Press, Atlantic City, 2nd Place in Newspaper Sports Action.

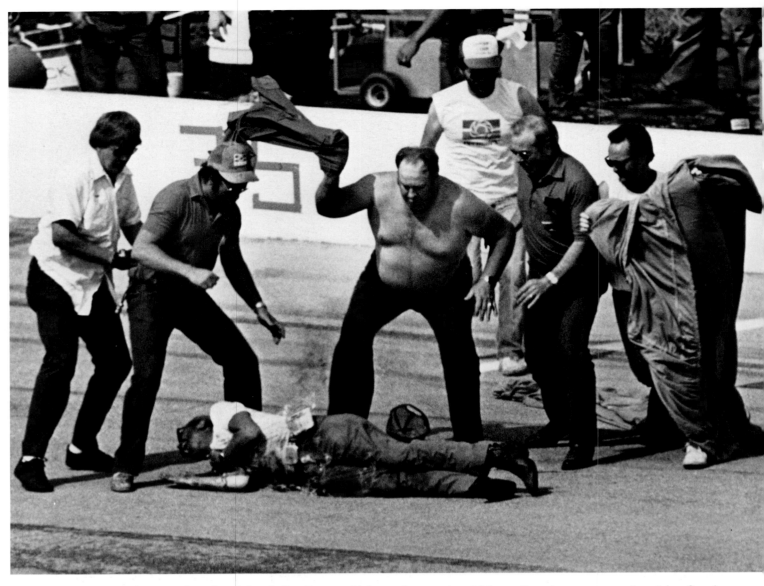

Pit crew members at the Grand National Stock Car Race at Alabama International Motor Speedway try to extinguish a fire that engulfed a fellow crew member while he was filling a car with gas./ **Phil Coale, Tallahassee (Fla.) Democrat, Award of Excellence in Newspaper Sports Action.**

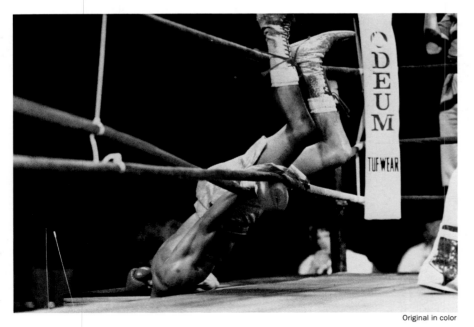

Original in color

Johnny DuPlessis of New Orleans hangs through the ropes after being pushed by Louie Lomelli of Chicago during their fight in Villa Park, Ill. / **Charles Cherney, Chicago Tribune, Award of Excellence in Newspaper Sports Action.**

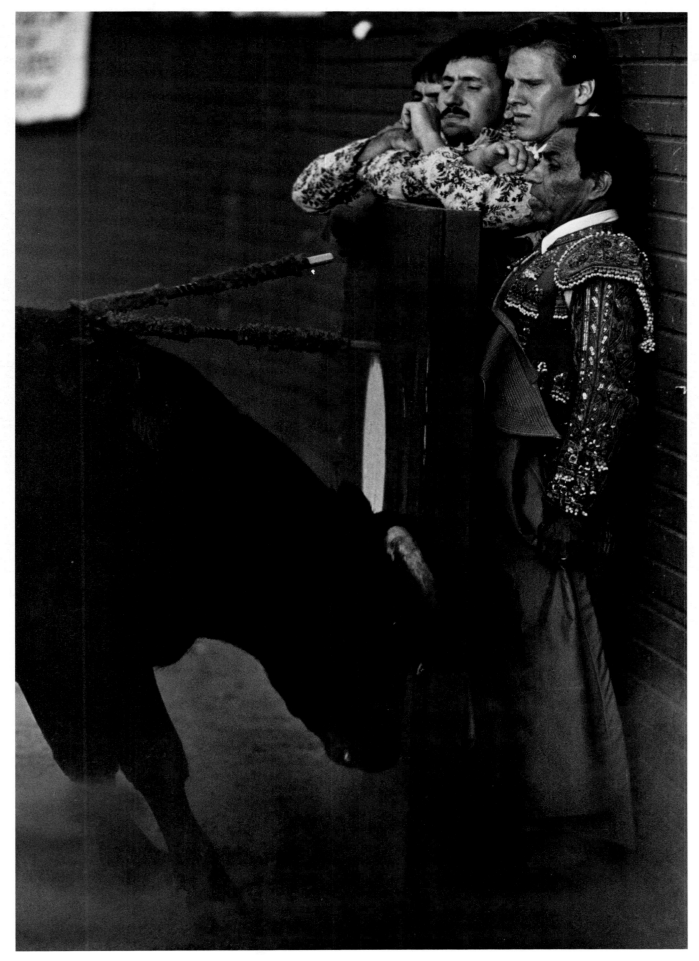

David Agular (front) and three Forcaderos find protection from the bull behind a barrier during Portuguese-style bloodless bullfighting in Artesia, Calif. Velcro-tipped swords adhere to a velcro pad on the bull's back.
/ Brian Gadbery, Los Angeles Times (freelance), 1st Place in Newspaper Sports Feature

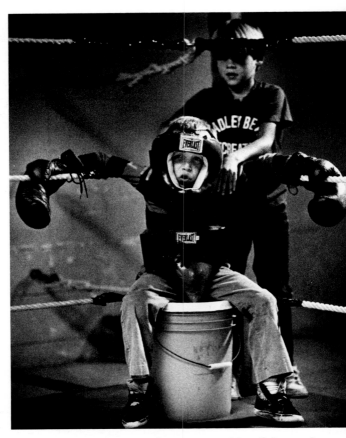

Chris Purpura gives moral support to Matt Johnson betwee rounds at a weekly boxing clinic in Bradley Beach, N.J. Bo boys are 8 years old./ **Peter Ackerman, Asbury Park Pres Award of Excellence in Newspaper Sports Feature.**

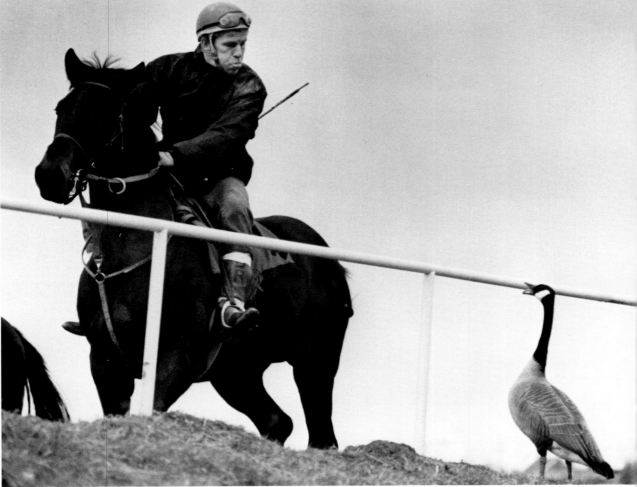

Exhibition Park Racetrack exercise boy Bob Roman shares his feelings of mutual disrespect with a Canada Goose guarding its nest next to the track. / **Les Bazso, The Province, Vancouver, 3rd Place in Newspaper Sports Feature.**

Original in c

Allison Hightshoe, the only girl on the high school soccer team, waits with three teammates for a direct free kick on their goal, hoping their hands will protect them from the ball. / **Brian K. Johnson, The Champaign-Urbana (Ill.) News-Gazette, 2nd Place in Newspaper Sports Feature.**

Edward Morse is caught in a midair spin during his dive off the one-meter springboard at the U.S. Outdoor Nationals at Irvine, Calif. / **Tim DeFrisco, Allsport U.S.A., 1st Place in Magazine Sports Picture.**

Spanish bullfighters are protected by police while trying to leave the bull ring as fans throw cushion seats in protest of a poor performance. / **Raul de Molina, Shooting Star Photo Agency, 2nd Place in Magazine Sports Picture.**

Original in color

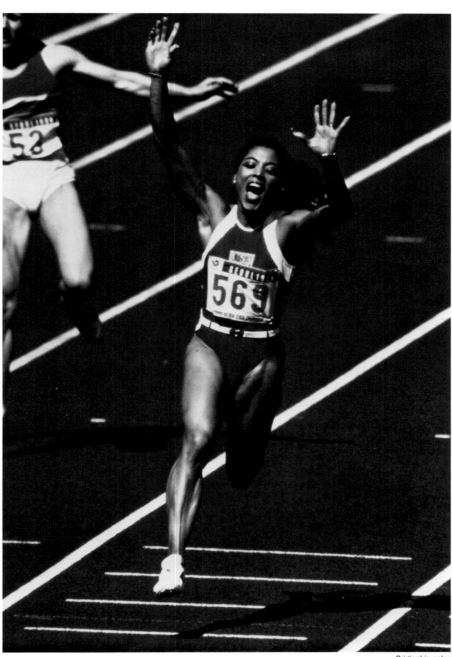

Original in color

Florence Griffith-Joyner wins the gold for the 100 meters at the Summer Olympics in Seoul. / **Rich Clarkson, Time, 3rd Place in Magazine Sports Picture.**

Jerry Lodriguss
The Philadelphia Inquirer

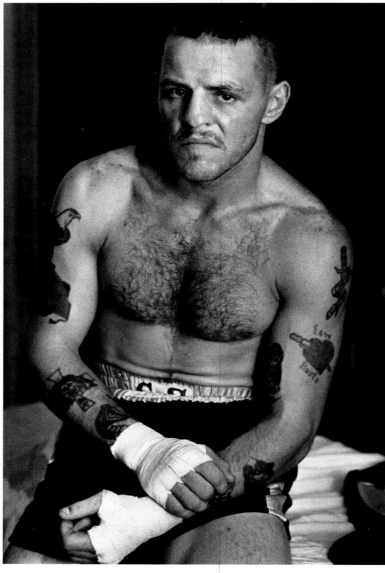

Chris Organtini is a club fighter who works in a tire warehouse during the day in Norristown, Pa.

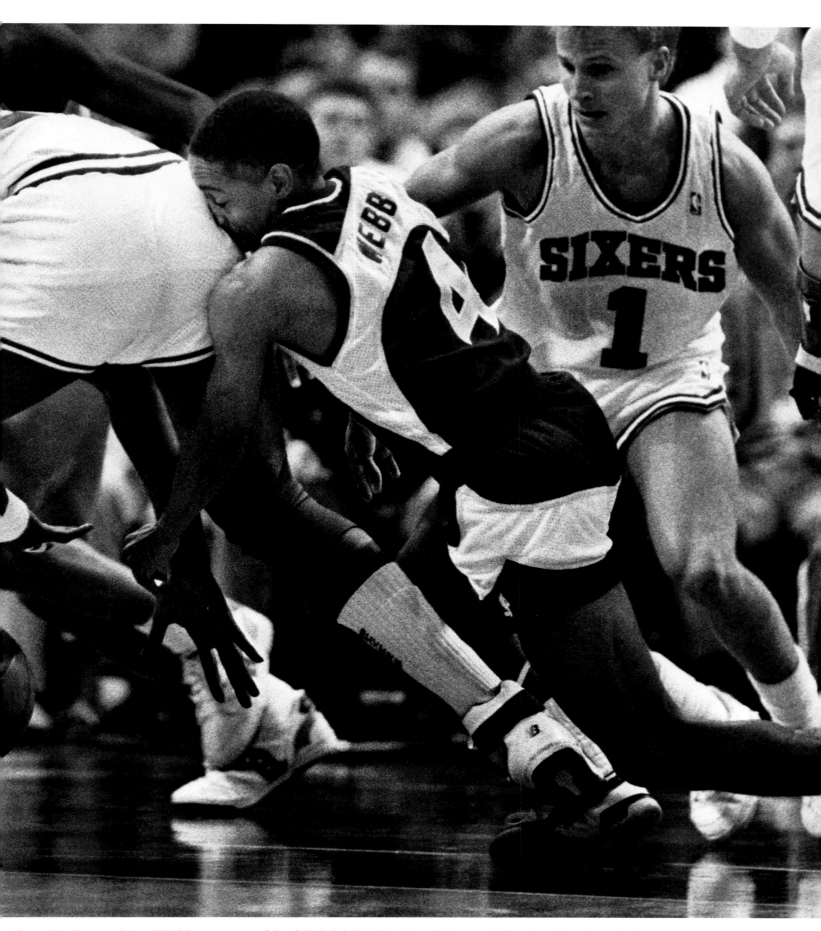

Atlanta Hawks guard Spud Webb gets a noseful of Philadelphia 76er Ben Coleman while going for a loose ball.

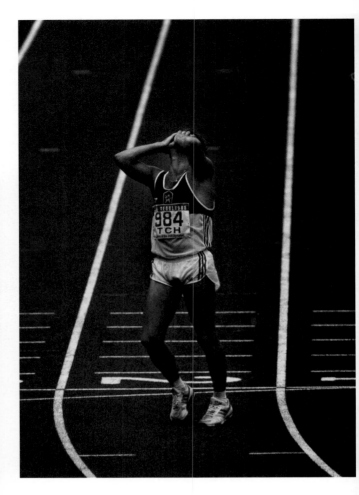

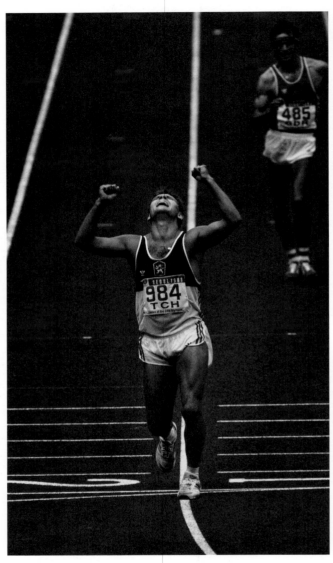

Czechoslovakia's Jozef Pribilinec crosses the finish line to win the 20-kilometer walk and the gold medal, then realizes what he has done and falls to the track in exhaustion during the Summer Olympics.

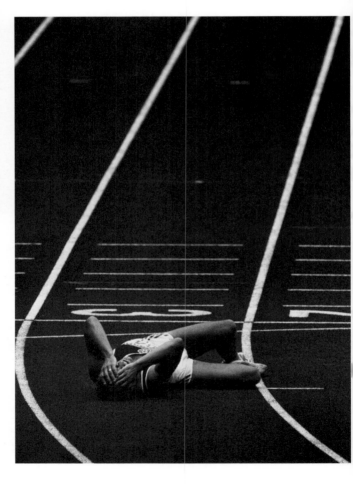

Newspaper Sports Portfolio / Jerry Lodriguss, First Place

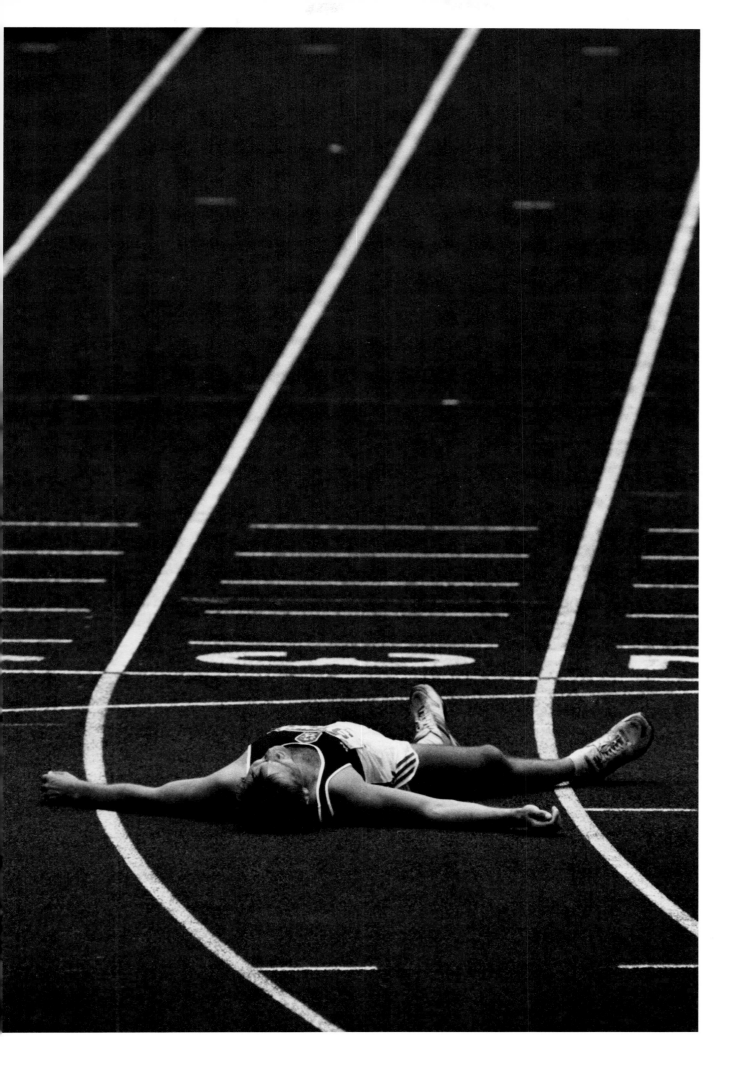

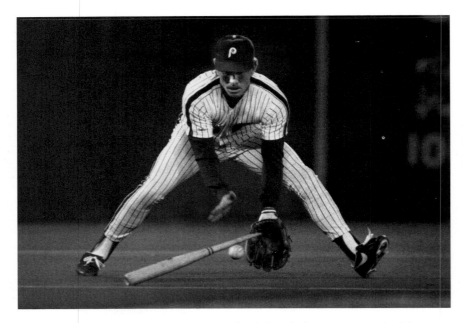

Philadelphia Phillies third baseman Mike Schmidt has to contend with a broken bat as well as fielding the ball before throwing Pittsburgh Pirate Darnell Coles out at first base.

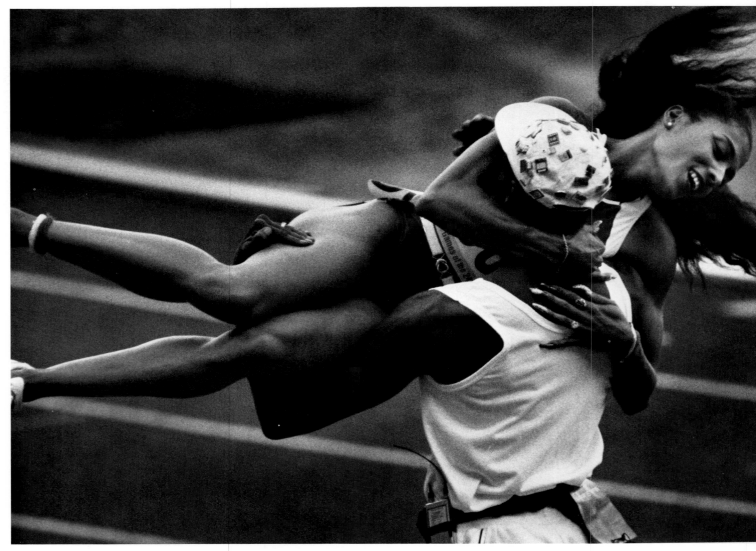

Florence Griffith-Joyner is lifted by her husband, Al Joyner, for a victory ride after winning the 200-meter dash finals and setting a world record.

Catharine Krueger

The Sun-Tattler, Hollywood, Fla.

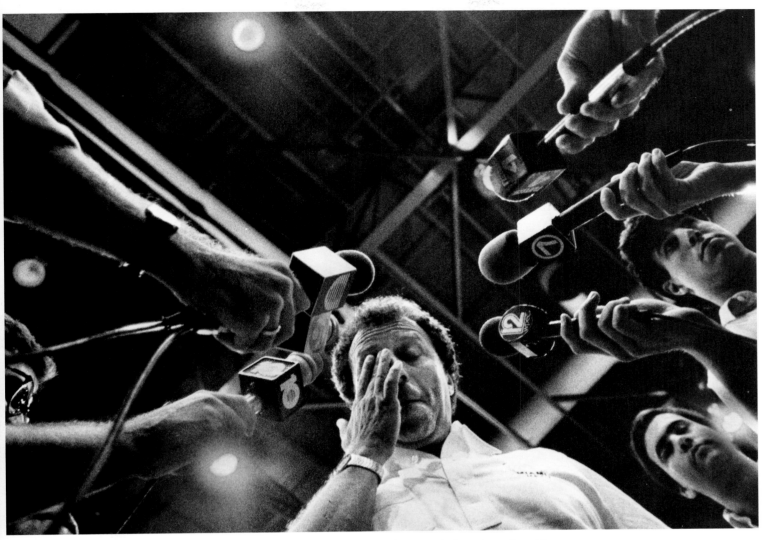

Miami Heat head coach Ron Rothstein is the center of attention at the team's first day of rookie camp.

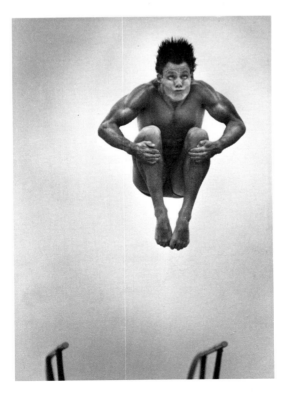

Mark Bradshaw is upward bound in his final one-meter springboard dive at the McDonald's International Diving Championships in Boca Raton, Fla.

Aspiring jockey Kim Pion, 19, and her boyfriend, Terry Veltri, relax in their room at Calder Race Track in North Dade, Fla., at the end of the day.

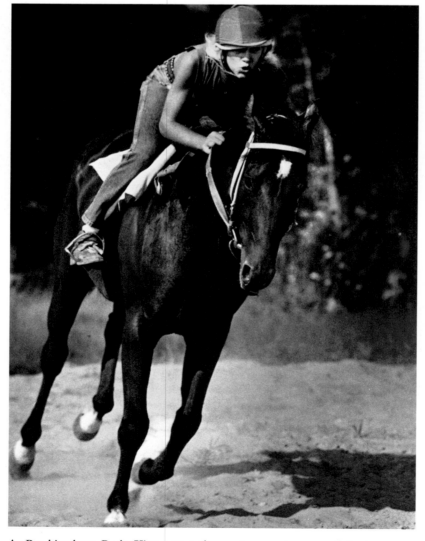

At Rockingham Park, Kim gets a chance to exercise one of the horses.

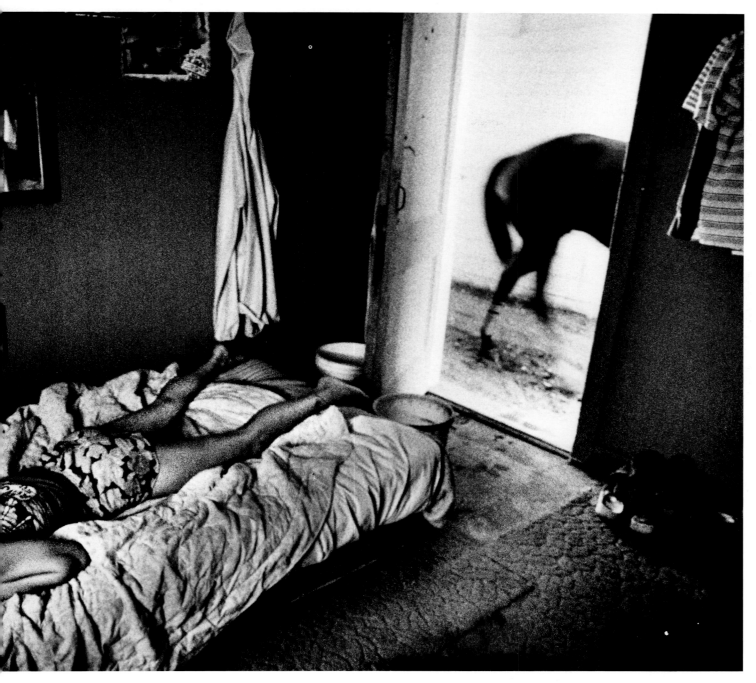

As Kim sleeps in her room in the stable area, horses are walked past her door during their cool-down after being exercised.

Ready to Ride

Nothing has ever taken Kim Pion far from the behind-the-scenes life of race tracks. Her father, Jerry "The Mop" Pion, was a jockey, and at the age of 7 she began working at Rockingham Park in Salem, N.H., during school vacations.

Instead of schoolbooks and recesses, Kim's interest centered on bridles, saddles and stables. At 14 she ran away from home to work at a race track in Omaha, Neb. She never finished school.

She has worked as a groom and an exerciser, but lost her first chance at riding a race when she became pregnant at 16. Now she works odd jobs in the stables, hoping still for a chance to show her stuff as a jockey.

"I get high just riding a horse," she says. "That's a lot of power: 1,200 pounds. To have control over it makes you feel great."

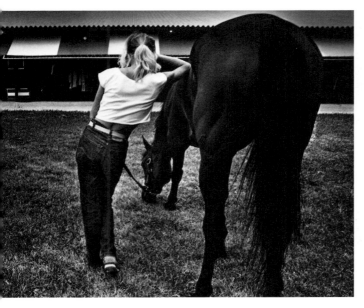

Kim, sleepy after a late night, lets a horse graze in the early morning at Calder.

Vince Musi

The Pittsburgh Press

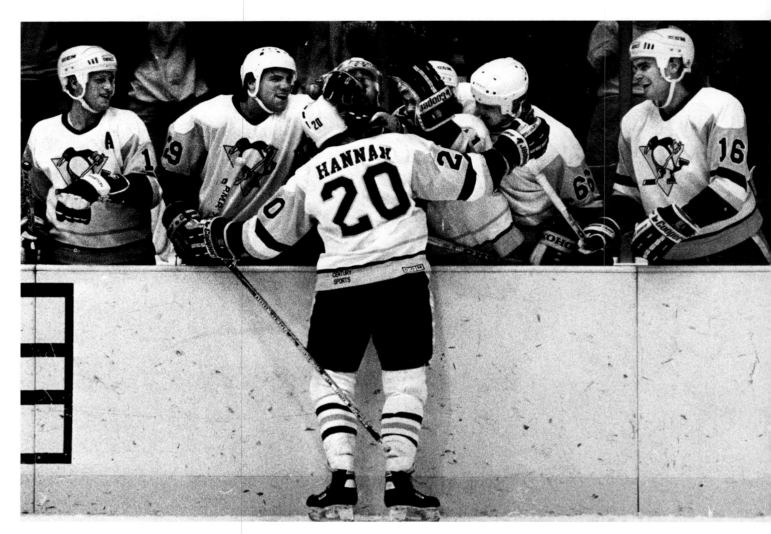

Pittsburgh Penguin Dave Hannah gets a rousing welcome from his teammates after scoring the winning goal with five seconds left in a tie game with the Chicago Blackhawks.

Pittsburgh Pirate Jose Lind argues with the umpire after being thrown out at second to end the inning in a loss to Cincinnati.

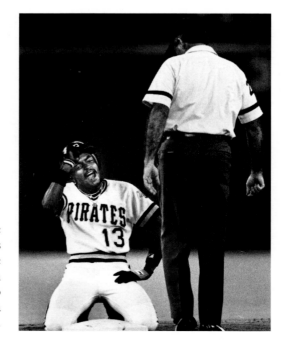

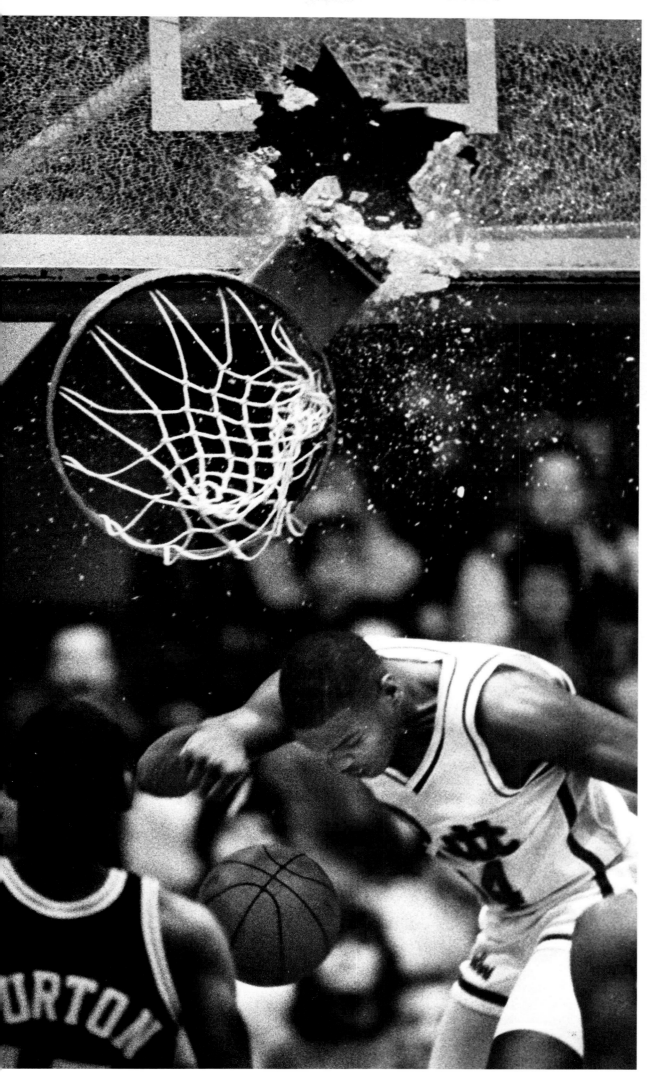

University of Pittsburgh basketball star Jerome Lane is showered with glass after shattering a backboard during a game with Providence.

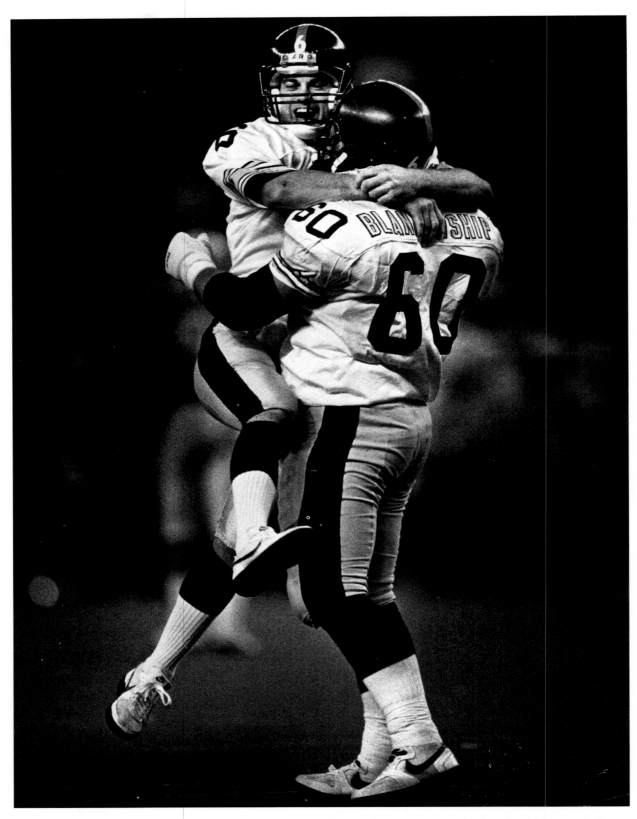

Pittsburgh Steelers quarterback Bubby Brister shows offensive lineman Brian Blankenship his appreciation for allowing him the time to complete an 80-yard touchdown pass.

Mike Powell

Allsport

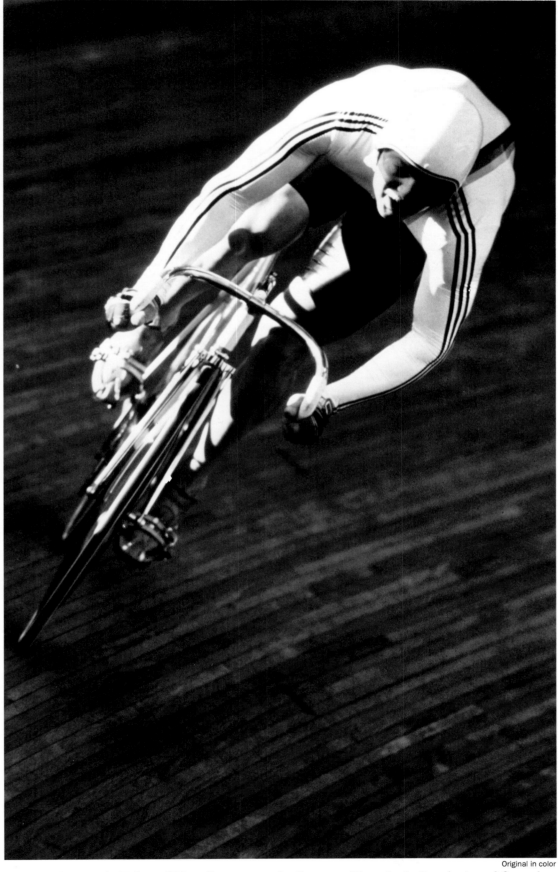

Original in color

Sprint cyclist Frank Weber of West Germany at the Summer Olympics in Seoul, viewed from the top of the velodrome.

Andre Agassi at the
U.S. Open in New
York in September.

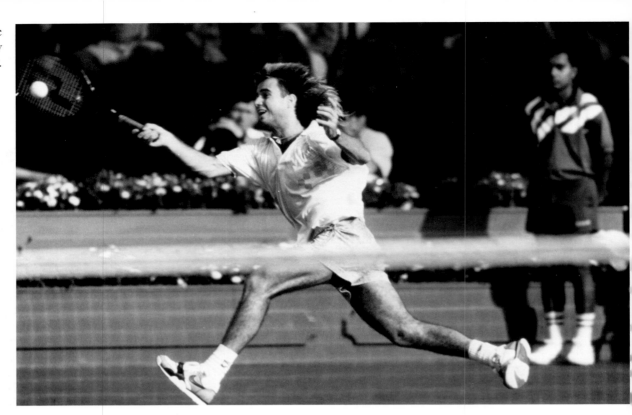

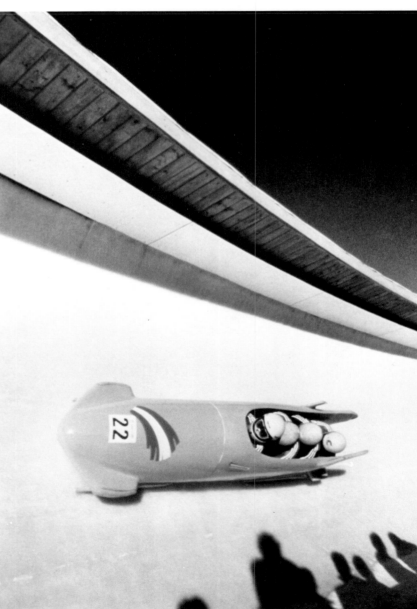

Four-man bobsled
team at the Calgary
Winter Olympics.

Original in color

Magazine Sports Portfolio / Mike Powell, First Place

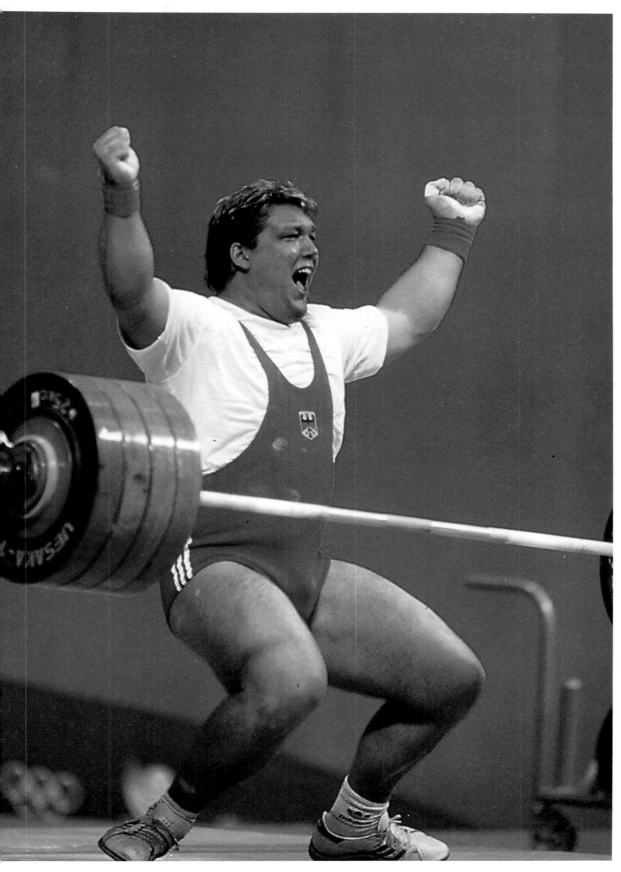

uper heavyweight Zawieja of the Federal Republic of Germany at the Summer Olympics in Seoul.

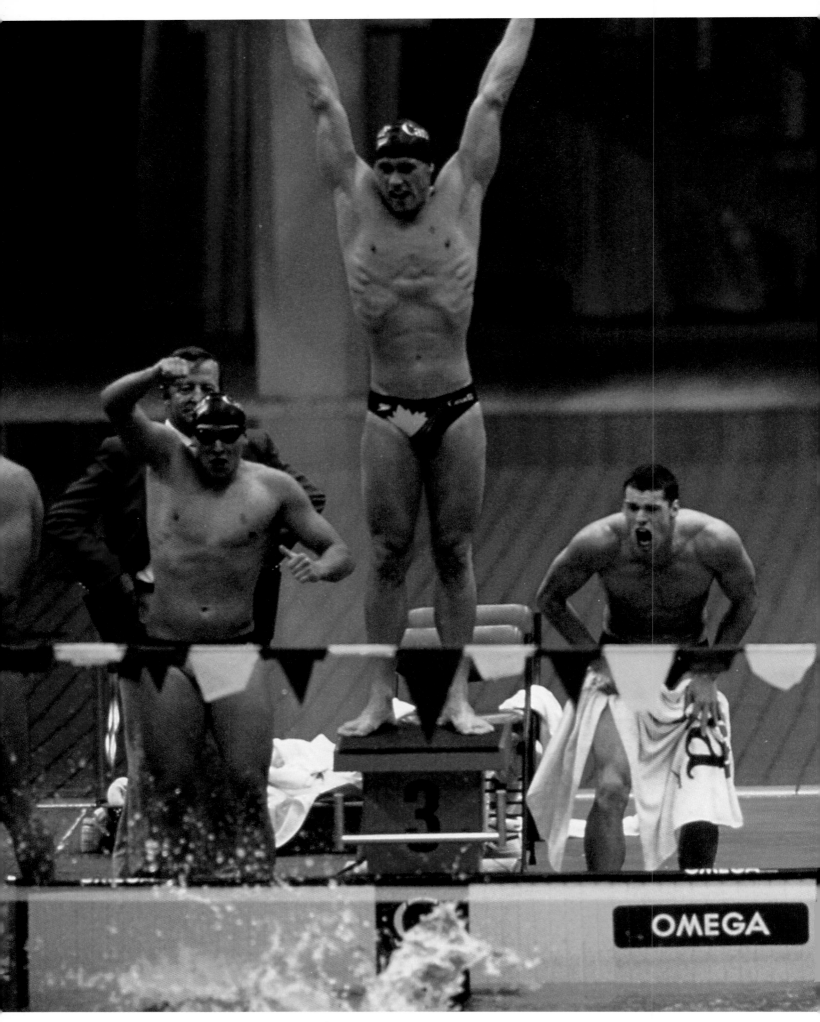

Jubilation at the finish of the Olympic 4x100 meter medley relay.

Magazine Sports Portfolio / Mike Powell, First Place

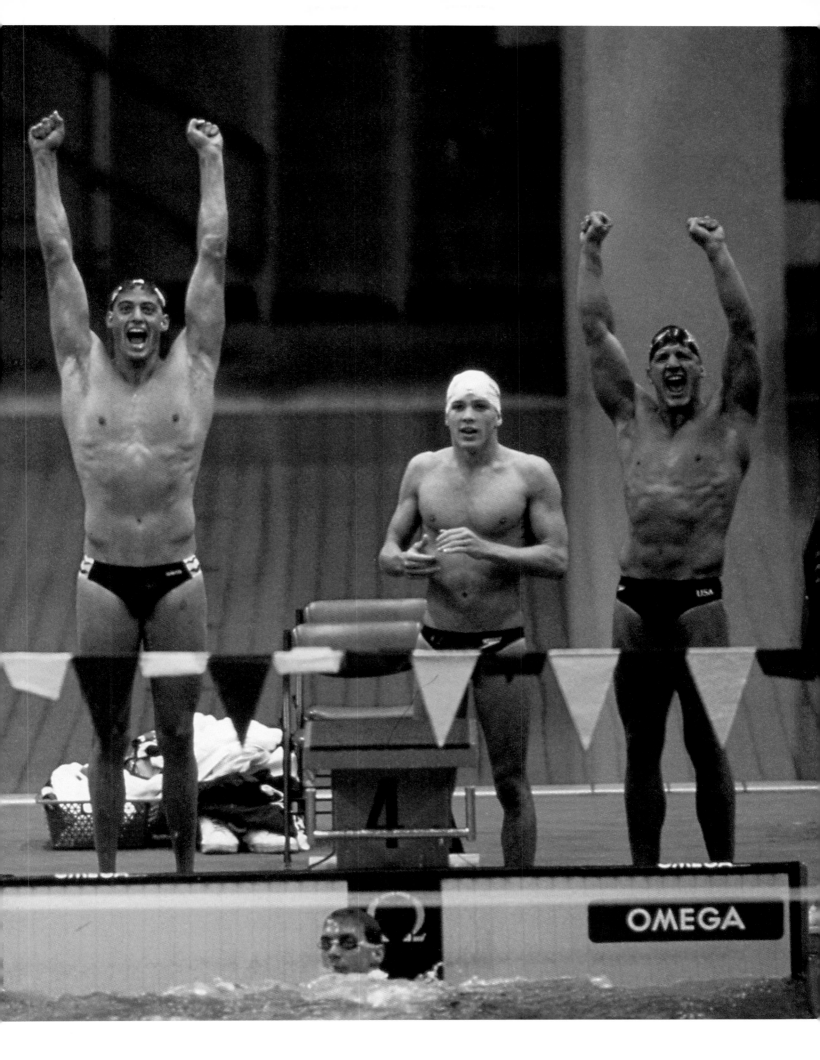

Magazine Sports Portfolio / Mike Powell, First Place

David Drapkin

Time

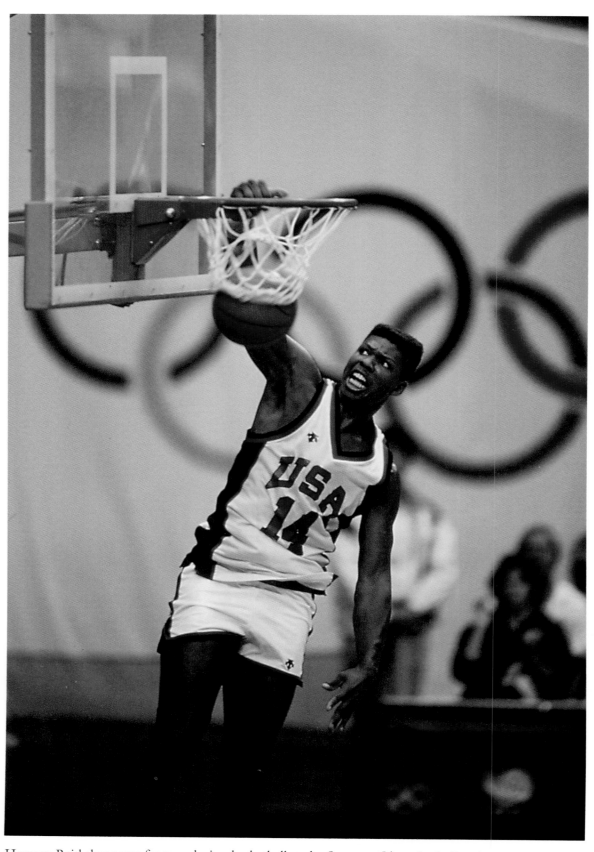

Herman Reid slams one for two during basketball at the Summer Olympics in Seoul.

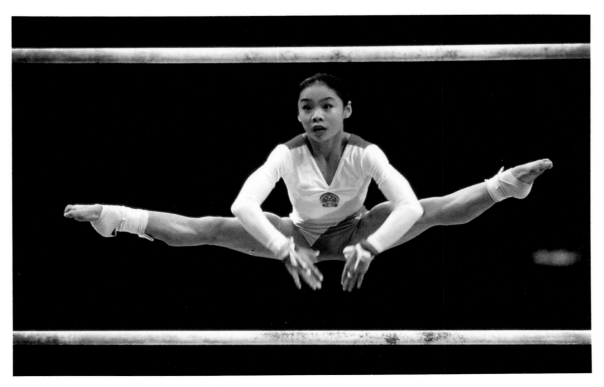

A Chinese gymnast competes in Seoul.

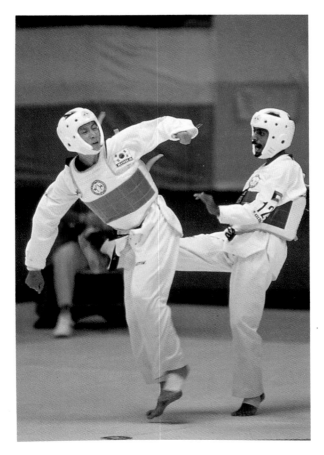

Men's tae kwon do competition: France vs. Korea.

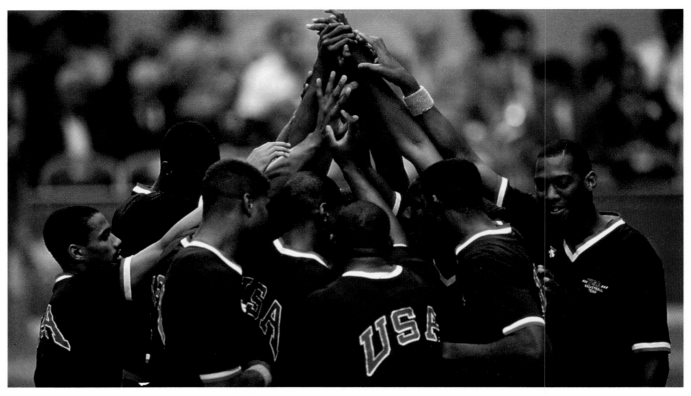

U.S. men's basketball team, Chamshil Gymnasium, in Seoul.

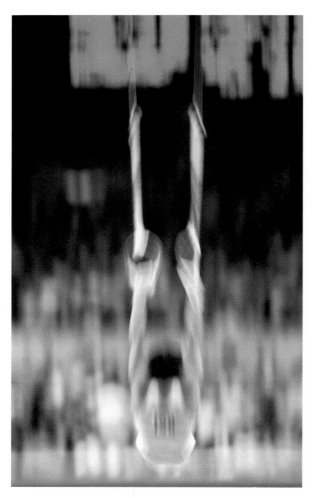

Men's gymnastic competition in Seoul.

Magazine Sports Portfolio / David Drapkin, Second Place

Myrtis Walking Eagle attends Christmas Mass in the Jesuit Mission church at Soldier Creek, S.D. / **Don Doll, Christmas in America, 1st Place (tie) in Magazine Feature Picture.**

On a holy feast day, an Ixil Indian and his son offer prayers and candles inside the church in Chajul, Guatemala. / **James Nachtwey, unpublished, 1st Place (tie) in Magazine Feature Picture.**

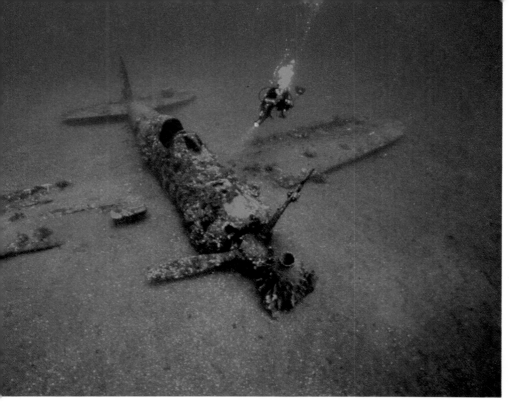

Sponges and coralline algae encrust a Japanese Zero downed in World War II in the southwestern Pacific near Rabaul, a Japanese fortress on New Britain Island. Some 200 to 300 Japanese aircraft were destroyed in and over Rabaul from October 1943 to 1944 alone. / **David Doubilet, National Geographic, 3rd Place in Magazine Feature Picture.**

A celebration of Easter in Atacama Desert, Chile, reflects an extension of European brotherhood. / **David Alan Harvey, National Geographic, Award of Excellence in Magazine Feature Picture.**

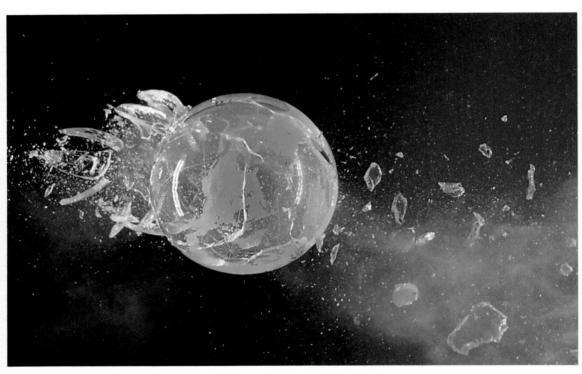

A bullet bursts through a glass globe. This illustration was a backup for the December 1988 *National Geographic* cover featuring a hologram of a shattered Earth. / **Bruce Dale, National Geographic, 3rd Place in Magazine Illustration.**

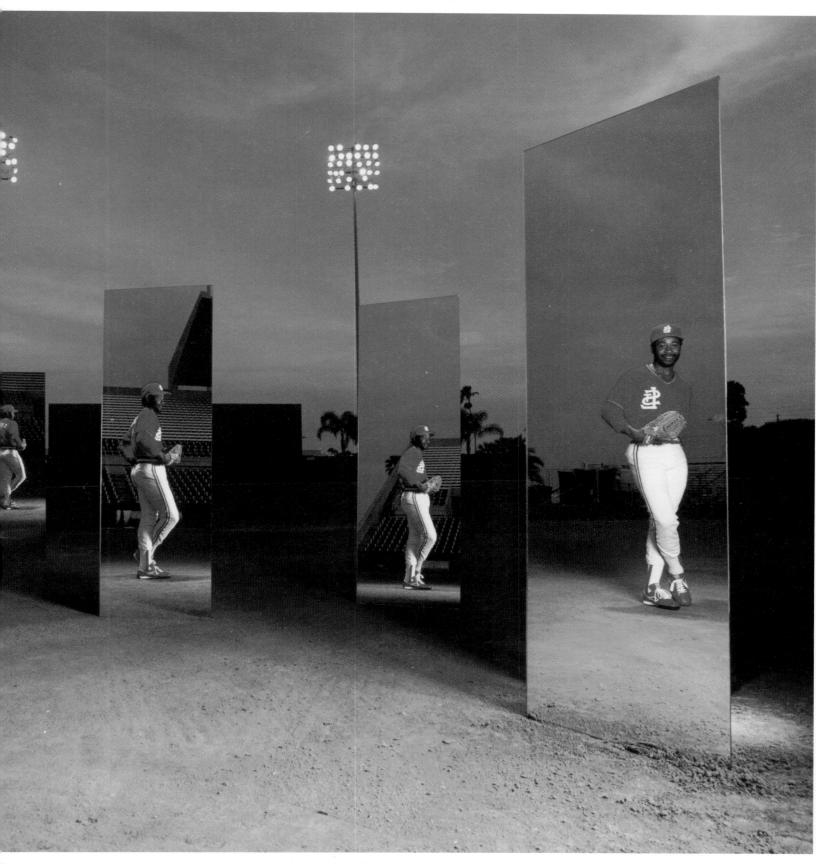

Shortstop Ozzie Smith, the wizard of the St. Louis Cardinals infield, redefines the baseball cliche of "doing it with mirrors." /
Joe McNally, Sports Illustrated, 1st Place in Magazine Illustration.

In Vacaville, Calif., the mile-long "Wooz" maze has become a craze. Challengers use flashlights to maneuver through the labyrinth, brought to America by Japanese promoters. / **Roger Ressmeyer, Life magazine, Award of Excellence in Magazine Illustration.**

Belle Island in Detroit was the location for this fashion shoot. / **Michelle Andonian, Detroit Monthly Magazine, Award of Excellence in Magazine Illustration.**

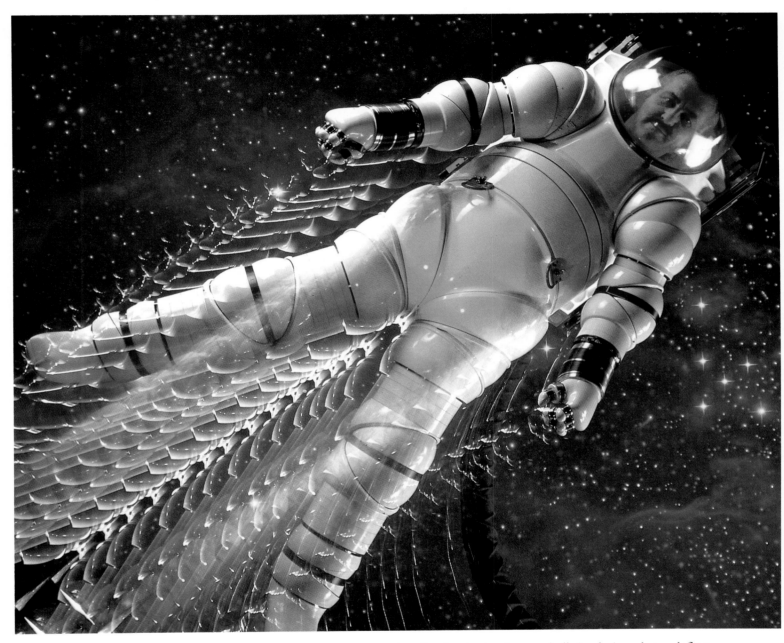

Presenting the AX-5, one of NASA's two prototype space suits. Its hard aluminum shell is designed to deflect orbital debris. The suit, worn by NASA designer Vic Vykukal, is adaptable to any body type in minutes. /
Roger Ressmeyer, Life magazine, 2nd Place in Magazine Illustration.

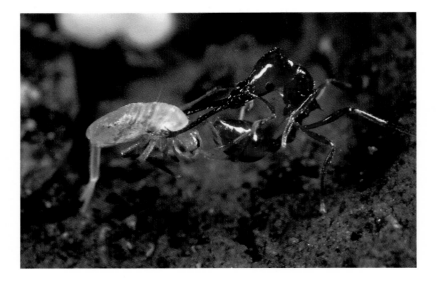

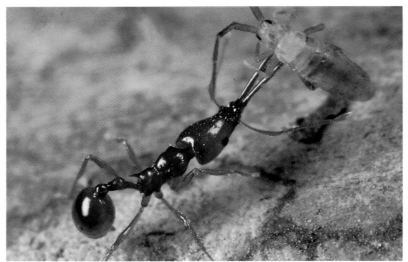

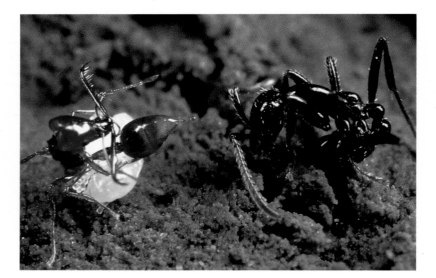

Shown under natural conditions in a Costa Rican jungle, rare and tiny (1/10th inch long) trap-jaw ants live in small colonies within dead twigs. Using a second set of jaws that resembles spring-loaded traps, they catch common but elusive springrails — the rabbits of the insect world. / **Mark Moffett, National Geographic, 2nd Place in Magazine Science/Natural History.**

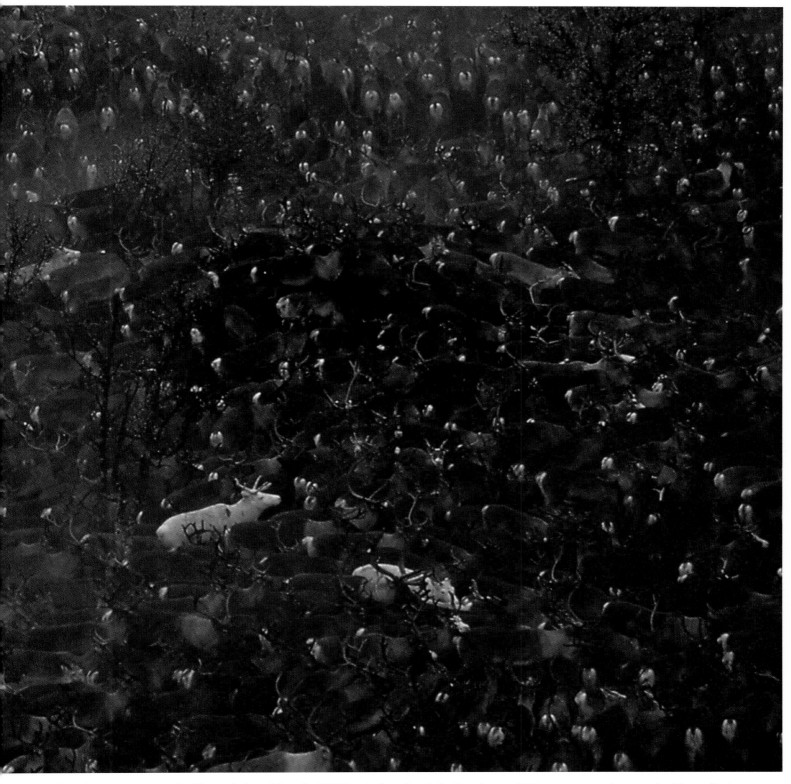

For days after the Soviet Union's Chernobyl accident in 1987, reindeer herds in Sweden and Norway were showered with radiation. Today, high levels of cesium 137 are detected in the herd. / **Karen Kasmauski, National Geographic, 1st Place in Magazine Science/Natural History.**

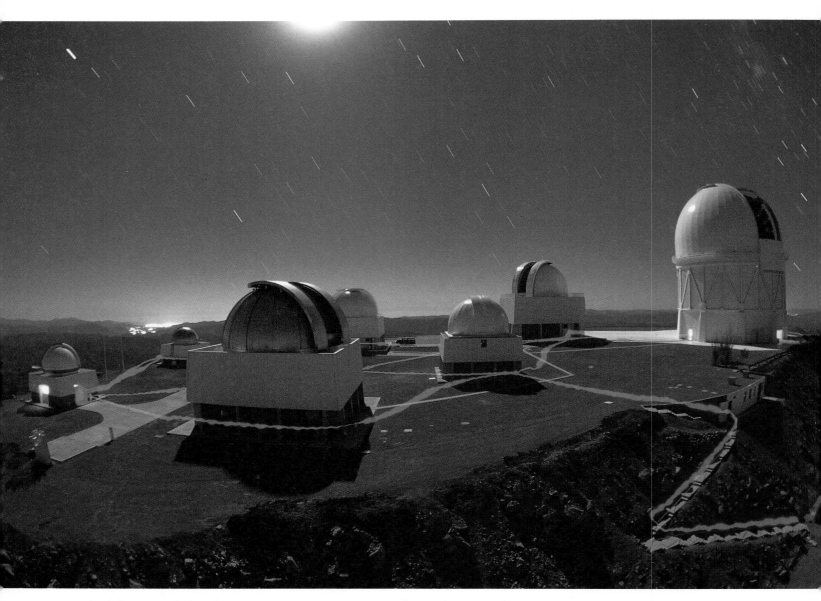

Bathed by moonlight during a 10-minute exposure from the top of a weather tower, Cerro Tololo Inter-American Observatory appears laced with trails created by red flashlights carried by astronomers to protect their night vision. The observatory is near La Serena, Chile. / **Roger Ressmeyer, National Geographic, Award of Excellence in Magazine Science/Natural History.**

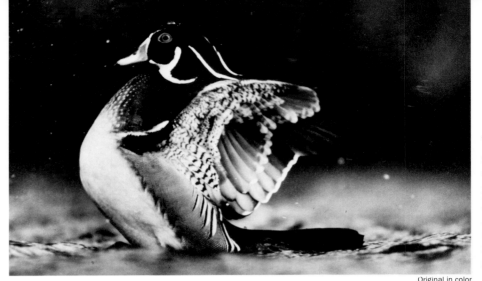

With a furious beating of its wings, a drake wood duck dries itself after a morning bath on Shawaga Lake, northwest of Ely, Minn. / **Dr. Scott Nielsen, National Wildlife Magazine, 3rd Place in Magazine Science/Natural History.**

Original in color

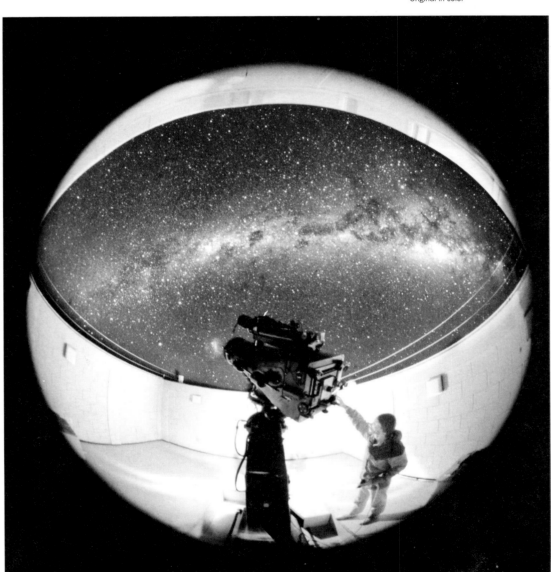

Original in color

Using the discovery telescope, Ian Shelton observes the Milky Way and Supernova 1987A, the brightest exploding star seen from Earth in 400 years. Shelton discovered the supernova as University of Toronto's resident observer at Las Campanas Observatory, north of La Serena, Chile. / **Roger Ressmeyer, National Geographic, Award of Excellence in Magazine Science/Natural History.**

Donna Ferrato
Life

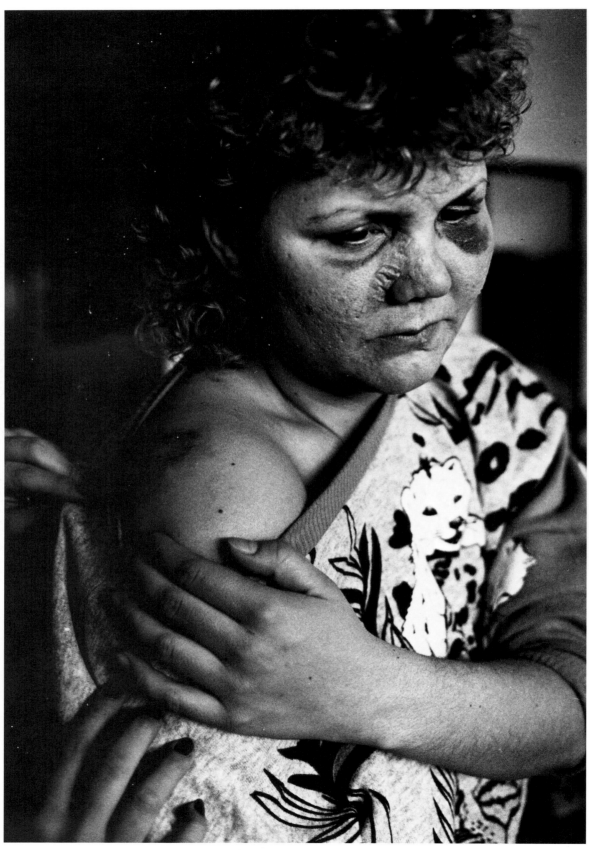

Jane, a victim of domestic violence, is slowly healing one week after a beating. "The police didn't charge him with a felony," she says. "He didn't break any bones."

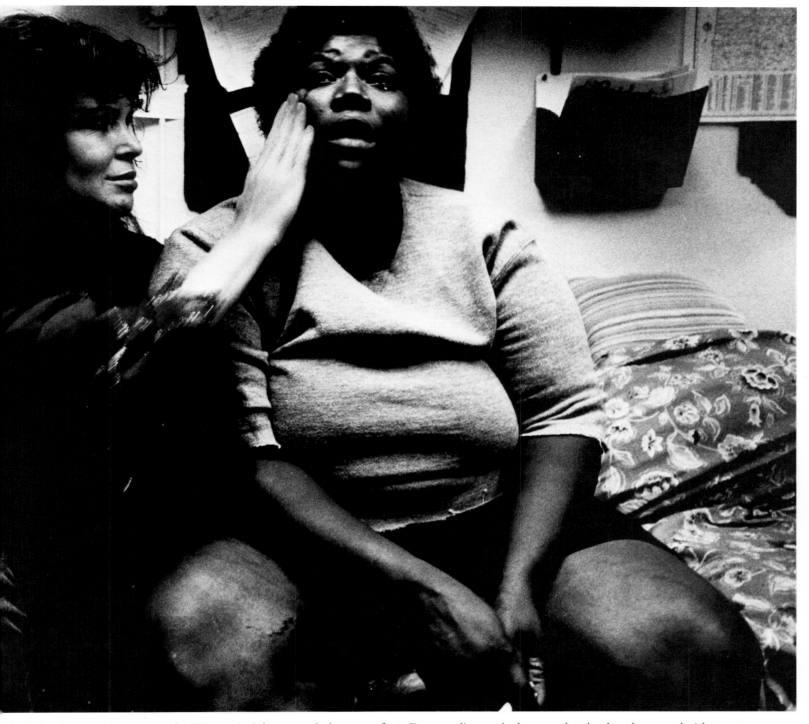

Rachel, a battered woman at the Women's Advocates shelter, comforts Donna, distraught because her husband swore she'd never get custody of their children.

Domestic Violence

Each year, almost 4 million women are victims of domestic violence in the United States. More than 1 million of them seek medical treatment, making battery the largest cause of injury to women in this country.

The first shelter for these victims started in a rented apartment in Minneapolis in 1974. Women's Advocates is now one of more than 1,000 such centers, offering refuge to women with nowhere else to turn.

The staff, many of them formerly battered wives, tries to help the women understand that they do not have to accept violence in their lives. "A battered woman often thinks nothing like this ever happened to anyone but herself," says psychologist Cheryl Beardsley, one of the founders of Women's Advocates. "In a shelter you escape that myth."

A 1984 Minneapolis study showed that arrest is the most effective deterrent to men who batter. But many times the woman is afraid to prosecute, for fear the man will return and hurt her worse. It's a valid fear. The FBI reports that in 1986, almost a third of all female homicide victims were killed by their husbands or boyfriends.

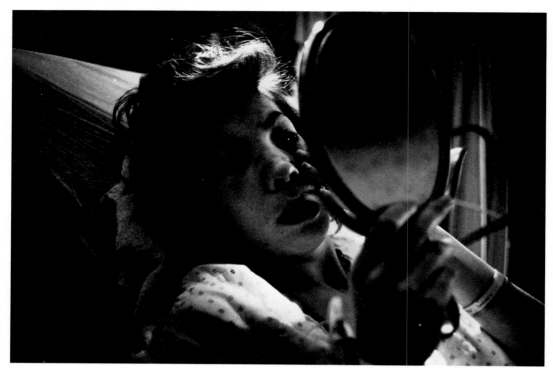

"I guess I don't look too bad," Diane Brown tells herself as she looks at her face two days after her boyfriend ran over her with his van.

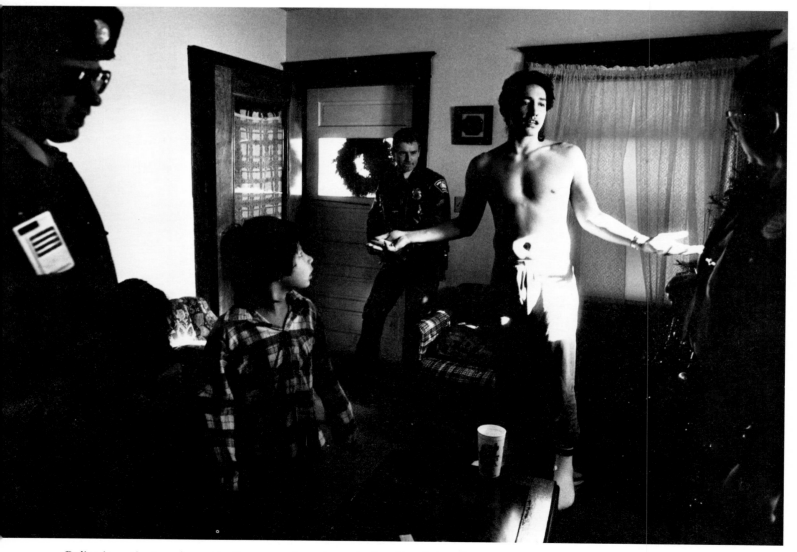

Police investigate a domestic dispute, only to hear the boyfriend deny beating the woman he says he loves.

Magazine Picture Story / Donna Ferrato, First Place

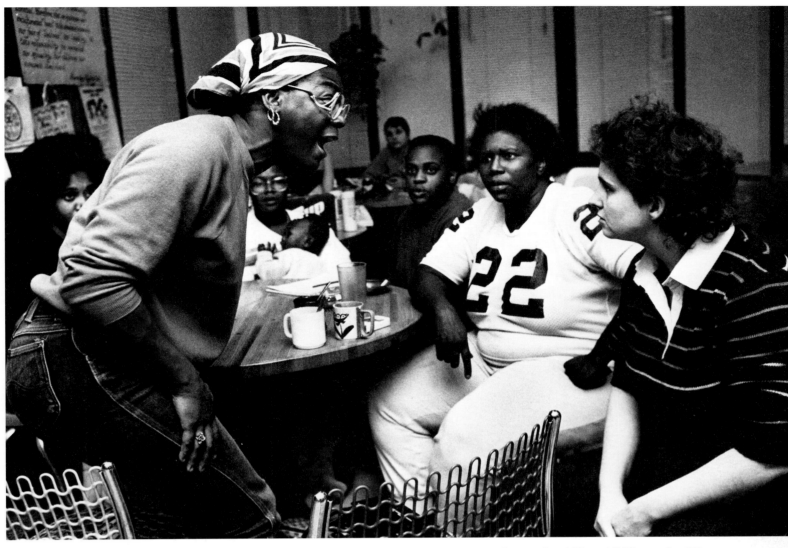

At the shelter, one woman yells at another, "What does he have to do to make you understand ... kill you?" The reply: "You are here for the same reasons I am. I don't think you are in a position to judge me."

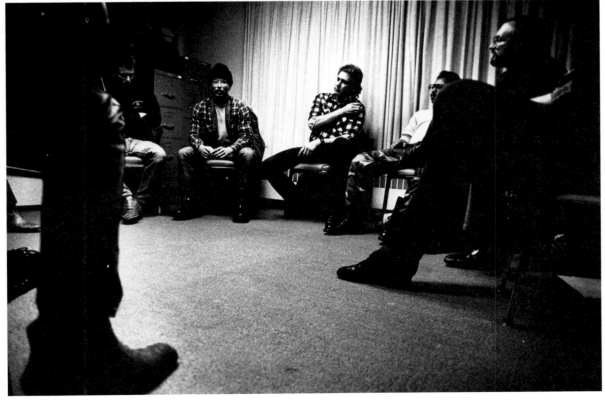

A group discusses the violence they have aimed at the women they say they love. Whether batterers can change their behavior is questioned, and only about 2 percent do so.

Magazine Picture Story / Donna Ferrato, First Place

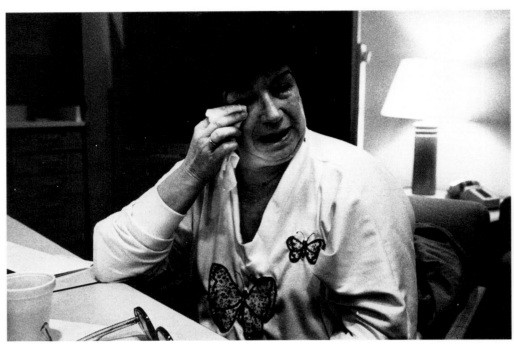

Jo Ann Hennum, in prison for killing her abusive husband, says, "My first night in jail was the first rest I'd gotten in nine years."

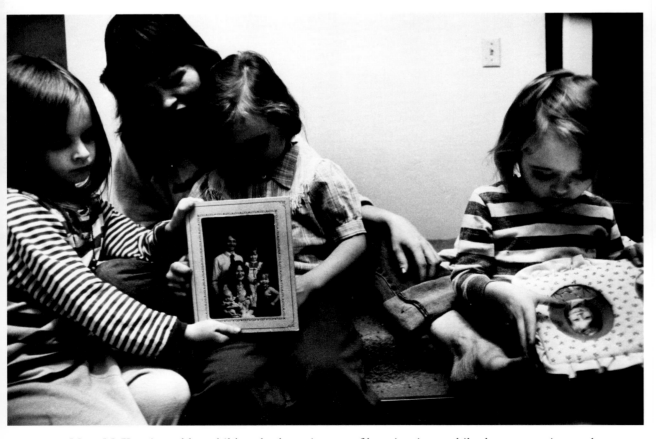

Mary McKenzie and her children look at pictures of happier times while they are staying at the Women's Advocates shelter. One of the children explains, "This is what we looked like ... before the police arrested Daddy for hurting Mommy."

Magazine Picture Story / Donna Ferrato, First Place

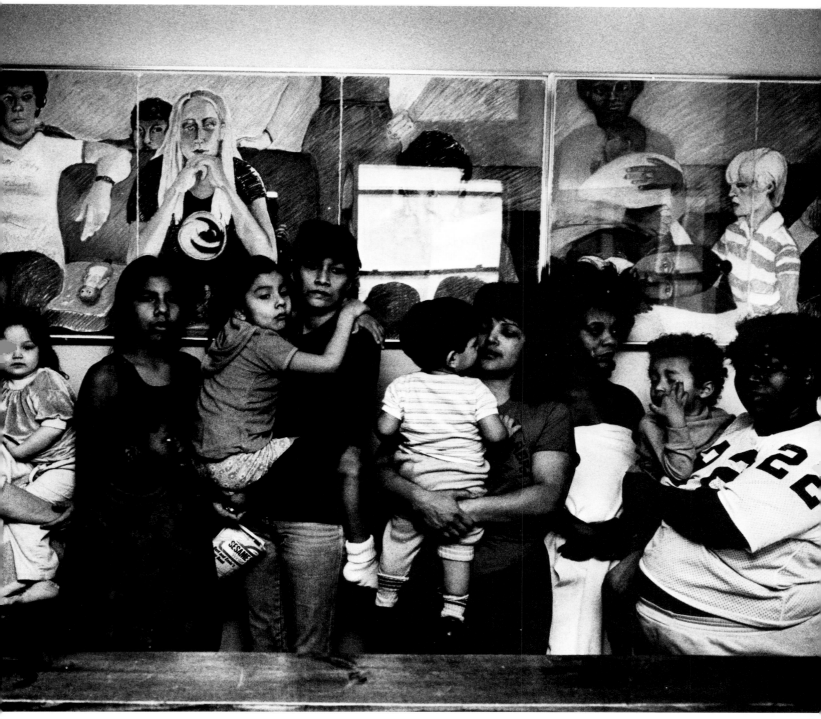

Despite the work of counselors at the shelter, many women return to abusive men. "Often the fear of being beaten is not as strong as the fear of losing him and being out on her own and unable to take care of the kids," says Minneapolis police officer Gayle Cronquist.

Merry Alpern
Daily News Magazine, New York

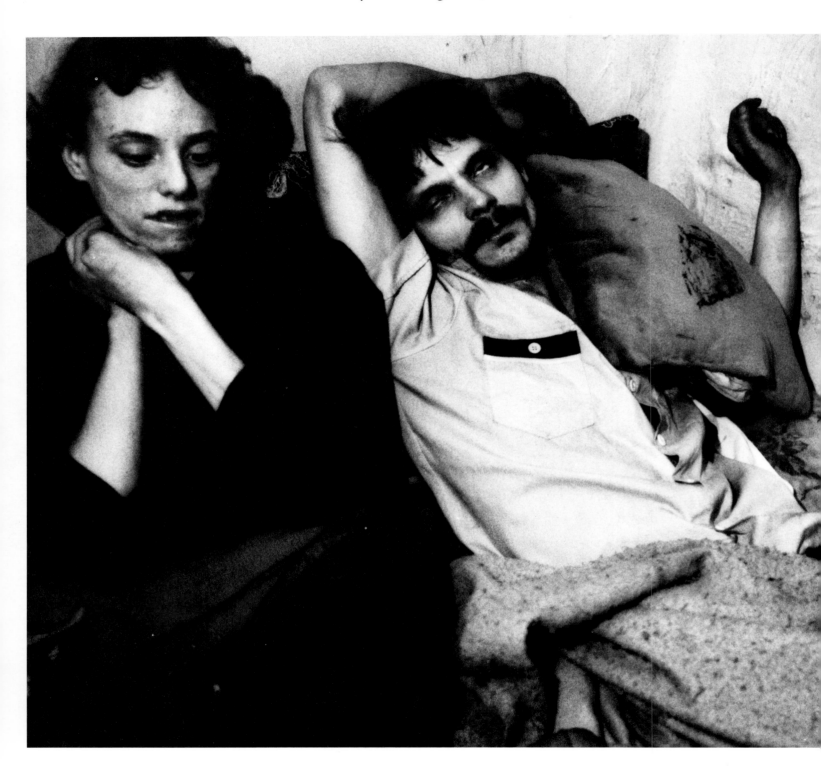

A.J. and Jim Bob

A.J. and Jim Bob, both 24, have been a couple since age 12. Small-town Ohio castoffs, they came to New York City in search of wealth and excitement. Now they are crack addicts, living in a squalid, city-owned building on Manhattan's upper West Side.

A.J. still has her dreams, and often speaks of a desire to get off drugs, marry Jim Bob, have her tooth fixed and move to another apartment. Meanwhile, her health deteriorates while her craving for crack increases.

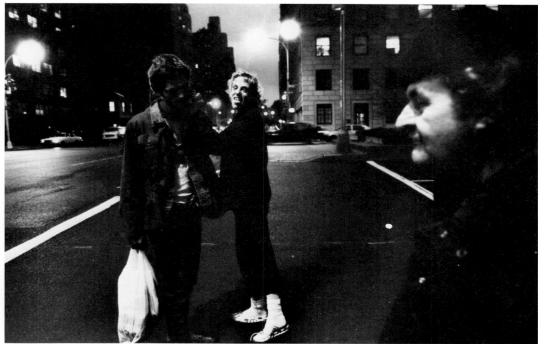

Jim Bob carries a plastic bag of cans he collects for money, while A.J. works a street corner as a prostitute. The other man is Eddie, one of her steady customers.

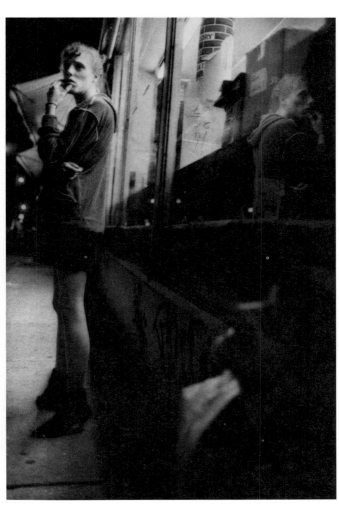

A.J. often prefers the activity of the street at night to the loneliness of her apartment.

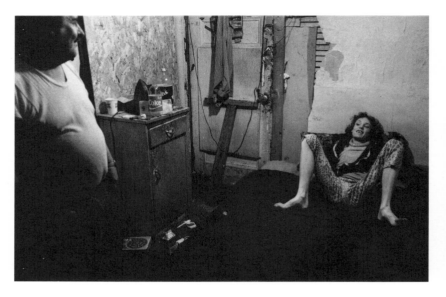

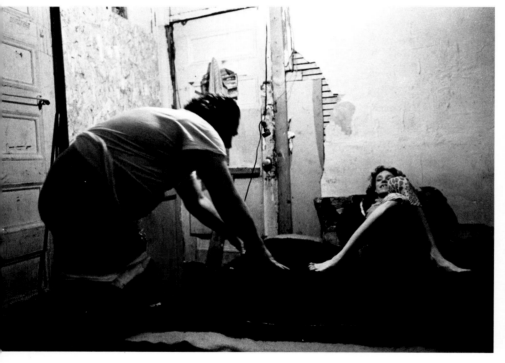

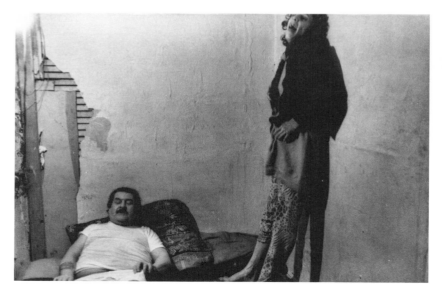

In her apartment, A.J. teases Eddie as he undresses. "Come and get it," she says. After giving him oral sex, she jumps on the bed, happy to have earned $10. Later, she uses the money to buy some crack and gets high.

Magazine Picture Story / Merry Alpern, Second Place

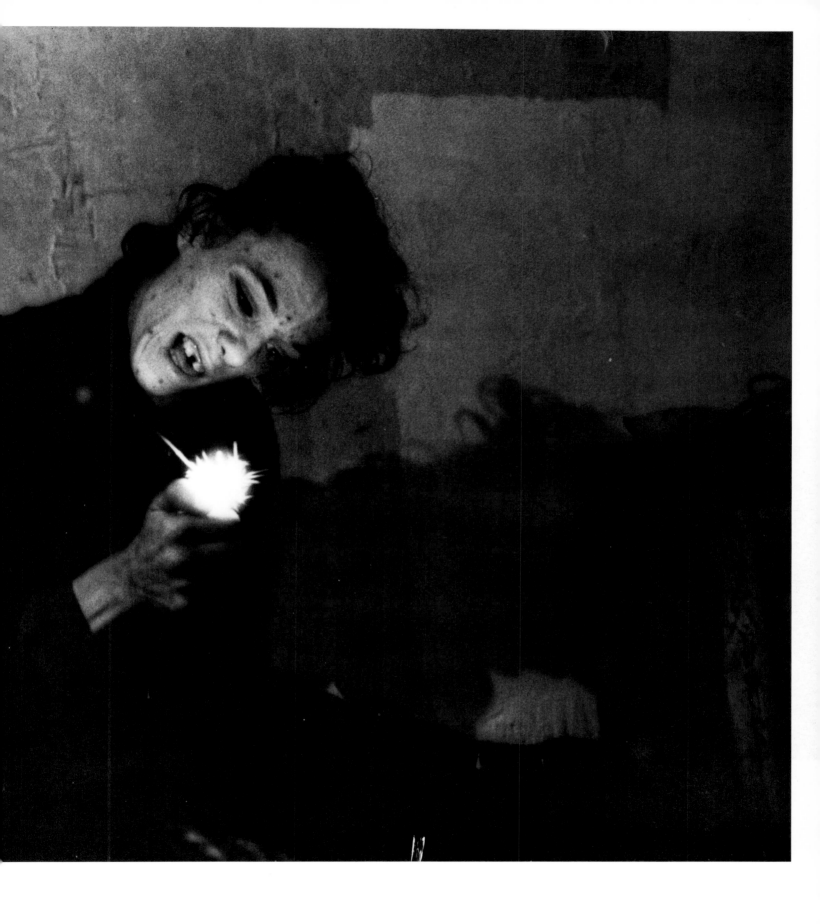

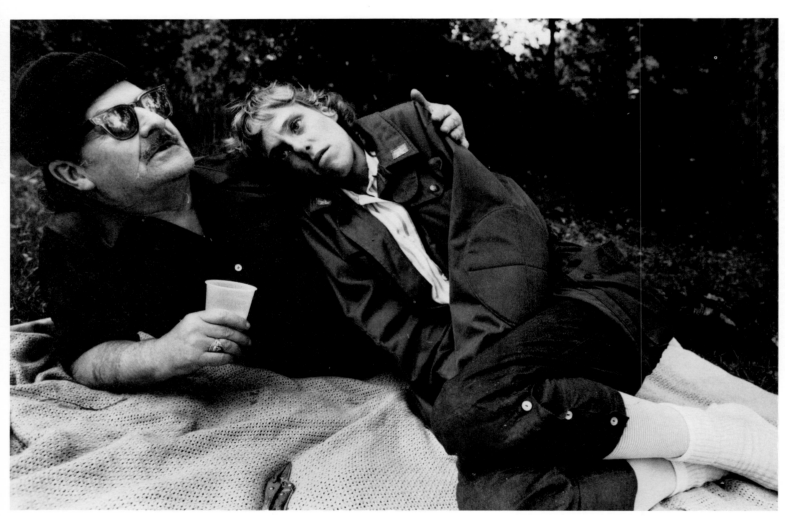

After a long night, A.J. rests with Eddie in Central Park.

Magazine Picture Story / Merry Alpern, Second Place

Peter Turnley
Newsweek

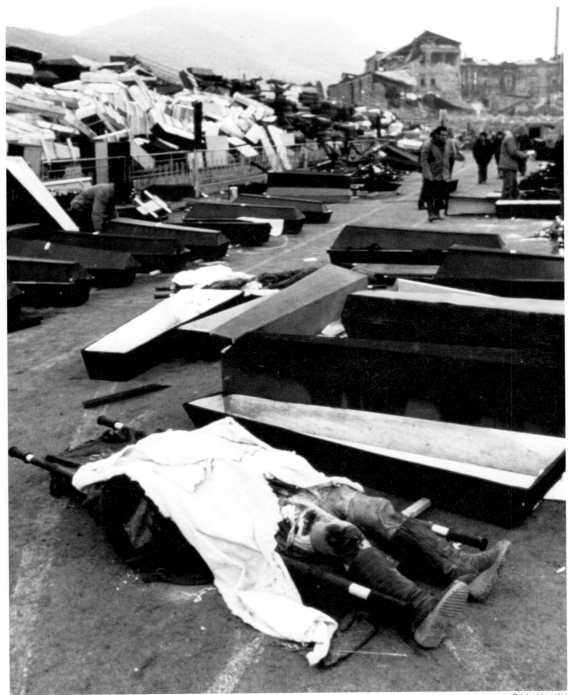

Original in color

Original in color

Death in Armenia

Makeshift mortuaries are set up in Spitak, Soviet Armenia, after an earthquake leveled cities and killed about 25,000 people. The town of 16,000, at the quake's epicenter, was destroyed, and widespread damage occurred in Leninakan and Kirovakan, Armenia's second- and third-largest cities.

The 30-second temblor on Dec. 7 left a half-million people homeless, and tent cities were set up throughout northwestern Armenia.

The planned two-year reconstruction process will cost $13 billion and include the building of physical-therapy centers for people requiring rehabilitation.

A Soviet soldier at a Leninakan cemetery mourns the death of his brother. *Below,* two men discover the body of their brother and prepare him for burial in Spitak.

Original in color

Original in color

Magazine Picture Story / Peter Turnley, Third Place

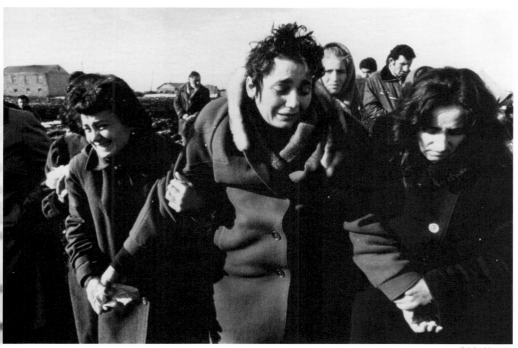

A widow is comforted by two women at her husband's funeral in a village near Leninakan. *Below*, others stand near the grave.

Original in color

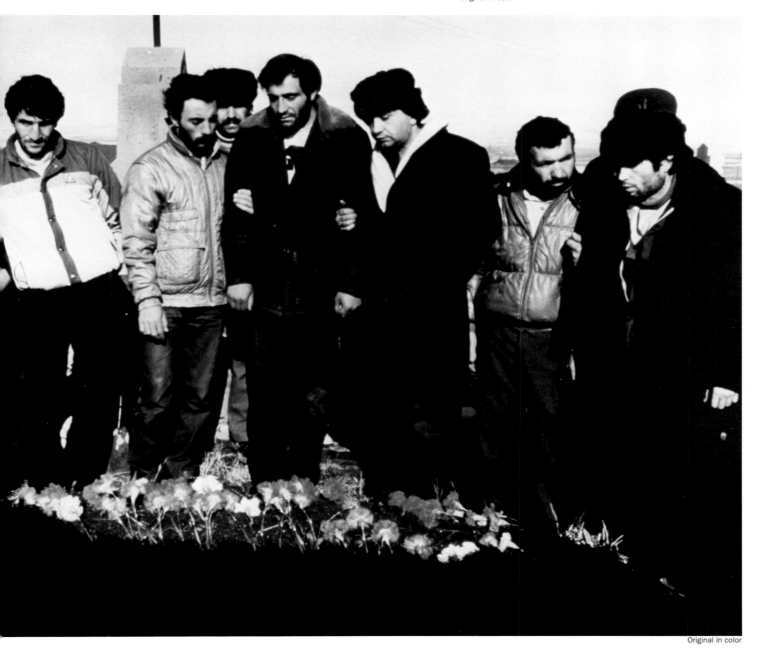

Original in color

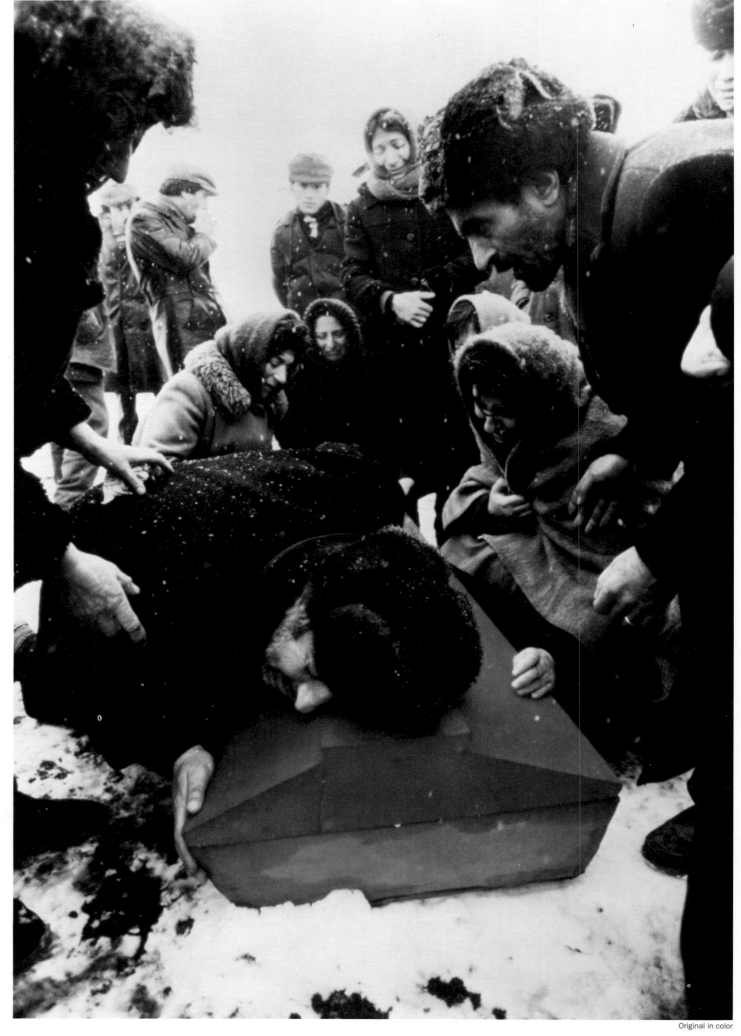

Original in color

Magazine Picture Story / Peter Turnley, Third Place

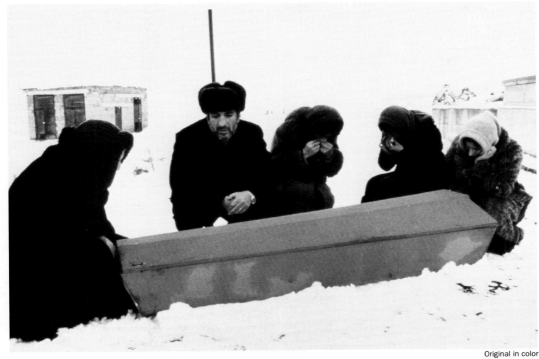

An Armenian family grieves at the funeral of a 17-year-old boy in Leninakan.

Original in color

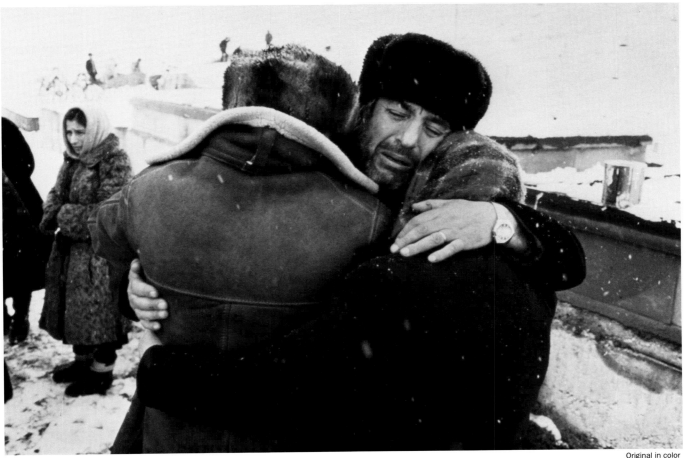

Original in color

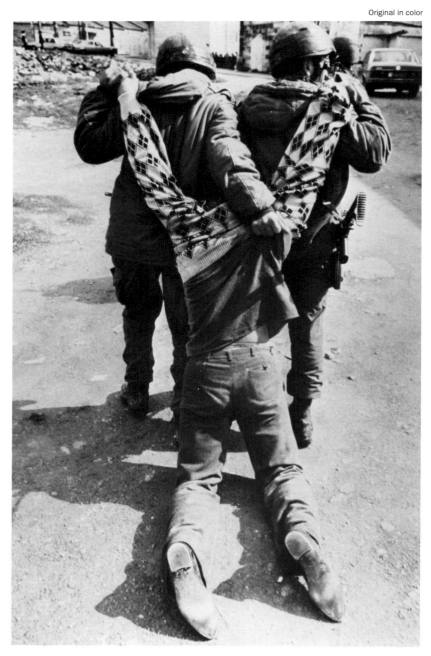

Original in color

Israeli soldiers drag an unconscious Palestinian fighter away after a beating in Ramallah on the West Bank. / **Peter Turnley, Newsweek, Award of Excellence in Magazine Picture Story.**

Original in color

Above, Panama's strongman General Manuel Noriega attends a political rally in San Martin. *Right,* anti-Noriega protesters battle riot police from a rooftop. / **Both by Christopher Morris, Black Star, Award of Excellence in Magazine Picture Story.**

Original in color

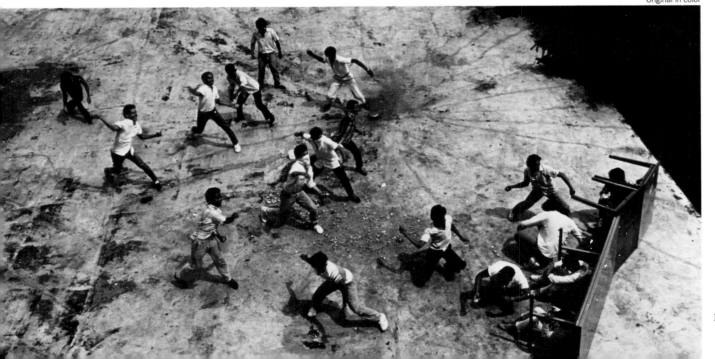

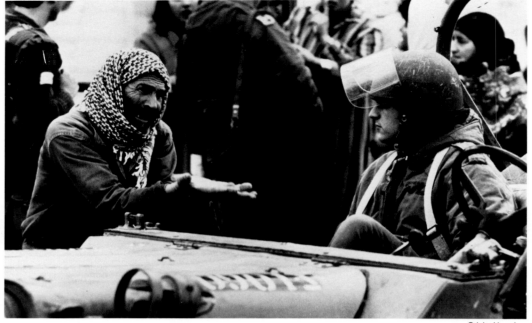

Original in color

A Palestinian father pleads with an Israeli soldier to release his son, who was arrested in clashes in Ramallah on the West Bank. / **Peter Turnley, Newsweek, Award of Excellence in Magazine Picture Story.**

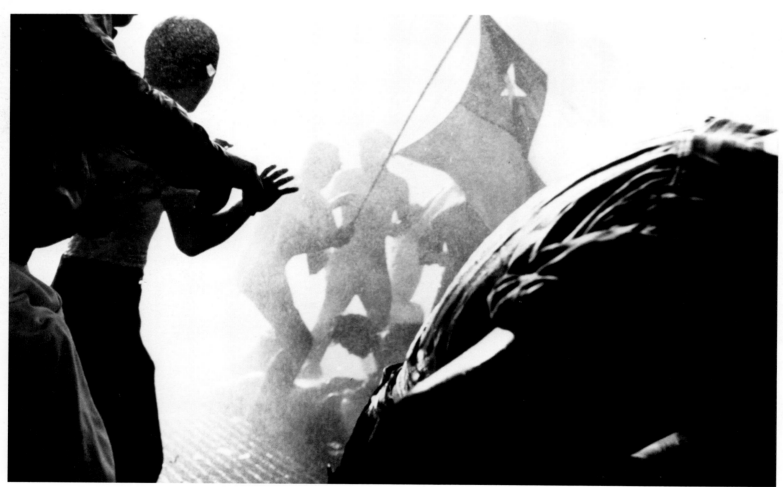

Original in color

Demonstrators in Santiago, Chile, recoil from water cannons and tear gas fired by forces of Gen. Augusto Pinochet. / **Anthony Suau, Black Star, Award of Excellence in Magazine Picture Story.**

Genaro Molina

The Sacramento Bee

Nikki Goldfoot waits to be picked up at the corner of Austin and Polk streets in San Francisco.

Runaway: Teen-age Prostitute

In San Francisco, an estimated 2,000 teen-age runaways are either prostituting themselves or selling drugs to survive. Nikki Goldfoot is an 18-year-old from Portland, Ore., who has been trading sex for money or drugs since he was 13.

Nikki says he has turned about 2,000 tricks. When he was 15, he was earning enough money as a male prostitute to rent an apartment, but now he is homeless, selling himself for a place to sleep.

Like many runaways, Nikki is a fugitive. He uses an alias among his street friends, and there is a warrant out for his arrest.

"Money, money, money. That's all you have in your mind," Nikki says, before getting into a customer's Peugeot on Polk Street.

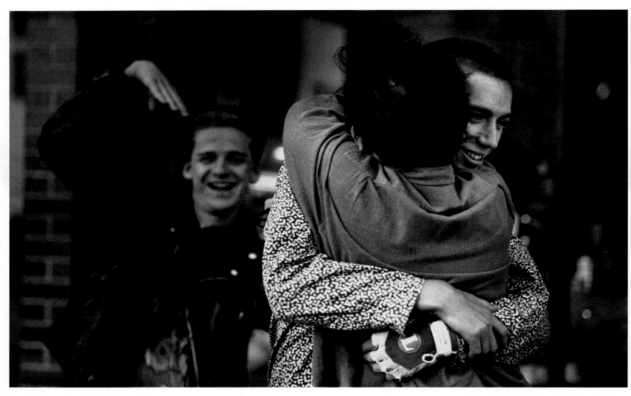

Above, Nikki gets a hug from a fellow runaway, also from the Portland area. When a local health clinic hands out condoms, Nikki puts one over his head and clowns around for friends. Nikki, who has tested false positive for the AIDS virus, says he uses a condom with some of his customers.

Newspaper Feature Picture Story / Genaro Molina, First Place

A man who goes by the name Alexis lets Nikki stay at his apartment in return for sex.

As another day ends, Nikki waits on a corner for customers.

Lois Bernstein
The Sacramento Bee

The Dark Side of Light

Sunrise in Jim and Kim Harrison's household means it's time to draw the shades and lock the doors, so that their two small daughters cannot sneak outside to play in the sunny skies of Vallejo, Calif.

Both girls were born with xeroderma pigmentosum, a rare disease that offers their skin no protection from the effects of ultraviolet light. The disease results from a genetic fluke, a combination of genetic deviations in both parents. The odds against being born with it are a million to one; the hope of surviving is nil.

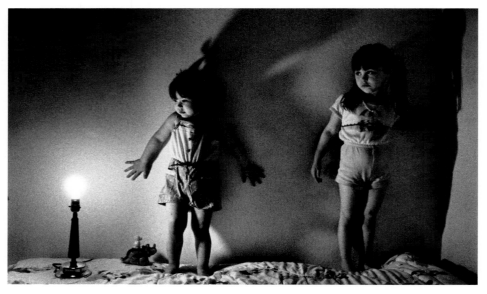

Sunlight is their enemy, yet light holds a special attraction for Sherry, left, and Jaime Harrison, who must spend their lives indoors during daytime.

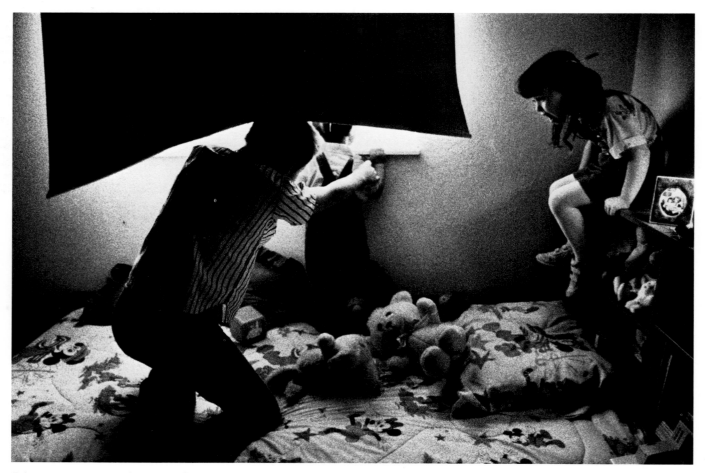

Jaime screams, "get her out of the window," as brother Robert reaches for Sherry, who has tried to sneak a look at the world outside the prison of her home.

With no genetic protection from the sun, Sherry and Jaime must spend their lives in darkness. And their lives will be short. Their mother already sees the telltale spots on Jaime, spots that forebode of the skin cancer that will kill her daughters.

But Kim has promised herself that her children won't die in the darkness they're forced to live in. "When I find out I'm going to lose them anyway, it won't be in this dark house," she says. "I'll take them to the beach."

Sherry wears a helmet with reflective film to screen her face during a daytime trip. This cuts her vision, so her mother must guide her.

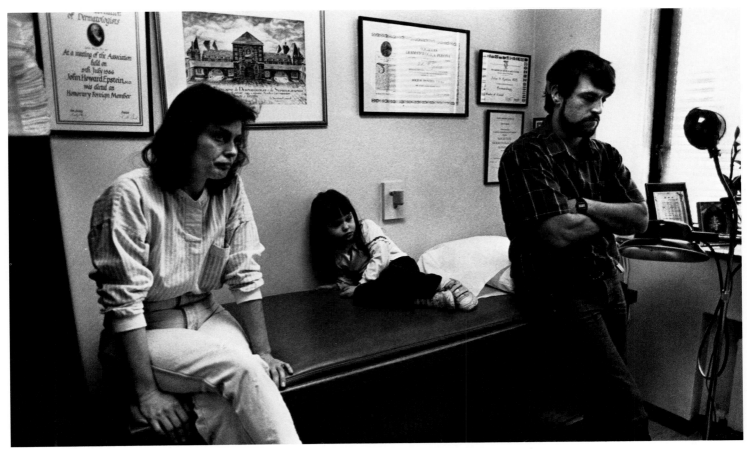

Kim and Jim Harrison take Jaime to a dermatologist in San Francisco, a tiring, frustrating trip. They wait a long time and learn nothing new.

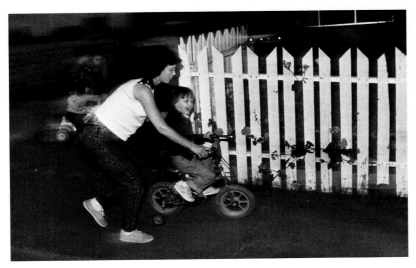

The only time the girls can play outside like other children is at night. Kim helps Jaime ride downhill on the sidewalk in front of their house.

Michael Patrick
The Knoxville News-Sentinel

A Legacy of Hope

Four months before her birth, Hope Mount's parents, Rick and Kay Mount, learned that she would be anencephalic, a malformation of the skull in which all or part of the brain is missing.

Rather than aborting the fetus, the Knoxville, Tenn., couple decided to have their first child.

Hope lived only 59 days, but her parents called each day a blessing. Knowing Hope's condition was terminal, they allowed doctors to videotape her life and perform tests on her.

Photographer Michael Patrick chronicled the last 49 days of Hope's life for The Knoxville News-Sentinel.

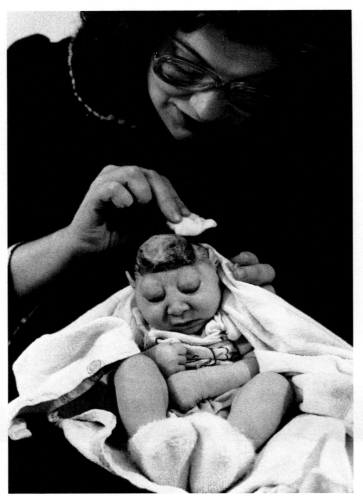

Kay Mount cleans Hope's encrusted lobal tissue.

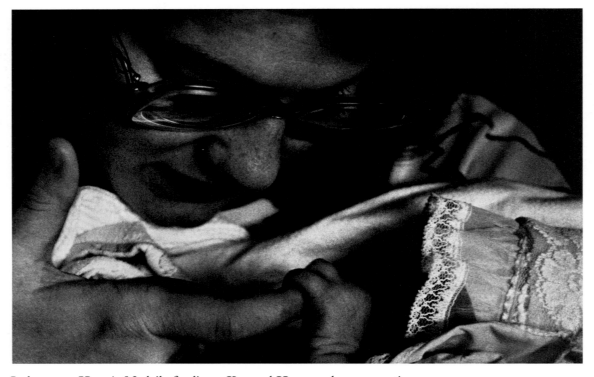

In between Hope's 12 daily feedings, Kay and Hope exchange greetings.

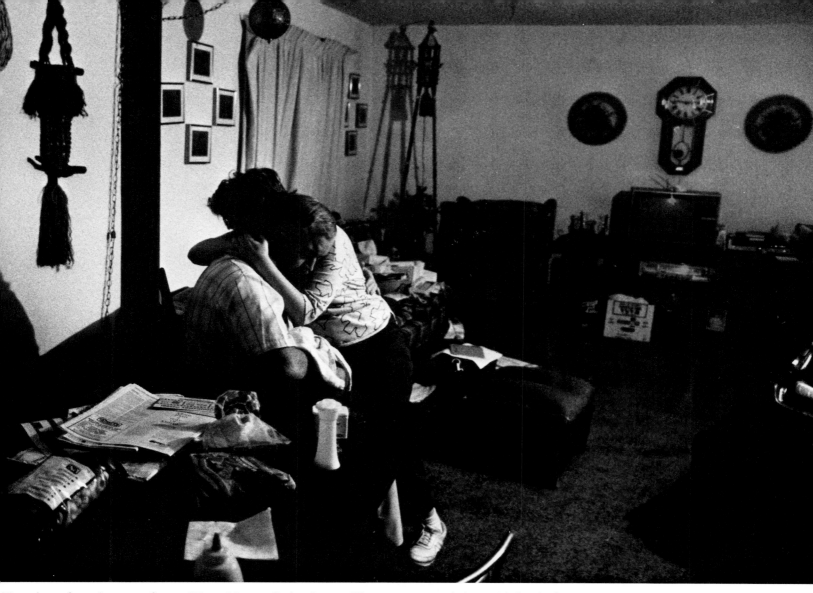

Two days after a battery of tests, Hope Mount died at home. Her parents spend time with her before going to the hospital.

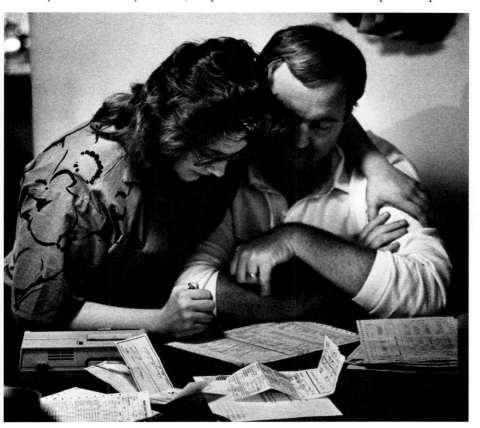

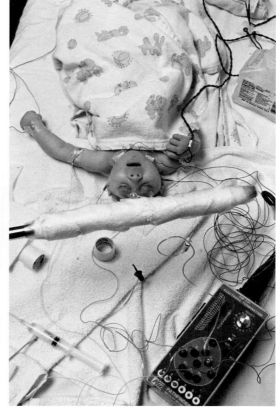

Rick and Kay look over bills after others are asleep. *Right*, Hope undergoes a battery of tests a month and a half after her birth.

John Kral
The Miami Herald

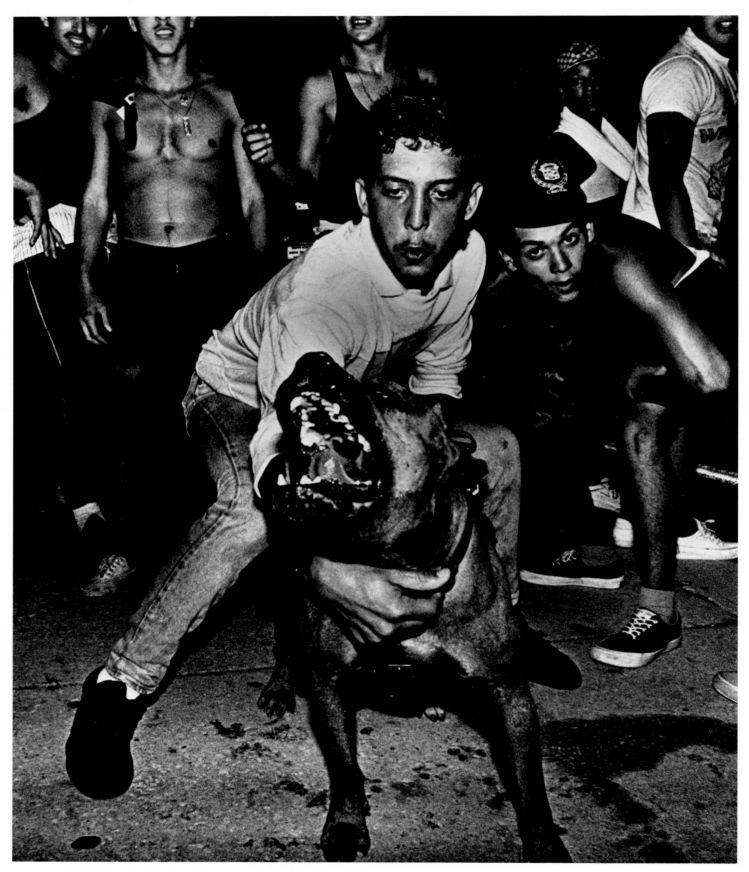

A member of a Miami gang shows off his prize dog during the summer of 1988.

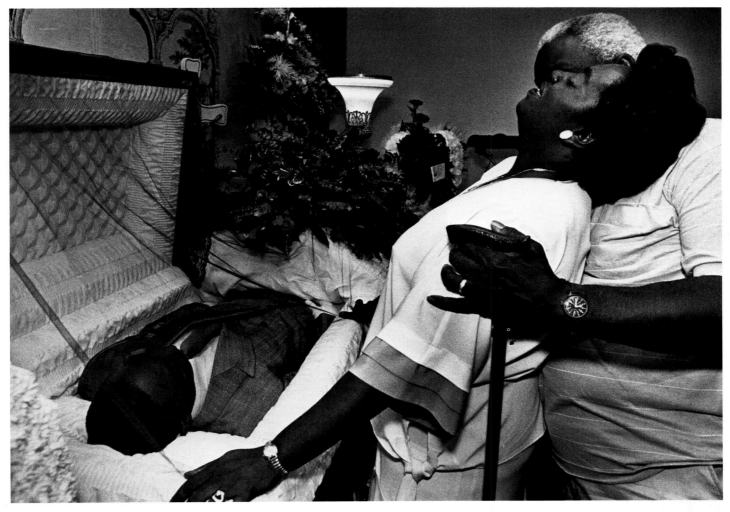

The price of childsplay: A Miami family grieves over the body of Darren Bibbs, a bystander caught in the crossfire.

Miami Gangs

On a hot August night in Miami, two gangs known as the Latin Kings and the International Posse rumbled in Coconut Grove. Photographer Jon Kral, who had been covering the random violence of the Miami gangs during the summer, was in the midst of the action.

"I saw guys with hair up on back of their necks, like snarling dogs," he remembers. "I held myself in the shadows, and then it started to happen. The fight exploded into the street."

When the police arrived, Kral was arrested. His cameras were thrown to the ground, and the film exposed. When Joel Achenbach, the reporter with Kral, protested, he too was arrested.

But the photographs Kral had taken over the months were not lost. They portray youths lost in a senseless cycle of make-believe war with all-too-real casualties, groups of teens with nothing better to do than to prove themselves tougher than the next group.

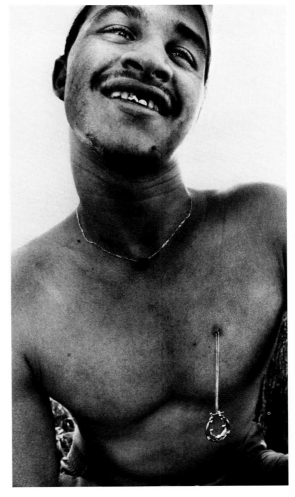

An 18-year-old Miami youth, who claims membership in the 35th Street Players gang, displays his latest proof of macho.

Joel Sartore
The Wichita Eagle-Beacon

Bobby Comes Home

Bobby Cory loved to party. A New Yorker for 11 years, he knew all the gay bars and the slummy East Side where he could score speed and cocaine. He was, he knew, at high risk of contracting AIDS.

Cory ignored signs of the early stages of acquired immune deficiency syndrome, but he couldn't ignore the symptoms of pneumocystis pneumonia — a primary indication of AIDS. Cory returned to his hometown of Wichita, Kan., and moved into Eades House, a house for AIDS patients established by the Wichita AIDS Task Force. He lived the last months of his life there, comforted by the support of his family and a group of volunteers.

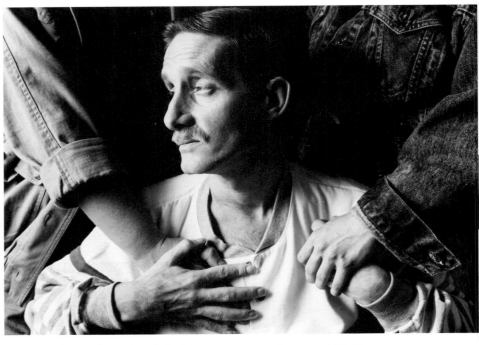

At 36, suffering from AIDS, Bobby Cory comes home to Wichita and support.

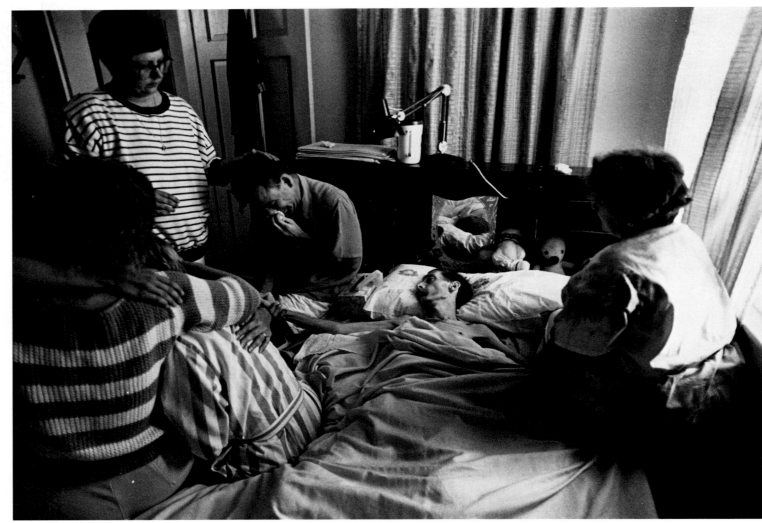

At 2:20 p.m. on June 29, Bobby dies quietly and without pain, surrounded by friends, family members and AIDS volunteers.

Joe Cavaretta
The Albuquerque Tribune

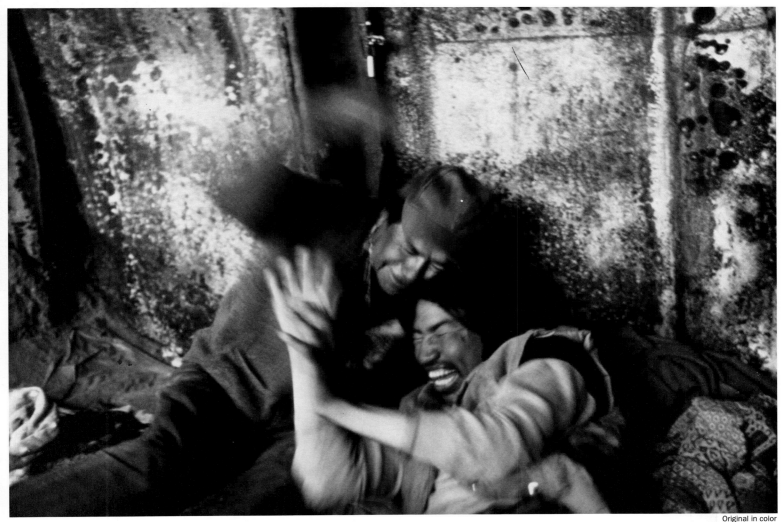

Original in color

Danny Draper and George Taylor, Navajo clan brothers and best friends, playfully fight in the "Chinle Hole," an abandoned railroad boxcar they call home. The two had just finished a gallon of Garden DeLuxe, a fortified wine bottled in Gallup.

Gallup: A Town Under the Influence

Tribune photographer Joe Cavaretta and two reporters spent three months in Gallup, N.M., for a special report dealing with Native Americans' alcohol-abuse problems in the city.

Gallup lies on the edge of the Navajo Indian Reservation, the nation's largest, and in nearly every alcohol-related statistic — drunken-driving deaths, exposure deaths, arrests — the city is five to six times worse than the national average.

Cavaretta's images appeared in a six-part, 33-page special report. After the series, 200 Gallup residents walked more than 200 miles to Santa Fe, the state capital, to seek passage of a package of alcohol-related laws. All four bills in the package were passed.

The first-place award in this category went to John Kaplan of The Pittsburgh Press for "Rodney's Crime," which appears on pages 18-21.

Original in color

Benny Largo's body lies frozen where he passed out in the Gallup Chamber of Commerce Park. The mid-April overnight temperature dipped to below freezing. Largo's blood-alcohol level was 0.425.

Original in color

Robert Silago, his pants leg ablaze, leaps out of the dumpster he was sleeping in until it caught fire.

Newspaper News Picture Story / Joe Cavaretta, Second Place

Frankie Nez, his face still bearing the scars of a recent beating from "someone I tried to rip off," mixes a batch of "Montana Gin," a concoction of Aqua Net hair spray and water that is drunk on the streets of Gallup on Sundays, when no alcoholic beverages can be purchased.

Original in color

The body of 15-year-old Lisa Platero lies on the seat of a car after a rollover on N.M. 666, "the devil's highway." The impact of the accident crushed the beer can that was clenched in her hand between her legs.

Original in color

A doctor in Leninakan works furiously on one of the quake's survivors.

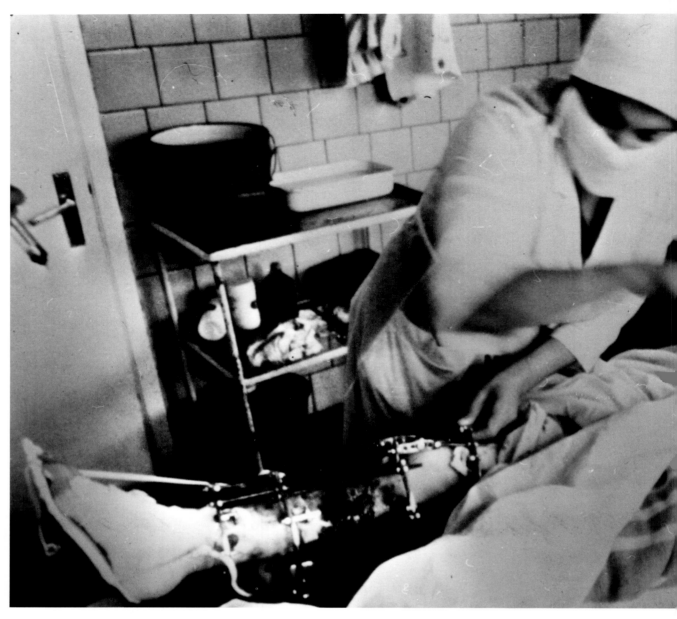

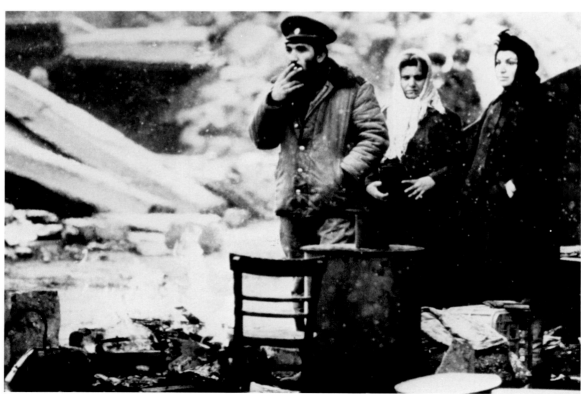

A soldier and his family stand near a fire in the streets of Leninakan. Their apartment building was destroyed.

Newspaper News Picture Story / David C. Turnley, Third Place

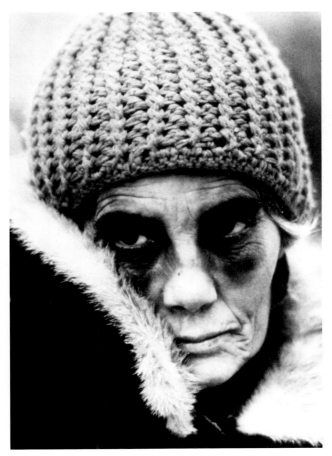

David C. Turnley
Detroit Free Press

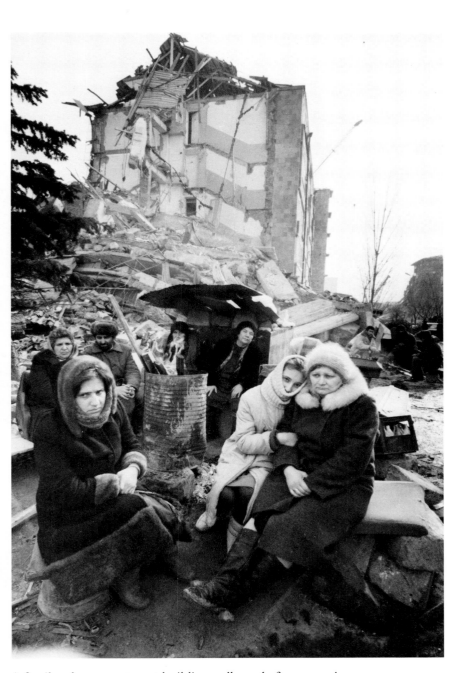

A family whose apartment building collapsed after a massive earthquake in Soviet Georgia sits in the street, waiting for word about relatives. *Left,* A woman's eyes were blackened by falling debris during the temblor.

Raymond Gehman
The Virginian-Pilot and the Ledger-Star

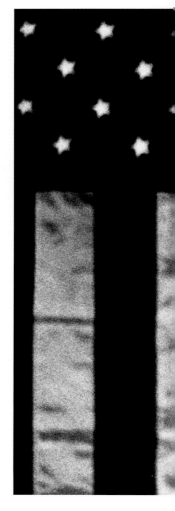

Jim DiNardo, 96, can still fit into the uniform he wore in World War I, where he fought in the Battle of Argonne Forest.

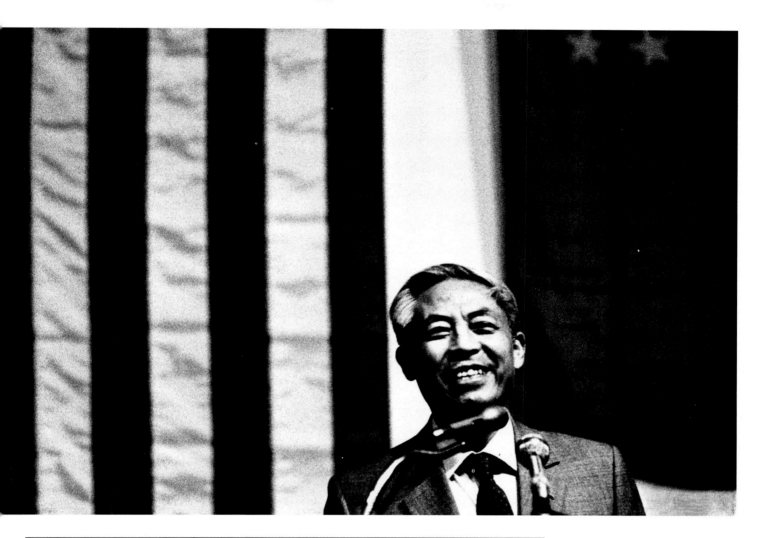

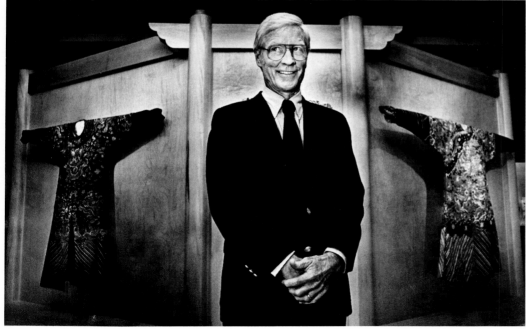

Ambassador Han Xu of China expresses his personal satisfaction with the election of George Bush while speaking at a university.

Chrysler Museum Director David Steadman delights in an exhibit of Chinese robes.

A pass play is broken up during the annual Oyster Bowl between the Virginia Military Institute and The Citadel in Norfolk, Va.

Newspaper One Week's Work / Raymond Gehman, First Place

P.D. Lambert rests against a barn on the farm in southwest Virginia where he was born and raised. The farm has been bought by a land developer, putting Lambert out of a job and off the farm forever.
Below, an Australian shepherd awaits the next command from a cowboy during the farm's last roundup.

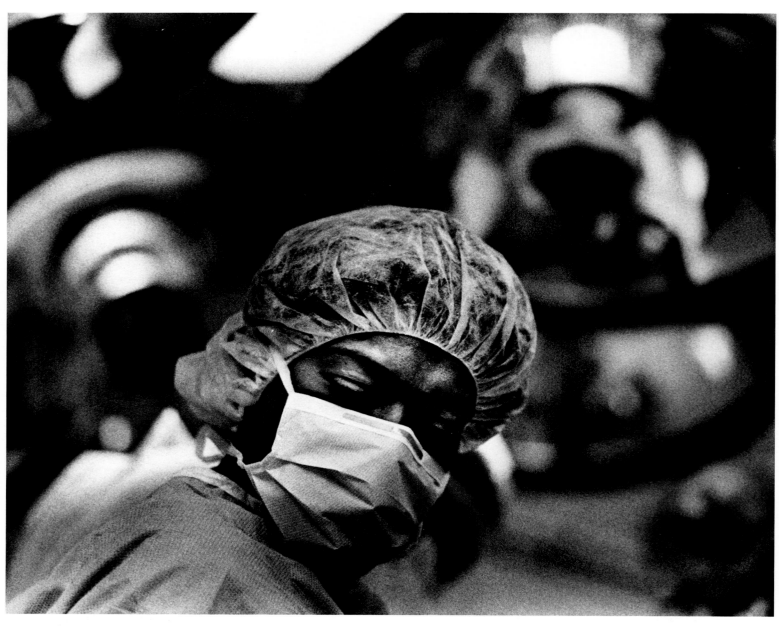

Scrub nurse Mattie Davis remains at the doctor's side throughout an operation, selecting and passing surgical instruments to him. *Right,* operating-room nurses take a break in their lounge.

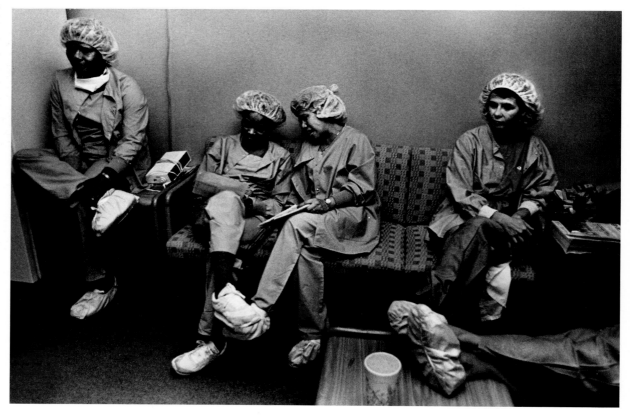

Newspaper One Week's Work / Raymond Gehman, First Place

The president of Newport News Savings Bank, left, leaves a hearing at which he was forced to resign. Giving him support is the bank's board chairman, who was cleared of allegations of profiting from questionable land deals.

Peggy Peattie
Press-Telegram, Long Beach, Calif.

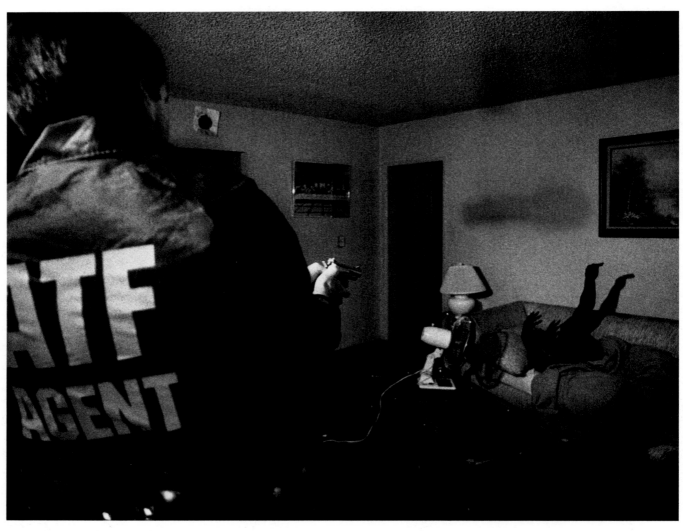

An Alcohol, Tobacco and Firearms agent keeps his gun on a suspected drug dealer, just awakened, during a search. *Below,* police look under a woman's bed for her boyfriend's weapons stash while she holds her terrified child.

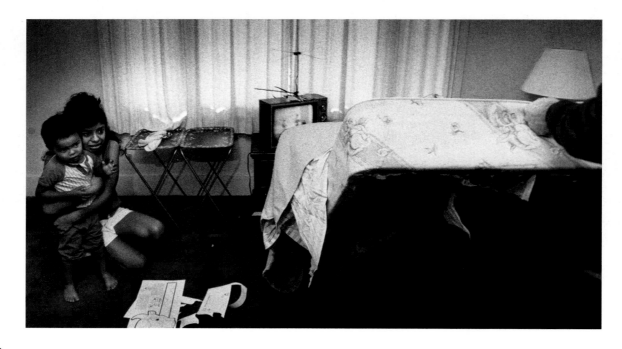

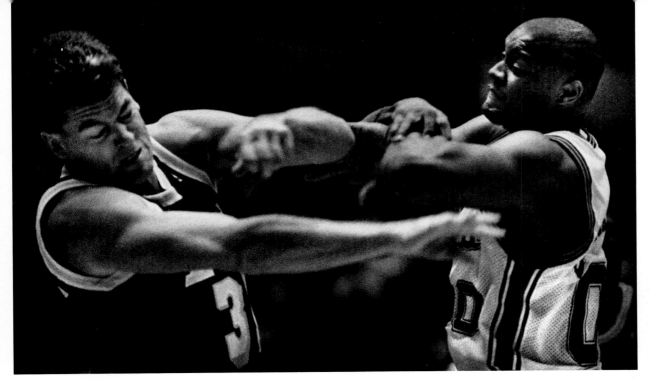

A testy Benoit Benjamin dukes it out with Laker John McNamara over a loose ball foul.

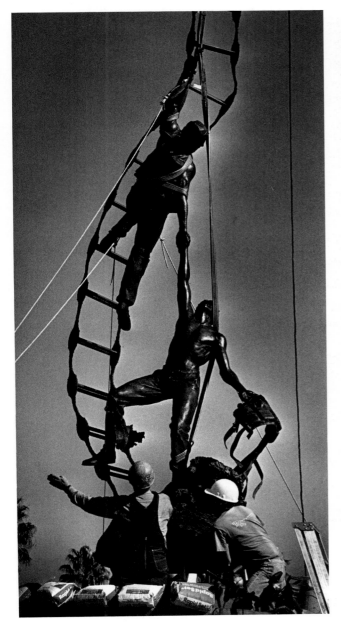

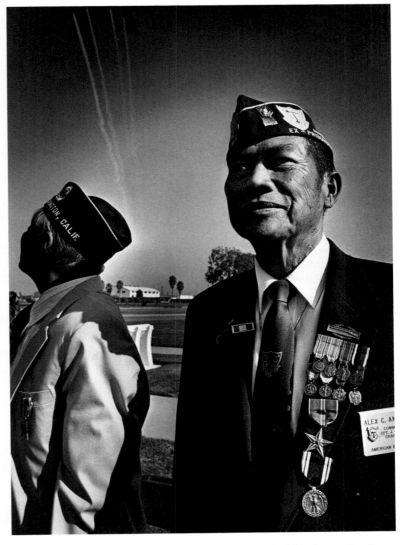

Above, Philippine survivors of the Bataan Death March are finally decorated with the bronze star and honored with a fly-over. *Left,* a work crew installs a memorial statue to the Merchant Marines during a ceremony at Los Angeles Harbor.

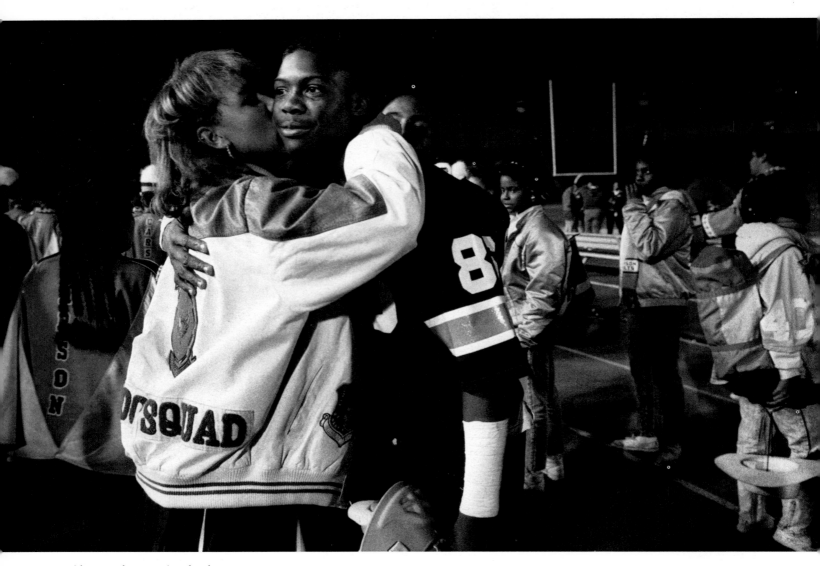

Above, a shy running back gets a congratulatory kiss from a cheerleader after their team won the all-city finals against cross-town rivals. *Right*, a linebacker from the defeated team sits alone on the bench.

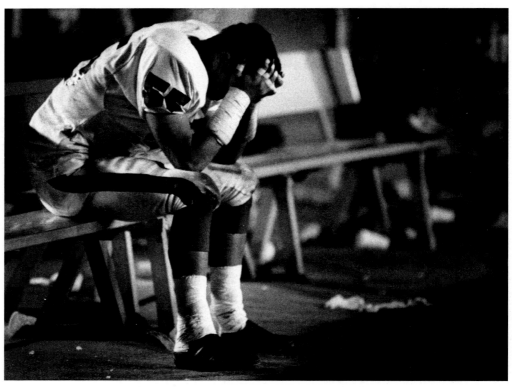

Newspaper One Week's Work / Peggy Peattie, Second Place

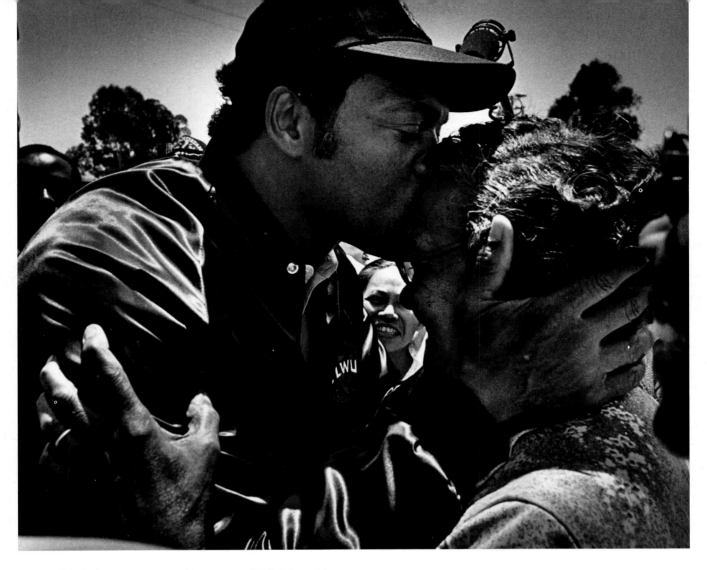

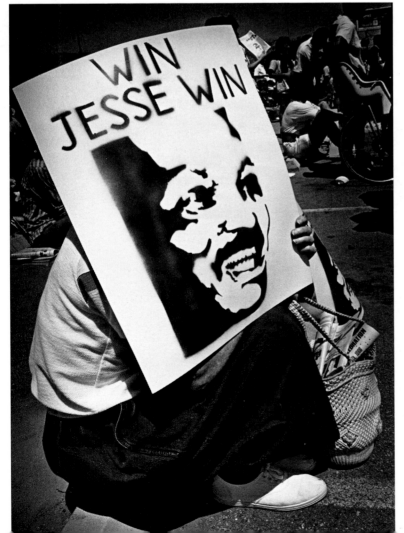

Above, Democratic hopeful Jesse Jackson gives a kiss to a delighted Dorothy Chambers at a rally in San Pedro, Calif. *Left,* a supporter uses her sign as a sun shield while waiting for Jackson to arrive.

**NEWSPAPER ONE WEEK'S WORK,
THIRD PLACE**

Peggy Peattie

Press-Telegram,
Long Beach, Calif.

A huge rotary for an oil refinery rests precariously on a freeway gaurdrail after rolling off the flatbed truck that was carrying it.

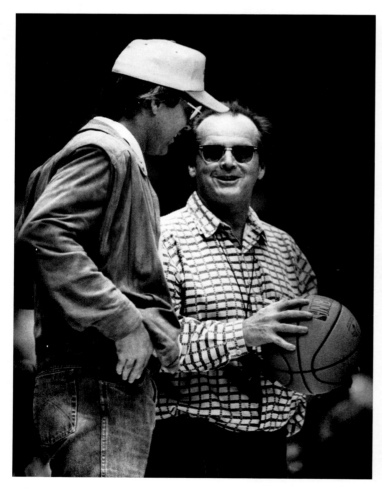

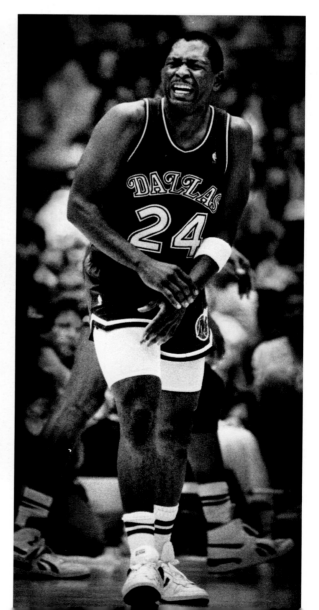

Above, Lakers fan Jack Nicholson picks up the ball that rolled over to him and Chevy Chase during a game. *Right,* Mark Aguirre (then of the Dallas Mavericks) hollers in pain after jamming his hand at the same game.

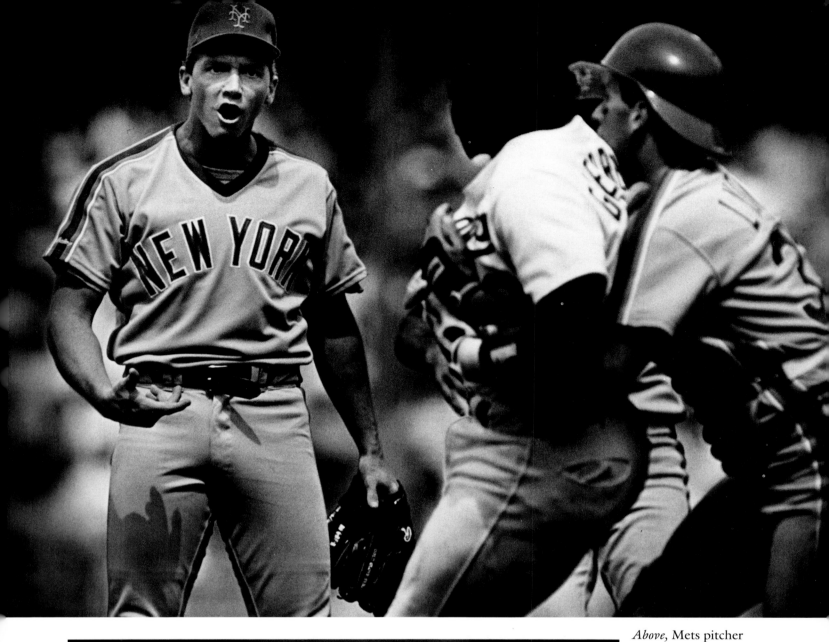

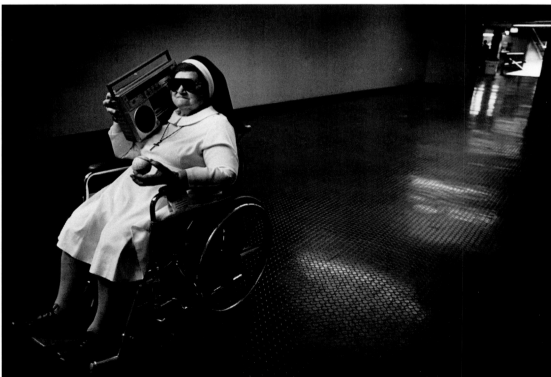

Above, Mets pitcher Dave Cone tells Pedro Guerrero to stay away as the slugger comes after him for nearly hitting him with two pitches.
At the end of eight innings that game, 80-year-old Sister Panacratilla, *left,* keeps track of play with her blaster as she waits for the elevator.

Don Tormey
Los Angeles Times

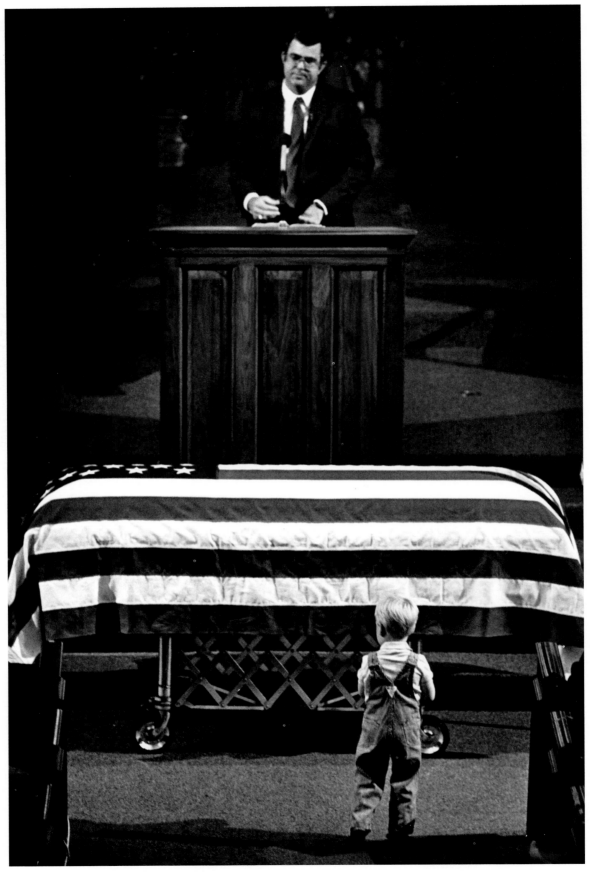

At the funeral for California Assemblyman Richard Longshore, his 2-year-old son wanders up the aisle to the father's coffin.

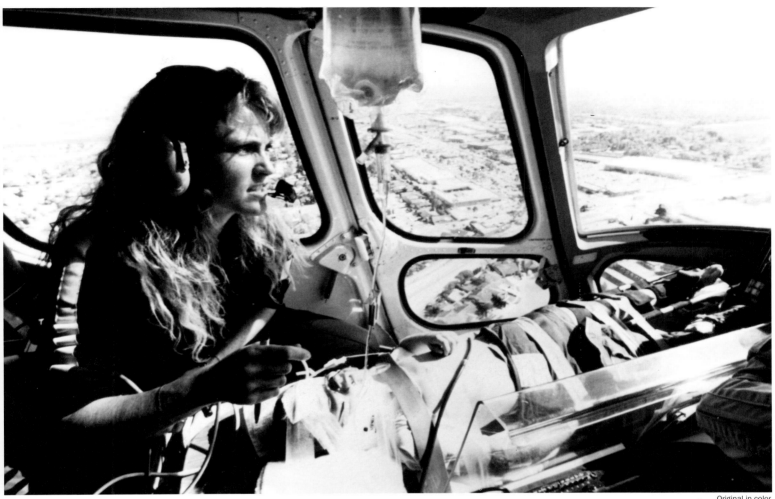

Original in color

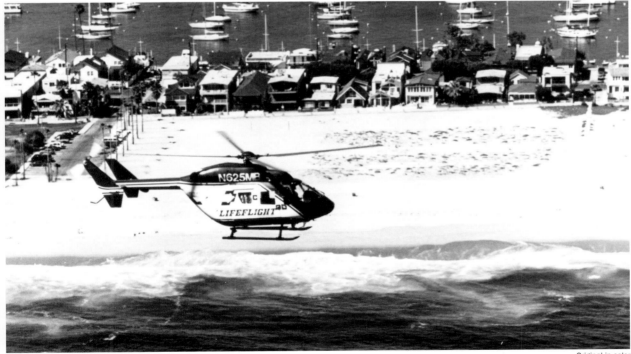

Above, Lifeflight nurse Marylee Blow aids a boy injured in a bicycle accident while talking by radio to doctors at a Fountain Valley, Calif., trauma center. *Left*, a Lifeflight helicopter flies along Newport Beach.

Original in color

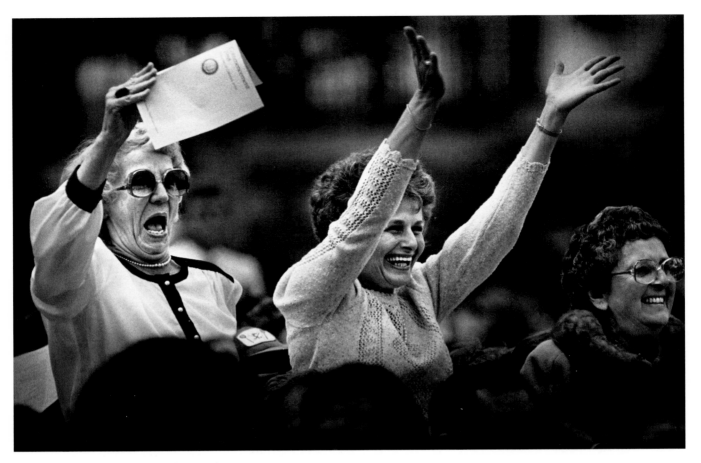

Above, a happy grandmother and mother yell out during graduation ceremonies at the University of California at Irvine. *Right*, graduate Elena Messer gets flowers, hugs and kisses from her daughter Donnie, 8.

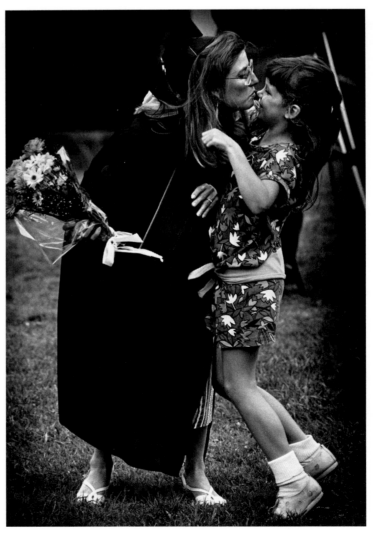

Newspaper One Week's Work / Don Tormey, Award of Excellence

Charles Moore

Black Star

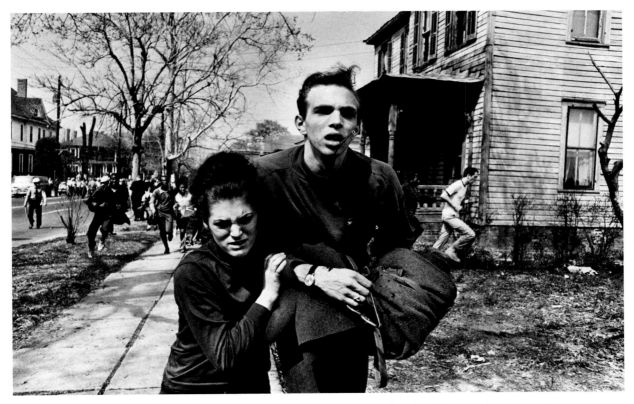

Montgomery, Ala.; March 16, 1965 Civil rights workers are beaten by sheriff's deputies and police on horses.

Photographer Charles Moore, who documented the civil rights struggles of the 1950s and '60s, is the first recipient of the Kodak Crystal Eagle Award for Impact in Photojournalism.

Moore's attempts at chronicling the strife of the times, to the extent of physical danger and harassment, were proof of his commitment to photojournalism. During demonstrations in Birmingham in May 1963, the Montgomery, Ala., native was injured by a chunk of concrete thrown at firemen, and a few days later was arrested on trumped-up charges of refusing to obey a police officer.

Public display of Moore's photos, many of which appeared in *Life* magazine, is credited with playing a role in passage of the 1964 Civil Rights Act.

His work during the unrest in the South ranged from capturing for history the enrollment of the first black at the University of Mississippi, to the use of police dogs against protesters, to the arrest of the Rev. Dr. Martin Luther King Jr. on charges of loitering in Montgomery.

Raymond H. DeMoulin, vice president and general manager of Kodak's Professional Photography division, said that by choosing Moore as the first recipient of the Crystal Eagle Award, "Pictures of the Year judges have inaugurated this competition category in an auspicious way. ... Charles Moore's photographs are unforgettable. They will always be key images in terms of history and photojournalism."

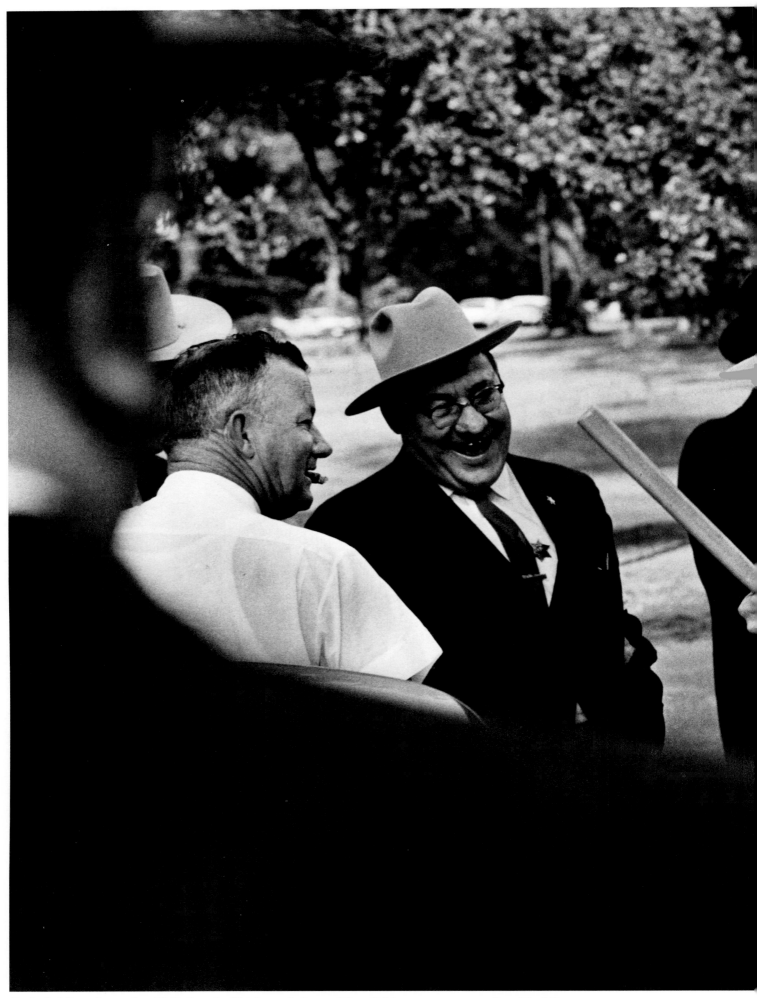

Oxford, Miss.; September 1962 Local officials await James Meredith's attempt to enroll at Ole Miss.

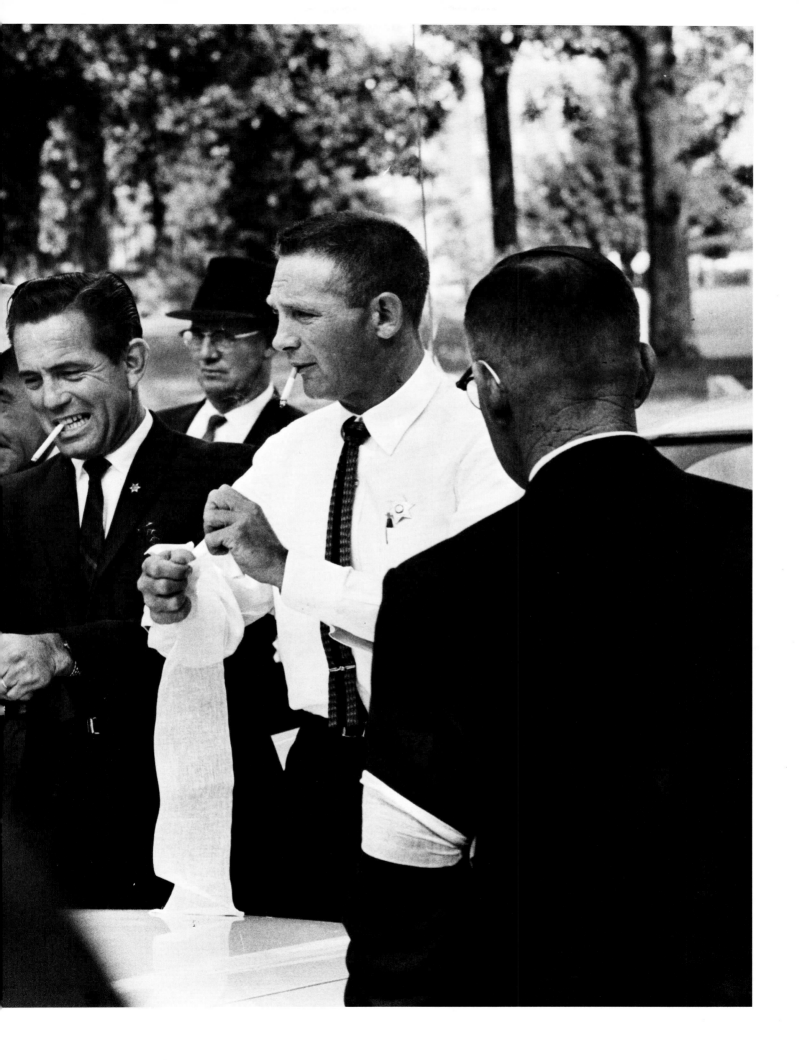

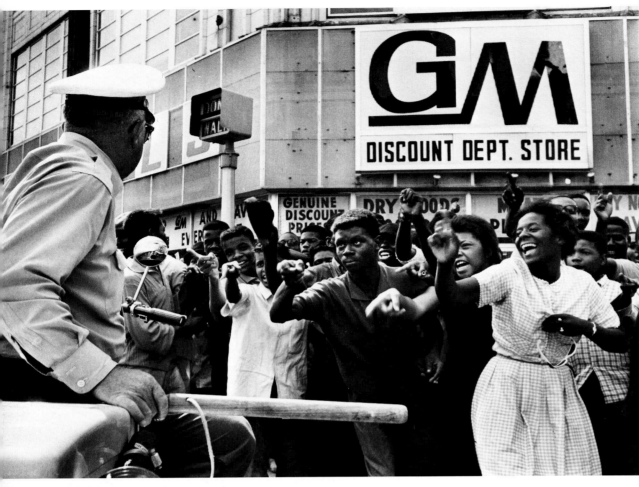

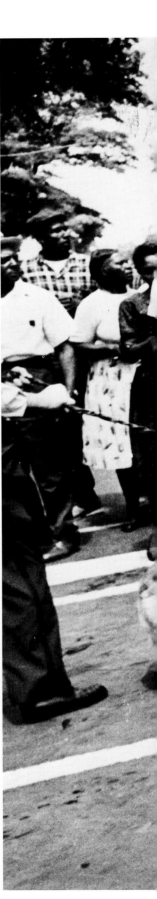

Birmingham, Ala.; May 1963 Jubilant teens sing freedom songs. On May 20, 1963, the Supreme Court rules Birmingham's segregation ordinances unconstitutional.

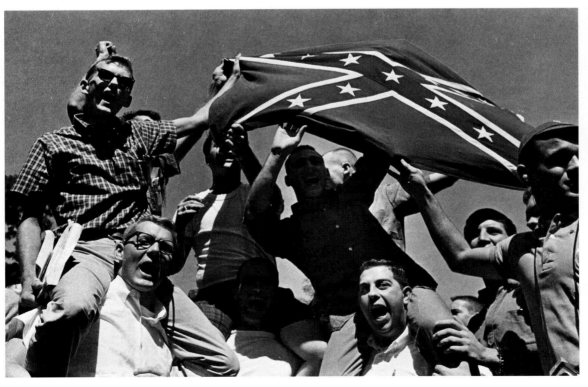

Oxford, Miss.; September 1962 Segregationists at the University of Mississippi, "Ole Miss," react to the imminent enrollment of James Meredith, the first black student at the university.

Kodak Crystal Eagle/Charles Moore

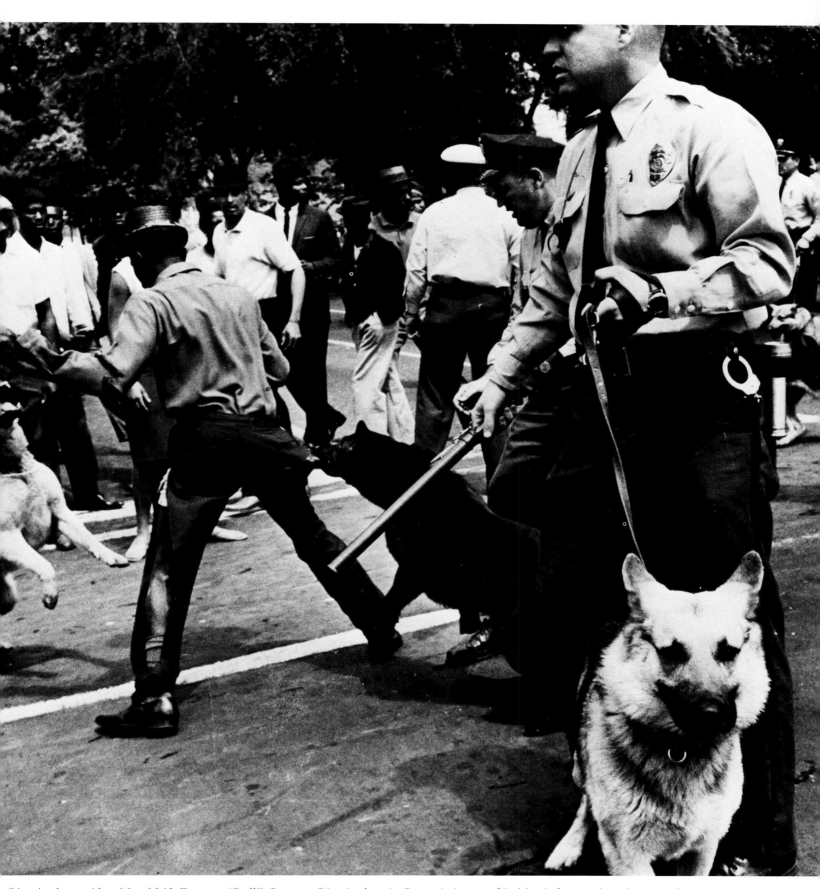

Birmingham, Ala.; May 1963 Eugene "Bull" Conner, Birmingham's Commissioner of Public Safety, orders the use of police dogs and fire hoses against civil rights activists.

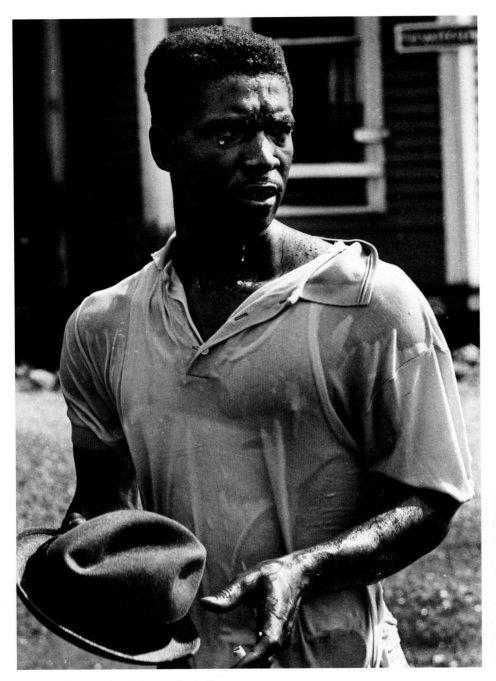

Birmingham, Ala.; May 1963 A demonstrator.

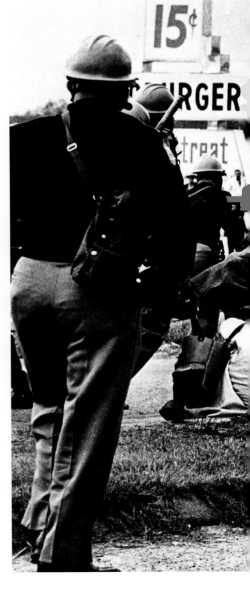

*Selma, Ala.;
March 7, 1965*
"Bloody Sunday" clash between
a group of marching
demonstrators and state highway
patrolmen at the Edmund Pettus
Bridge. Marchers were
attempting to begin their journey
from Selma to Montgomery.

Kodak Crystal Eagle / Charles Moore

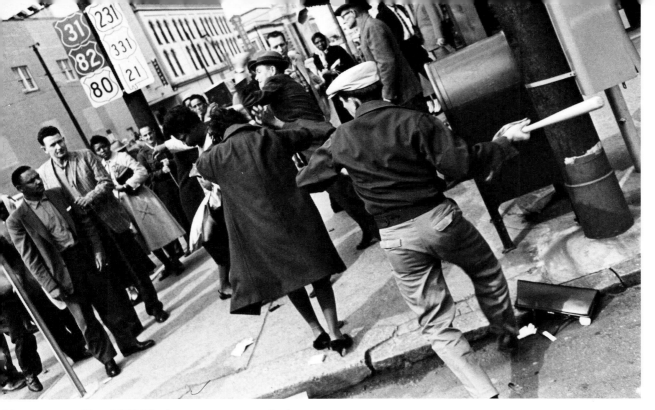

Montgomery, Ala.; 1958 Black women are attacked on a street corner.

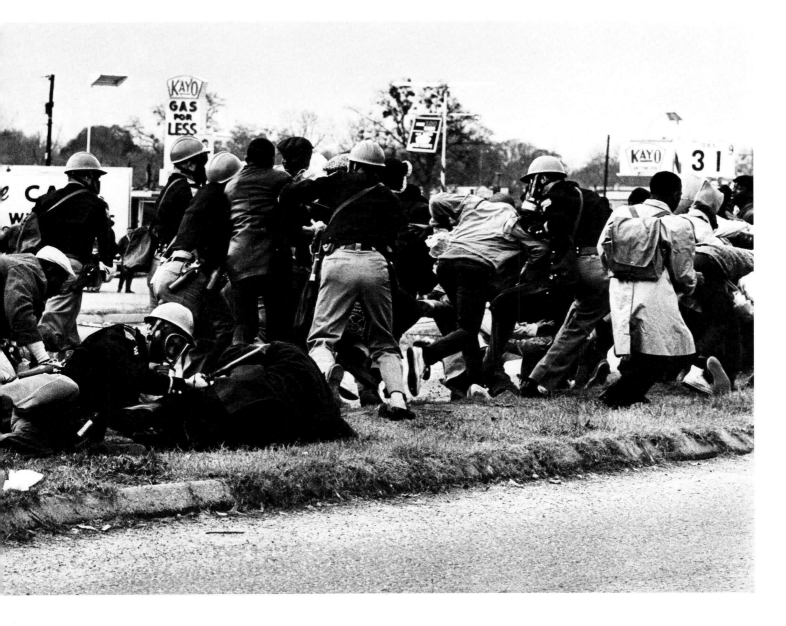

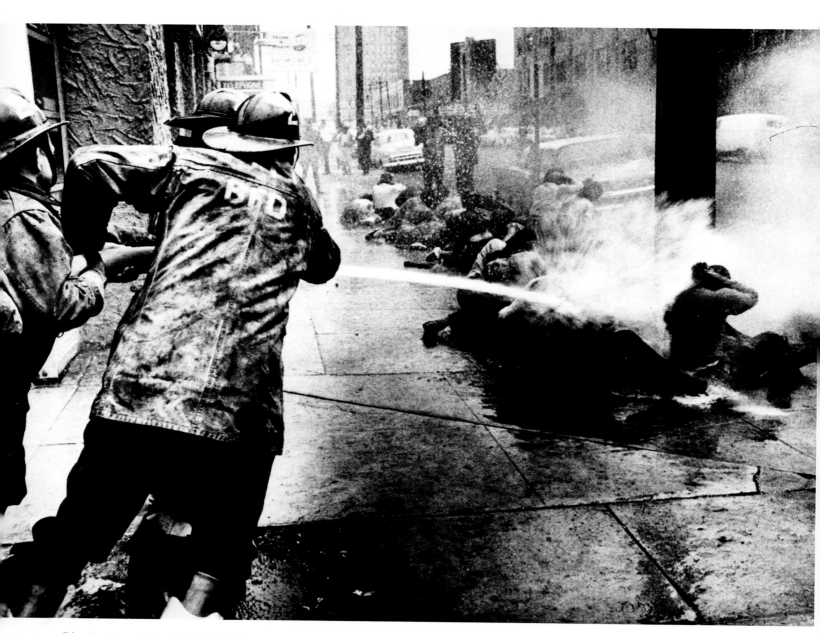

Birmingham, Ala.; May 1963 Hoses are used on civil rights demonstrators.

Kodak Crystal Eagle / Charles Moore

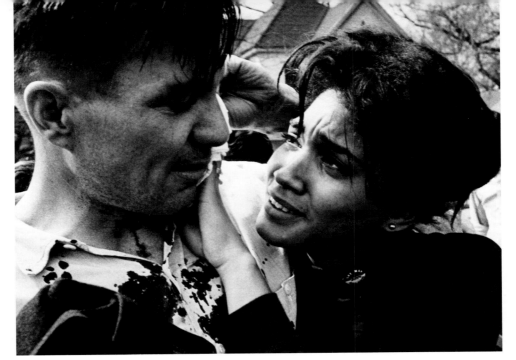

Montgomery, Ala.; March 16, 1965 Civil rights workers are beaten by sheriff's deputies and police on horseback.

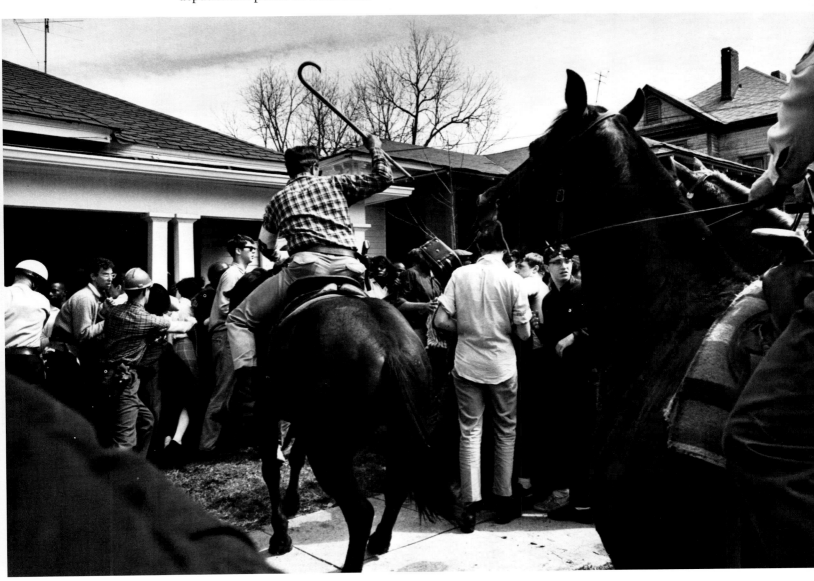

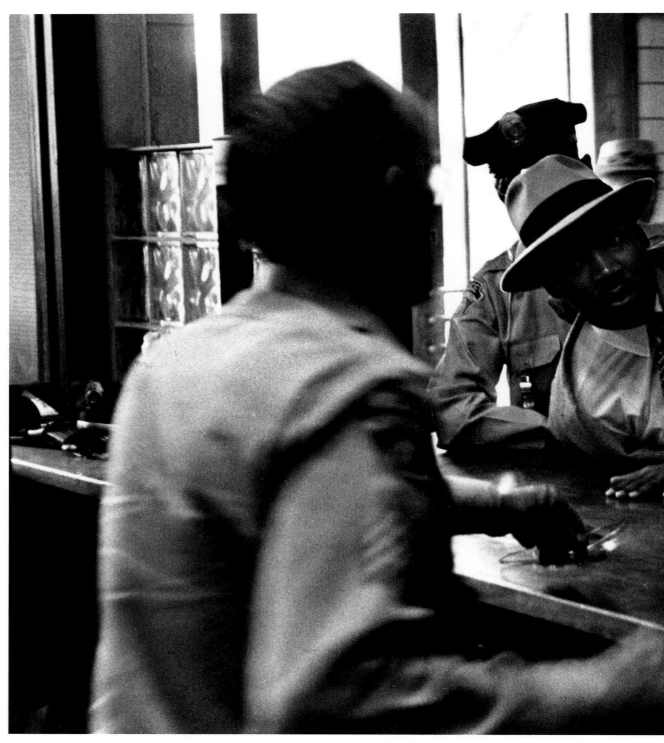

Montgomery, Ala.; Sept. 3, 1958 Martin Luther King Jr. is arrested, charged with "loitering" in the vicinity of Montgomery Recorder's Office.

Kodak Crystal Eagle / Charles Moore

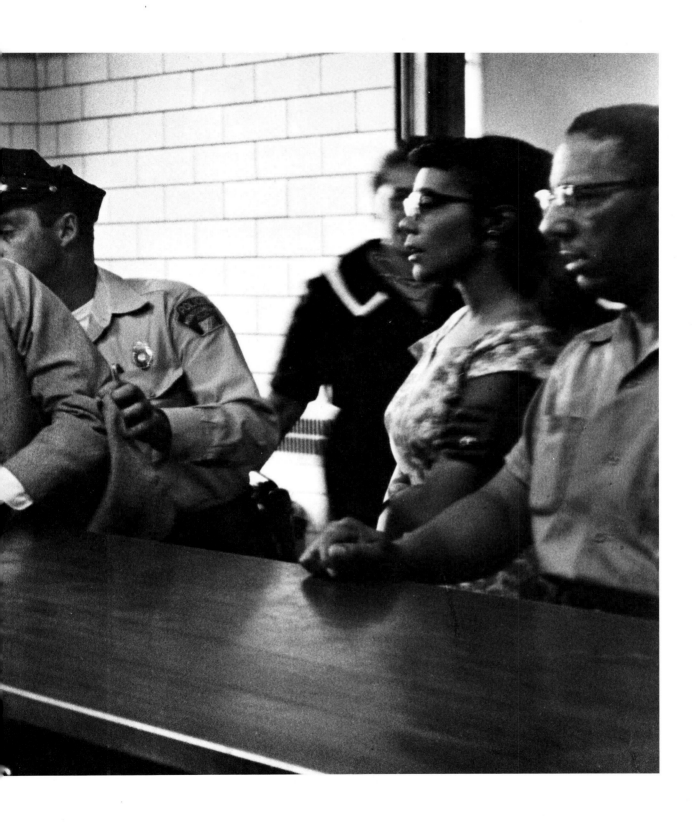

Kodak Crystal Eagle / Charles Moore

A POY judging report from the

By Bill Kuykendall

Pictures of the Year judge Carolyn Lee—who returned this year to provide continuity between the 1988 and '89 panels—noted an important distinction between POY 46 and POY 45 when she observed that "I feel universally much happier with our winners now than I did last year. There's a real strong level You don't have any nagging doubts about the winners."

Indeed, though the total number of entries and entrants declined slightly (37,000 photos in 1988 to 35,000 in 1989; 1,995 photographers and editors in 1988 to 1,937 in 1989), no category failed to produce work deserving of top POY awards. The leveling off of numbers was welcomed because the contest had seen 20 percent increases in each of the previous two years following the change from print to slide entries. The overall improvement in quality suggests that not only were more good pictures entered but photographers also were better editors.

Particularly important was the growth in two categories that had been added in 1987. Newspaper Sports Portfolio grew from 109 to 124 during the past year; the One Week's Work category (created to rec-

Bill Kuykendall / **Photo by Garth Dowling.**

ognize excellence in coverage of everyday newspaper assignments) increased from 24 to 37. Magazine Sports Portfolio also grew from five entries to 10; though quality of the winners was high, more participation is needed if this category is to truly represent the best in magazine sports photography.

Though major changes were introduced to POY in 1987 (the switch from print to slide entries and the creation of 1 new categories) and in 1988 (an increase in judging from one to two weeks), none have strengthened POY more than the arriva this year of the Professional Photography Division of the Eastman Kodak Company as corporate co-sponsor. Kodak's invest ment, along with that of Canon USA, Inc (completing its fifth year with POY), ha made possible, among other things, more valuable awards for top winners, an annua touring gallery exhibition and an importan new category, the Kodak Crystal Eagle Award for Impact in Photojournalism.

The Crystal Eagle Award was created to recognize a photojournalist "whose work has had an acknowledged impact or society. . . who, by photographically ex ploring and reporting an issue of significan social concern, has changed the way people live or the things they believe." Black Sta photographer Charles Moore captured the first Crystal Eagle award and set a high standard for future entrants with his docu mentation of the civil rights struggles of the 1960s (see pages 211 — 221). Though this category attracted only 15 entries, man were exceptional. For this reason it wa decided to award no special recognition and to allow non-winning entries to be re submitted in future POY competitions.

Though the total number of POY en tries was greater in 1988, this year's pane spent more time in discussion. Thanks to detailed records of the 1988 judging, it wa: possible to accurately project judging time for each category and for the contest as whole. Thus, judges were encouraged to deliberate as long as they liked during the final rounds of each category. Occasionally the panel, dissatisfied with its final choices rescreened the rejects in search of good work that may have been missed. Judging averaged 10 hours each of the 10 days. The 1988 panel finished in nine slightly shorte days.

Joining New York Times picture edito Lee on the first week's panel that judged the newspaper photography entries were J Bruce Baumann, Karen Borchers, Miche duCille, Terry Eiler and Bill Greene. Lee and Greene were replaced the second week by Jim Brandenburg and Rich Clarksor who helped Baumann, Borchers, duCille and Eiler judge magazine and editing en-

From left, judges Michel duCille, Carolyn Lee, Karen T. Borchers and Bruce Baumann evaluate slides for Newspaper Photographer of the Year. / **Photo by Matt Campbell.**

University of Missouri

From left, judges Borchers, Terry Eiler, Bill Greene, Baumann, Lee and duCille view slides at the end of a category on the main viewing screen. / **Photo by Matt Fisherwood.**

ries. Baumann, who had entries in several of the picture editing categories, was excused from judging the day those awards were decided. All but Brandenburg, who left early for an assignment, judged the Canon Essayist and Crystal Eagle entries.

The number of entries in some editing categories declined from last year (Feature Story, 244 to 167; Sports Story, 103 to 65; Series/Special Section, 74 to 38). The Feature Story category, however, included so many fine magazine and newspaper layouts that the category was split and honors given for newspapers and magazines separately. Best Use categories, in general, increased (25,000 - 150,000 circulation , 14 to 16; over 150,000, eight to 12; Zoned Editions, six to eight).

Overall quality seemed higher throughout the editing division. The decision between 1st and 2nd in the over-150,000 circulation category of Best Use of Photographs required a painstaking page-by-page comparison of the best edition entered by each newspaper. Throughout each best use category the judges compared the number and quality of local photos; use of wirephotos; news enterprise photos that accompanied text; lines-only feature photos; active, documentary photography vs. the use of photo illustrations; section front design and exploitation of inside display holes; appropriateness of captions and headlines; and the appropriateness of color.

These editing awards, which recognize those institutions that encourage the practice of photojournalism, are among the

most important honors bestowed by Pictures of the Year. Next year a separate feature story category for magazines will be included and editing division judging will increase from nearly two to three full days.

Not all categories impressed the judges. The illustration categories—Food, Fashion and Editorial Illustration—disappointed and frustrated this panel as they had those of 1988 and 1987. The consensus continues to be that these categories contain few images made with the intellectual and technical finesse that often is found in top advertising photography. Almost without exception the work submitted has been sophomoric in conception and execution. This panel, as those before, urged that

Continued on the next page

The 46th POY Judges

J. Bruce Baumann is assistant managing editor/graphics of The Pittsburgh Press. For five years he worked as a layout editor and photographer at National Geographic magazine. He is a former NPPA Region 4 Photographer of the Year.

Karen Borchers has been a staff photographer at the San Jose (CA) Mercury News for the past six years. Previously she worked at the West Palm Beach (FL) Post and the Fredericksburg (VA) Free Lance-Star. She received special recognition in the Canon Essayist category in the 1983 POY competition.

Jim Brandenburg is a contract photographer for National Geographic and won Magazine Photographer of the Year honors in 1981 and 1983. He began his career as a natural history photographer and film maker while studying studio art at the University of Minnesota, Duluth. He has been a photographer and photo editor at the Worthington (MN) Daily Globe. His most recent book, White Wolf—Living with a Legend, was published last October.

Michel duCille is picture editor of The Washington Post. He shared a Pulitzer Prize in 1985 for spot news coverage of the eruption of Colombia's Nevado Del Ruiz volcano and won the Pulitzer for feature photography in 1988 with an essay on crack addicts in a Miami housing project. Both awards came while he was a staff photographer on The Miami Herald. DuCille has worked as a photographer at the Gainesville (GA) Times and the Louisville Courier-Journal.

Rich Clarkson is a freelance photojournalist based in Denver, CO, under contract to Sports Illustrated. He was director of photography at National Geographic magazine from 1985 to 1987 and held the same position at the Denver Post from 1980 to 1984 and at the Topeka (KS) Capitol-Journal from 1957 to 1980. Clarkson has photographed seven Olympics and has worked as photographer and editor on five Day in the Life books. He has co-authored five books and is the producer-coordinator of the Brian Lanker "I Dream A World: Portraits of Black Women Who Changed America" exhibition, book and video project.

Terry Eiler is associate director of the School of Visual Communication at Ohio University, Athens, and was chair of the School of Fine Arts photography program there from 1978 to 1982. Co-owner of Mugwump Stock Photography, Eiler has worked for a number of magazine and corporate clients including National Geographic, Geo, Stern and Paris Match.

Bill Greene is the 1987 Newspaper Photographer of the Year. He won this title at the Boston Globe where he has been a staff photographer since 1985. Greene has won the New England Photographer of the Year competition four times in four years. He also worked five years as assistant photo editor at The Patriot Ledger, Quincy, MA, and graduated from the University of Massachusetts, Amherst, with a bachelor's degree in marketing.

Carolyn Lee, at the time of this year's judging, was picture editor of The New York Times where now she is senior editor. She also has served the Times as assistant national editor, assistant news editor and deputy picture editor. Lee has worked in various editing positions at the Houston Post and The Courier-Journal, Louisville, KY.

The 46th POY judging report

Continued from previous page

we eliminate the editorial illustration category from POY. This we are going to do.

When the POY philosophy and rules were rewritten and new categories added three years ago, the aim was to focus more precisely the spotlight of professional attention upon those who best exploit the still camera as a reporting tool.

This year there were many important and deserving documentary single photographs and stories—Eugene Richards' Canon Essayist study of a neighborhood destroyed by crack, Donna Ferrato's exhaustive investigation of domestic violence and John Kaplan's fresh, sympathetic but unsentimental look at a young killer. Each demonstrates the impact and understanding that can result when a committed photojournalist takes the field to observe and report. Each story, however, had its counterpart among the studio-produced editorial illustrations that was legally-safe, inexpensive to produce and colorful, but which offered no new knowledge or insights. It is hoped that, by discontinuing awards for contrived images, Pictures of the Year can emphasize its commitment to the documentary photograph.

In the future we hope that POY will become, even more than it is today, a forum for celebrating reportorial photography. POY 47 will send calls for entries to photojournalists throughout the world whether they be NPPA members or even newspaper and magazine photographers or not. We hope that every serious photographer—journalist, artist, anthropologist or sociologist—who uses still cameras to explore and comment upon contemporary culture will participate. Thus, perhaps, the collective weight of the year's great, unposed photographs may better inspire the dedicated professionals who make them and influence others to follow their example.

The Winners List

Judged Feb. 20 through March 3, 1989, at the University of Missouri-Columbia and sponsored by the National Press Photographers Association and the University of Missouri School of Journalism, with grants from Canon USA, Inc., and the Professional Photography Division of Eastman Kodak Co.

Newspaper Photographer of the Year

(120 Portfolios)

1st Place **John Kaplan,** The Pittsburgh Press, pages 17 - 28
2nd Place **Michael Bryant,** The Philadelphia Inquirer, pages 41 - 45
3rd Place **Lois Bernstein,** The Virginian/Pilot & Ledger/Star, pages 46 - 50

Magazine Photographer of The Year

(25 portfolios)

1st Place **James Nachtwey,** Magnum, pages 29 - 40
2nd Place **Kenneth Jarecke,** Contact Press Images, pages 51 - 55
3rd Place **Anthony Suau,** Black Star, pages 56 - 60

Awards of Excellence
Charlie Cole, Newsweek
Karen Kasmauski, National Geographic
Christopher Morris, Black Star
Peter Turnley, Black Star for Newsweek

Canon Photo Essay Award

(59 essays)

1st Place **Eugene Richards,** "Crack: The Downfall of a Neighborhood," Magnum, pages 61 - 70
Finalists
Ken Heyman, "Unseen New Yorkers," Freelance
John Kaplan, "Rodney's Crime," The Pittsburgh Press, pages 18 - 21

Michael Williamson, "And Their Children After Them," The Sacramento Bee

Kodak Crystal Eagle Award

(16 submissions)

Charles Moore, " Civil Rights," Black Star, pages 211 - 221

Individual Awards: Newspaper Division

Newspaper Spot News

(1,490 pictures)

1st Place **Charles Daughty,** "Crash," Associated Press, page 71
2nd Place **Robin Rombach,** "Critical Moment," The Pittsburgh Press, page 72
3rd Place **Michael Rondou,** "Skin to Skin," San Jose (CA) Mercury News, page 73

Awards of Excellence
Joe Burbank, "Shelter Scuffle," The Orlando (FL) Sentinel, page 75
Jim Mahoney, "Hostages Saved," Boston Herald, page 75
Patrick Murphy-Racey, "Breath of Life," for The Milwaukee Sentinel, page 73
Max Nash, "Weapon: Slingshot," The Associated Press
Susie Post, "Bridge Jumper," The Pittsburgh Press, page 74

Newspaper General News

(1,469 pictures)

1st Place **Bruce Chambers,** "Solicitation Bust," Long Beach Press-Telegram (CA), page 76
2nd Place **Elaine Thompson,** Untitled, Ohio University, page 77
3rd Place **Vince Musi,** "Transplant Campers," The Pittsburgh Press, page 78

Awards of Excellence
Todd Buchanan, "Dried Up," The Louisville (KY) Courier-Journal, page 80
Michael Green, "Goodbye," The Detroit News

Paul Hosefros, "One Yea Vote," The New York Times
Jon Kral, "Father and Son," The Miami Herald, page 78
Cloe Poisson, "Abandoned Baby Funeral," The Hartford Courant, page 79
Richard Schmidt, "Drought Victims," The Sacramento Bee, page 81
Nuri Vallbona, "Drought Victims," Freelance for The Dallas Morning News, page 81

Newspaper Campaign '88

(992 pictures)

1st Place **Larry McCormack,** "Looking Presidential," Nashville Banner, page 89
2nd Place **Gary O'Brien,** "Tired Campaigner," for Mesa (AZ) Tribune (Entry withdrawn)
3rd place **Richard Carson,** "Mrs. Manners to the Rescue," The Houston Chronicle, page 90

Awards of Excellence
Allen Eyestone, "The End," The Palm Beach Post, page 90
David Peterson, "Hart's Remorse," The Des Moines Register, page 91
Bonnie Weller, "Deafening Dukakis," The Philadelphia Inquirer, page 91

Newspaper Feature Picture

(3,459 pictures)

1st Place **Robert Durell,** "Patient Mother," Freelance for Los Angeles Times, page 120
2nd Place **Pete Cross,** "The Gesture," The Miami Herald, page 121
3rd Place **Timothy Barmann,** "Free Kittens," The Journal-Bulletin (Providence, RI), page 121

Newspaper Sports Action

(2,175 pictures)

1st Place **Brian Smith,** "Inches Short," The Miami Herald for Agence France-Presse, page 123
2nd Place **Vernon Ogrodnek,** "Spinks Down and Out in Atlantic City,"

Continued on the next page

Continued from the previous page

The Press (Atlantic City, NJ), page 125
3rd Place **Bernard Brault**, "Ejection," La Presse (Montreal, QUE), page 124

Awards of Excellence
Carol Cefaratti, "Cheap Shot," Kent State University, page 124
Charles Cherney, "Tangled Up in Blue," Chicago Tribune, page 126
Phil Coale, "Pit Fire," Tallahassee (FL) Democrat, page 126
Vince Musi, "Slam Dunk," The Pittsburgh Press
Bill Roth, "Bull Ride," Anchorage (AK) Daily News, page 122

Newspaper Sports Feature
(1,560 pictures)

1st Place **Brian Gadbery**, "Against the Wall," Freelance for Los Angeles Times, page 127
2nd Place **Brian Johnson**, "Cross Her Heart," Champaign-Urbana (IL) News-Gazette, page 129
3rd Place **Les Bazso**, "Mutual Feelings," The Province (Vancouver, BC), page 128

Award of Excellence
Peter Ackerman, "Pooped Puncher," Asbury Park (NJ) Press, page 128

Newspaper Portrait/ Personality
(2,287 pictures)

1st Place **Guy Reynolds**, "The Piano Teacher," Morning Advocate/ State-Times (Baton Rouge, LA), page 92
2nd Place **David Coates**, "Peggy Briller," The Detroit News, page 94
3rd Place **Brian Poulter**, "Sugar," Stamford (CT) Advocate, page 94

Awards of Excellence
David Turnley, "Afrikaner Miner," Detroit Free Press
Brant Ward, "Haitian Boy," San Francisco Chronicle, page 95

Newspaper Pictorial
(1,282 pictures)

1st Place **Richard Schmidt**, "Taking Flight," The Sacramento Bee, page 98

2nd Place **Carl Walsh**, "Rain Beads," Biddeford Journal Tribune (ME), page 100
3rd Place **Pat Davison**, "On the Range," The Albuquerque Tribune, page 100

Awards of Excellence
Kent Porter, "Spring Grapes," The Press Democrat (Santa Rosa, CA), page 101
Richard Sennott, "Prairie Fire," Star Tribune, Newspaper of the Twin Cities, page 101

Newspaper Food Illustration
(323 pictures)

1st Place **Thomas Szalay**, "High-Tech Mushrooms," San Diego Union/ Tribune, page 107
2nd Place **Hoyt Carrier II**, "Wishy Washy Asparagus," The Grand Rapids (MI) Press, page 108
3rd Place **Stan Badz**, "Chocolate Shells Delight," The (Jacksonville) Florida Times-Union, page 109

Awards of Excellence
Dennis Hamilton Jr., "Bananas - Handle with Care," The (Jacksonville) Florida Times-Union, page 108
Anne Lennox, "Pricey Catch," The Pittsburgh Press, page 109

Newspaper Fashion Illustration
(417 pictures)

1st Place **Betty Udesen**, "A Leg Up," The Seattle Times, page 96
2nd Place **Rosanne Olson**, "Fashion with Pears," Freelance for Seattle Weekly, page 96
3rd Place **Bill Wade**, "Pocket Square, New Under the Moon," The Pittsburgh Press, page 97

Awards of Excellence
Michael Bryant, "Shades of Summer," The Philadelphia Inquirer
J. Kyle Keener, "Black Magic," The Philadelphia Inquirer, page 97

Newspaper Editorial Illustration
(303 pictures)

1st Place **Susan Gardner**, "Cryonics," News/Sun-Sentinel (Fort Lauderdale, FL), page 113
2nd Place **Peter Monsees**, "Fine Faucet Filters," The Record (Hackensack, NJ), page 114
3rd Place **Steve Douglass**, "Gas vs. Electricity," Amarillo (TX) Globe News, page 115

Awards of Excellence
David Crane, "VDT vs. Pregnancy," Los Angeles Daily News, page 115

Newspaper News Pictures Story
(229 stories)

1st Place **John Kaplan**, "Rodney's Crime," The Pittsburgh Press, pages 18 - 21
2nd Place **Joe Cavaretta**, "Gallup: A Town Under the Influence," The Albuquerque Tribune, pages 191 - 194
3rd Place **David Turnley**, "Armenian Earthquake," Detroit Free Press, page 194, 195

Award of Excellence
George Riedel, "A Once Festive Crowd," The Associated Press

Newspaper Feature Picture Story
(419 stories)

1st Place **Genaro Molina**, "Runaway: Teen-age Prostitute," The Sacramento Bee, pages 181 - 183
2nd Place **Lois Bernstein**, "The Dark Side of Light," The Sacramento Bee, pages 184, 185
3rd Place **Michael Patrick**, "A Legacy of Hope," The Knoxville (TN) News-Sentinel, pages 186, 187

Awards of Excellence
Pete Cross, "Last Chance U.," The Miami Herald
Melissa Farlow, "Blind Mother - 5 Sighted Children," The Pittsburgh Press
Joel Sartore, "Bobby," The Wichita (KS) Eagle-Beacon, page 190
Jon Kral, "Gangs (The Boys of Summer)," The Miami Herald, pages 188, 189

Newspaper Sports Portfolio

(124 portfolios)

1st Place **Jerry Lodriguss**, The Philadelphia Inquirer, pages 132 - 136
2nd Place **Catharine Krueger**, The Sun-Tattler (FL), pages 137 - 139
3rd Place **Vince Musi**, The Pittsburgh Press, pages 140 - 142

Newspaper: One Week's Work

(37 entries)

1st Place **Raymond Gehman**, The Virginian/Pilot &Ledger/Star, pages 196-201
2nd Place **Peggy Peattie**, Press-Telegram (Long Beach, CA), pages 202-204
3rd Place **Peggy Peattie**, Press-Telegram (Long Beach, CA), pages 205-207

Award of Excellence
Don Tormey, Los Angeles Times, pages 208-211

Individual Awards: Magazine Division

Magazine News or Documentary

(307 pictures)

1st Place **Donna Ferrato**, "Domestic Violence," Black Star for Life, page 82
2nd Place **James Nachtwey**, "Sudan Famine, Hospital," Magnum for Life, page 84
3rd Place **Allan Tannenbaum**, "Rock the Casbah," Sygma, page 85

Awards of Excellence
Bill Hess, "Goodbye," Uiniq Magazine, page 88
Christopher Morris, "Pinochet Rally, Chile," Black Star for Newsweek, page 87
James Nachtwey, "Sudan Famine, Mother and Child," Magnum for Life, page 84
Robert Nichols, "Aloha Airlines Explosion," Black Star, page 86
Dick Swanson, "Death in Salvador," Freelance (Bethesda, MD), page 86

Magazine Campaign '88

(297 pictures)

1st Place **P. F. Bentley**, "I Want You," Time, page 110
2nd Place **Cynthia Johnson**, "Where Was George?" Time, page 111
3rd Place **Kenneth Jarecke**, "Presidential Campaign: The End," Contact Press Images, page 112

Awards of Excellence
Jim Curley, "Gary's Iowa Hart to Heart Talk," Freelance for AFP, page 112
Kenneth Jarecke, "Jesse Jackson in '88," Contact Press Images

Magazine Feature Picture

(316 pictures)

1st Place (tie) **Don Doll**, "Myrtis Walking Eagle," Professor, Creighton University for Christmas in America, page 151
1st Place (tie) **James Nachtwey**, "Religion in Guatemala," Magnum for National Geographic, page 152
3rd Place **David Doubilet**, "Sunken Zero," National Geographic, page 153

Awards of Excellence
David Alan Harvey, "Brotherhood," National Geographic, page 153
Chip Hires, "Generation Gap," Gamma-Liaison
Louis Psihoyos, "Cowboy and TV," Fortune Magazine

Magazine Sports Picture

(185 pictures)

1st Place **Tim DeFrisco**, "Diver," Allsport USA, page 130
2nd Place **Raul de Molina**, "Bullfighters' Protection," Shooting Star Photo Agency, page 131
3rd Place **Richard Clarkson**, "Flo at the Finish," Freelance for Time, page 131

Awards of Excellence
Neil Leifer, "Reaching for the Gold," Time
Ken Regan, "Shot-put," Camera 5 for Time

Magazine Portrait/ Personality

(422 pictures)

1st Place **Anthony Suau**, "Refugee Home," Black Star, page 116
2nd Place **Joe Traver**, "Buy This Pig," Freelance for The New York Times, page 117
3rd Place **Ric Ergenbright**, "Eyes of Age," Freelance, page 118

Awards of Excellence
David Gamble, "Reaching for the Stars," Time
Lori Grinker, "Mike Tyson/Robin Givens," Contact Press Images
Andrew Holbrooke, "Homeless in New York City," Black Star, page 119
Joseph McNally, "Leonard Bernstein at Work," Freelance, page 117

Magazine Pictorial

(158 Pictures)

1st Place **Jose Azel**, "Trout Fishing in Patagonia," Contact Press Images, page 103
2nd Place **Art Streiber**, "Stairway to Heaven," Fairchild Publications (Los Angeles, CA), page 104
3rd Place **Jim Jennings**, "A Day at the Beach," Freelance (Lexington, KY), page 105

Awards of Excellence
Bob & Clara Calhoun, "Autumn Abstract," National Wildlife, page 102
Darryl Heikes, "Alone in a Dinghy," U.S. News & World Report, page 106
Nick Kelsh, "Man Praying in Church," A Day in the Life of California, page 102
James Nachtwey, "Guatemala," Magnum for National Geographic
Peter Turnley, "Refugee Camp in Malawi," Black Star for Newsweek

Magazine Illustration

(82 Pictures)

1st Place **Joseph McNally**, "Doing It With Mirrors," Freelance, page 155
2nd Place **Roger Ressmeyer** "Space Suit of the Future," Starlight Photo Agency for Life, page 156
3rd Place **Bruce Dale**, "Our Fragile Earth," National Geographic, page 154

Awards of Excellence
Michelle Andonian, "Fashion," Detroit Monthly Magazine
Roger Ressmeyer "People Maze: 'The Wooz'," Starlight Photo Agency for Life, page 157

Continued on the next page

Magazine Science/Natural History

(135 pictures)

1st Place **Karen Kasmauski,** "Reindeer Herd," Freelance for National Geographic, page 159

2nd Place **Mark Moffett,** "Trap-Jaw Ant Defends Brood from Army Ant," Freelance for National Geographic, page 158

3rd Place **Scott Nielsen,** "Wood Duck," National Wildlife, page 160

Awards of Excellence

David Doubilet, "Barracuda Waltz," National Geographic

David Doubilet, "Purple Anthia's Fish," National Geographic

Roger Ressmeyer, "Moonlit Cerro Tololo Observatory," Starlight Photo Agency for National Geographic, page 160

Roger Ressmeyer, "Supernova Discoverer," Starlight Photo Agency for National Geographic, page 161

Magazine Picture Story

(219 Stories)

1st Place **Donna Ferrato,** "Domestic Violence," Black Star for Life, pages 162 -167

2nd Place **Merry Alpern,** "Untitled," Freelance (New York, NY), pages 168 -172

3rd Place **Peter Turnley,** "Death in Armenia," Black Star for Newsweek, pages 173 - 177

Awards of Excellence

Christopher Morris, "Noriega's Panama," Black Star, page 179

Christopher Morris, "General Pinochet Plebiscite, Chile," Black Star

James Nachtwey, "Sudan Famine," Magnum for Life

James Nachtwey, "Uprising," Magnum for Time

James Nachtwey, "Guatemala," Magnum for National Geographic

Anthony Suau, "Last Days of the Dictator," Black Star, page 180

Allan Tannenbaum, "Palestinian Demonstration," Sygma

Peter Turnley, "The Intifada," Black Star for Newsweek, page 178

Magazine Sports Portfolio

(10 Porfolios)

1st Place **Mike Powell,** Allsport USA, pages 143 - 147

2nd Place **David Drapkin,** Time, pages 148 - 150

No Third Place was awarded

Editing Division

The Seattle Times, 1st Place in Newspaper Picture Editing

Newspaper Picture Editing/Team

(22 Portfolios)

1st Place **Team Entry,** The Seattle Times

2nd Place **Team Entry,** Detroit Free Press

3rd Place **Team Entry,** Daily Breeze (Torrance, CA)

Awards of Excellence

Team Entry, The Pittsburgh Press

Team Entry, The Journal-Bulletin (Providence, RI)

Team Entry, San Jose (CA) Mercury News

Team Entry, Gazette-Telegraph (Colorado Springs, CO)

Team Entry, The Boston Globe

Team Entry, The Sacramento Bee

Detroit Free Press, 2nd Place in Newspaper Picture Editing

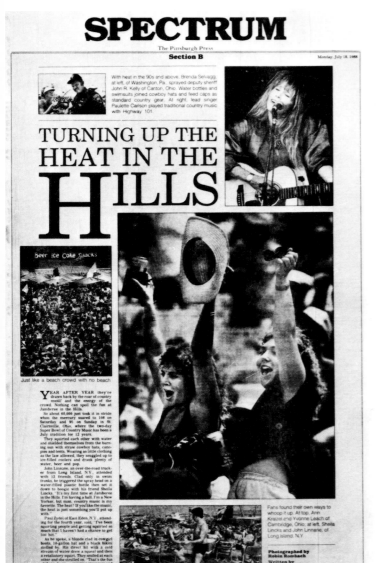

J. Bruce Baumann, The Pittsburgh Press, 1st Place in Newspaper Picture Editing/Individual

John Rumbach, The Herald, Jasper, Ind., 2nd Place in Newspaper Picture Editing/Individual

Newspaper Picture Editing/ Individual

(20 Portfolios)

1st Place **J. Bruce Baumann**, The Pittsburgh Press
2nd Place **John Rumbach**, The Herald (Jasper, IN)
3rd Place **David Pickel**, The Plain Dealer (Cleveland, OH)

Awards of Excellence
Tim Cochran, The Virginian/Pilot & Ledger/Star
Leslie Jacobs, The Hartford Courant
Murray Koodish, The Commercial Appeal (Memphis, TN)
Mary Jo Moss, San Jose (CA) Mercury News
Fred Nelson, The Seattle Times
Rick Perry, The Sacramento Bee

Fred Nelson, The Seattle Times, 1st Place in Newspaper Editing/News Story

Newspaper Editing— News Story

(135 Stories)

1st Place **Fred Nelson**, "Plane hits Sea-Tac terminal," The Seattle Times (April 16, 1988)
2nd Place **Randy Miller**, "When the Clocks Stopped," Detroit Free Press (Dec. 25, 1988)
3rd Place **Mike Davis**, "On the Edge of War," The Albuquerque Tribune (Dec. 30, 1988)

Awards of Excellence
Alex Burrows, "On the move: For now, family calls tent home," The Virginian/Pilot & Ledger/Star (June 19, 1988)
Tim Cochran, "Anguish injected into veins of area where syringe rules," The Virginian/Pilot & Ledger/Star (Aug. 14, 1988)

Continued on the next page

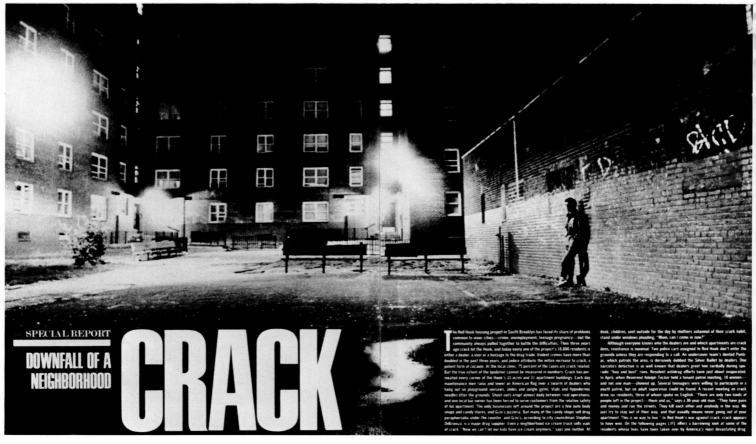

Peter Howe, Life, 1st Place in Magazine Feature Story Editing

Continued from the previous page

Tom Hardin and Staff, "Fiery deaths of 27 leave questions, anguish," The Louisville (KY) Courier-Journal (May 16, 1988)

Randy Miller, "Gaza: Anger & Anguish," Detroit Free Press (Oct. 2, 1988)

Randy Miller, "The Troubles," Detroit Free Press (Sept. 4, 1988)

Newspaper Editing– Feature Story

(167 Stories)

The judges decided to split this category due to the number and high quality of entries.

Newspaper

1st Place **Team Entry**, "Through The Valley," The Commercial Appeal (Memphis, TN) (May 22, 1988)

2nd Place **Geri Migielicz**, "Aids Hotel," San Jose (CA) Mercury News (May 22, 1988)

3rd Place **J. Bruce Baumann**, "There are 10,000 Things Worse Than Being Blind," The Pittsburgh Press (July 25, 1988)

Awards of Excellence

Team Entry, "On the Rebound," The Commercial Appeal (Memphis, TN)(March 13, 1988)

Team Entry, "Common Ground," The Seattle Times/Seattle Post-Intelligencer (Dec. 25, 1988)

Bill Kelley III, "A World Apart," The Virginian/Pilot & Ledger/Star (Feb. 21, 1988)

Magazine

1st Place **Peter Howe**, "Crack," Life

2nd Place **Peter Howe**, "Boot Camp," Life (Nov. 1988)

3rd Place **Peter Howe**, "Game Show," Life

The Commercial Appeal, Memphis, Tenn., 1st Place in Newspaper Editing/ Feature Story

Geri Migielicz, San Jose (Calif.) Mercury News, 2nd Place in Newspaper Editing/ Feature Story

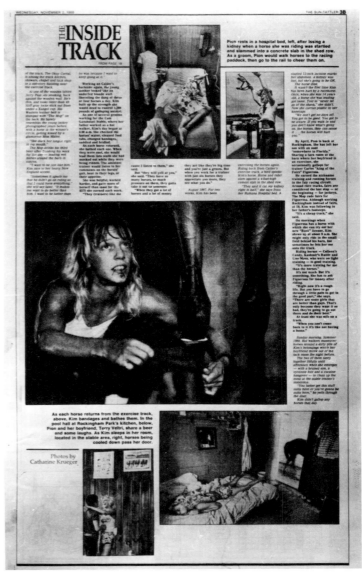

Tom Hardin and staff, The Louisville (Ky.) Courier-Journal, 1st Place in Newspaper Editing/Sports Story

Mark Edelson, The Sun-Tattler, Hollywood, Fla., 2nd Place in Newspaper Editing/Sports Story

Awards of Excellence

Dan Beatty, "The Riddle of Israel," The Commission (May 1988)

Team Entry, "The Island Within," Sunday Journal Magazine (The Journal-Bulletin, Providence, RI) (July 31, 1988)

Bert Fox, "Children of the Dust," The Philadelphia Inquirer (Dec. 25, 1988)

Bert Fox, "High Anxiety," The Philadelphia Inquirer (Dec. 11, 1988)

Peter Howe, "City of Lost Boys," Life

Peter Howe, "Ain't it Grand," Life

Peter Howe, "Work," Life

Peter Howe, "Ulster's Pain," Life

Peter Howe, "Hermit Kingdom," Life

Peter Howe, "Cuba," Life

Kathy Ryan, "Up from the Ashes," The New York Times Magazine

Kathy Ryan, The New York Times Magazine, 3rd Place in Newspaper Editing/Sports Story

Newspaper Editing— Sports Story

(65 Stories)

1st Place **Tom Hardin and Staff**, "Breeder's Cup Classic," The Louisville (KY) Courier-Journal (Nov. 6, 1988)

2nd Place **Mark Edelson**, "The Inside Track," The Sun-Tattler (Hollywood, FL) (Nov. 2, 1988)

3rd Place **Kathy Ryan**, "War at Sea," The New York Times Magazine (May 29, 1988)

Awards of Excellence

J. Bruce Baumann, "Back on Track," The Pittsburgh Press (Aug. 15, 1988)

J. Bruce Baumann, "The Blackwater 100," The Pittsburgh Press (June 20, 1988)

Continued on the next page

The deadly brew of alcohol and despair has devastated Alaska Natives. But now people are reaching out to one another in a sobriety movement that is slowly gathering strength.

A growing revolution of hope

BY DAVID HULEN

GLENNALLEN — Almost everyone had a horrible story to tell, stories of suicides and despair and deaths that shouldn't have been. These were the kinds of things people talked about openly. More discreetly, they whispered of sexually abused children and women beaten by husbands and boyfriends in bursts of drunken rage.

People in the villages of Alaska are like a man being pulled under by the currents of a river, said Walter Charley, a 79-year-old Athabascan from Copper Center. The people sitting around him — Indians, Aleuts and Eskimos from all over Alaska — knew exactly what he meant. Some nodded as he spoke.

"We're struggling for our lives," Walter Charley said.

Here, on a dusty baseball

See Page H-2, HOPE

A PEOPLE IN PERIL

INSIDE:
• Native Leaders' Roles
• Resources
• Comment

Richard Murphy, Anchorage (Alaska) Daily News, 1st Place in Newspaper Editing/Series or Special Section

Bible and drugs fight witchcraft

Mike Davis, The Albuquerque (N.M.) Tribune, 2nd Place in Newspaper Editing/Series or Special Section

Continued from previous page

Alex Burrows, "Over the Hill and Under the Hoop," The Virginian/Pilot & Ledger/Star (Nov. 9-10, 1988)

Team Entry, "The Thrill of Victory and . . .," The Hartford Courant (Dec. 14, 1988)

Keith Graham, "Moments of joy, heart-break," San Jose (CA) Mercury News (Feb. 29, 1988)

Newspaper Editing—Series or Special Section

(38 Stories)

1st Place **Richard Murphy,** "A People in Peril," Anchorage (AK) Daily News

2nd Place **Mike Davis,** "Unto Me," The Albuquerque Tribune (Feb. 8, 1988)

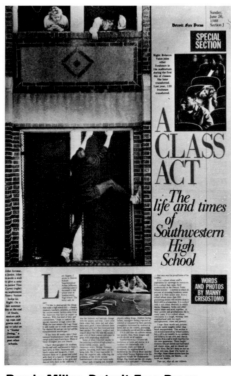

Randy Miller, Detroit Free Press, 3rd Place in Newspaper Editing/Series or Special Section

3rd Place **Randy Miller,** "A Class Act," Detroit Free Press (June 26, 1988)

Awards of Excellence

Bill Blanton, "A Legacy of Hope," The Knoxville (TN) News-Sentinel (Jul 3, 1988)

Randy Cox, "Politics part of the missio in Nicaragua," The Hartford Courant (Jan. 10-11, 1988)

Mike Davis, "Gallup: A Town Under the Influence," The Albuquerque Tribune (Sept. 26 - Oct. 1, 1988)

Team Entry, "Nov. 22 Twenty-five Years Later," The Dallas Morning News (Nov. 20, 1988)

Team Entry, "The California Desert Refuge at Risk," The Sun (San Bernardino County, CA) (Jan. 10, 1988)

Team Entry, "Memphis in May: The United Kingdom," The Commercial Appeal (Memphis, TN) (April 24 - May 30, 1988)

TROUBLE
IN
PARADISE

Sri Lanka's natural wonders and archaeological treasures make it one of the most beautiful lands on Earth. But warring ethnic factions are tearing the island nation apart.

In the north, a Hindu Tamil guerrilla patrols the countryside. In the south, a Sinhalese monk (right) meditates before a 43-foot Buddha, a masterpiece carved from stone in the 5th century.

Photography by Michael S. Wirtz
STORY BEGINS ON PAGE 21

Bert Fox, David Griffin, Tom Gralish, The Philadelphia Inquirer Sunday Magazine, 1st Place in Newspaper-produced Magazine Picture Editing Award

Randy Miller, "JFK 25 Years," Detroit Free Press (Nov. 13, 1988)

Chris Norman, "Crack: The Pipe Dream," Tallahassee (FL) Democrat (Nov. 13-17, 1988)

Newspaper-produced Magazine Picture Editing Award

(6 entries)

1st Place **Bert Fox, David Griffin, Tom Gralish**, The Philadelphia Inquirer Sunday Magazine

2nd Place **J. Bruce Baumann,** The Pittsburgh Press Sunday Magazine

3rd Place **Kathy Ryan,** The New York Times Magazine

Best use of Photos by a Newspaper

Circulation under 25,000

(9 Entries)

1st Place **Journal Tribune** (Biddeford, ME)

2nd Place **Concord** (NH) **Monitor**

3rd Place **The Californian** (El Cajon, CA)

Award of Excellence
Jackson Hole (WY) News

Continued on the next page

Journal Tribune, Biddeford, Maine, 1st Place in Best Use of Photos by a Newspaper w/circ. under 25,000

Gazette-Telegraph, Colorado Springs, Colo., 1st Place in Best Use of Photos by a Newspaper w/circ. of 25,000 to 150,000

The Boston Globe, 1st Place in Best Use of Photos by a Newspaper w/circ. over 150,000

Star-Tribune Newspaper of the Twin Cities, Minn., 2nd Place in Best Use of Photos by a newspaper w/circ. over 150,000

Continued from previous page

Best use of Photos by a Newspaper
Circulation of 25,000 to 150,000
(16 Entries)

1st Place **Gazette-Telegraph** (Colorado Springs, CO)
2nd Place **Anchorage (AK) Daily News**
3rd Place **The Albuquerque Tribune**

Awards of Excellence
Press-Telegram (Long Beach, CA)
The Daily Breeze (Torrance, CA)
The Sun (San Bernardino County, CA)

Best use of Photos by a Newspaper
Circulation over 150,000
(12 Entries)

1st Place **The Boston Globe**
2nd Place **Star-Tribune Newspaper of the Twin Cities**
3rd Place **The Seattle Times**

Awards of Excellence
Detroit Free Press
San Jose (CA) Mercury News
The Virginian/Pilot & Ledger/Star

Best use of Photos by a Newspaper— Zoned Editions
(8 Entries)

1st Place **The Orange County Register Community News**

2nd Place **The Sacramento Bee Neighbors**
3rd Place **The Virginian/Pilot & Ledger/Star, The Chesapeake Clipper**

Awards of Excellence
The Philadelphia Inquirer Neighbors
The Seattle Times Today

Best use of Photography by a Magazine
(14 Entries)

1st Place **Life**
2nd Place **National Geographic**
3rd Place **American Photographer**

Awards of Excellence
Foreign Mission Board
International Wildlife
National Wildlife
The Philadelphia Inquirer Sunday Magazine

Life, 1st Place in Best Use of Photos by a Magazine

National Geographic, 2nd Place in Best Use of Photos by a Magazine

American Photographer, 3rd Place in Best Use of Photos by a Magazine

Index

Index

Continued on next page

Index

This book was produced using Apple Macintosh computers, a Jasmine DirectPrint printer, a Varityper VT-600 printer, AmperPage, Microsoft Word and Aldus PageMaker software. Final output was done on a Linotronic typesetter